Portraits of Cuba

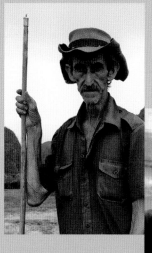
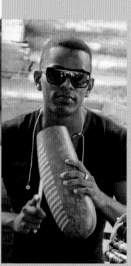
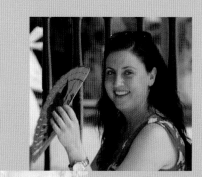
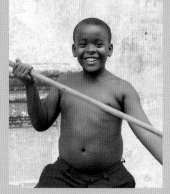

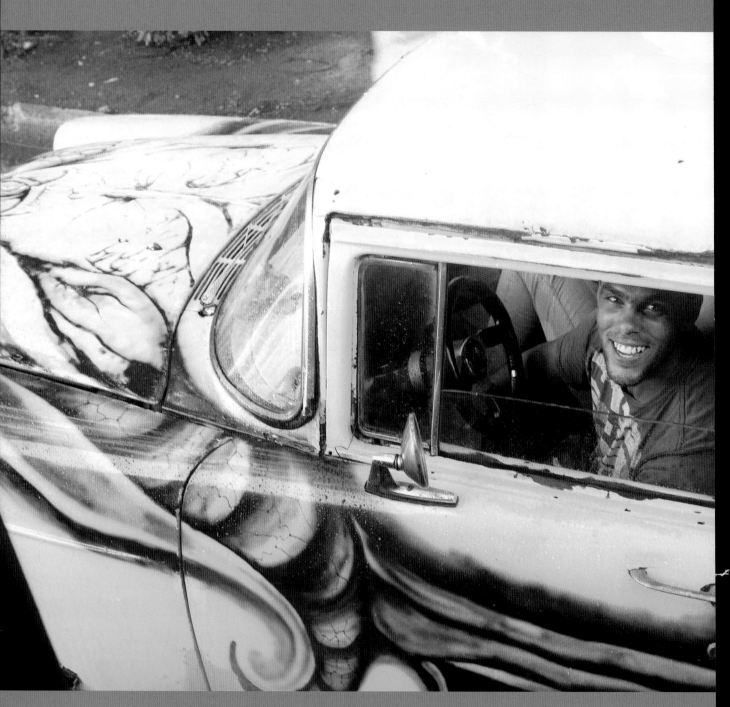

Vedado, Havana.

Portraits of Cuba

Daniel Duncan,
Marcela Vásquez-León,
and Dereka Rushbrook

University of Florida Press

Gainesville

25 24 23 22 21 20 6 5 4 3 2 1

Library of Congress Control Number: 2019954695
ISBN 978-1-68340-156-8

UF PRESS

UNIVERSITY
OF FLORIDA

University of Florida Press
2046 NE Waldo Road
Suite 2100
Gainesville, FL 32609
http://upress.ufl.edu

In memory of Cuban historian Fernando Martínez Heredia (January 31, 1936–June 12, 2017), who contributed to our understanding of Cuba, who shared a historical perspective that was often deeply personal, and with whom we had many inspiring conversations. Some of the quotes included in this book come from those conversations.

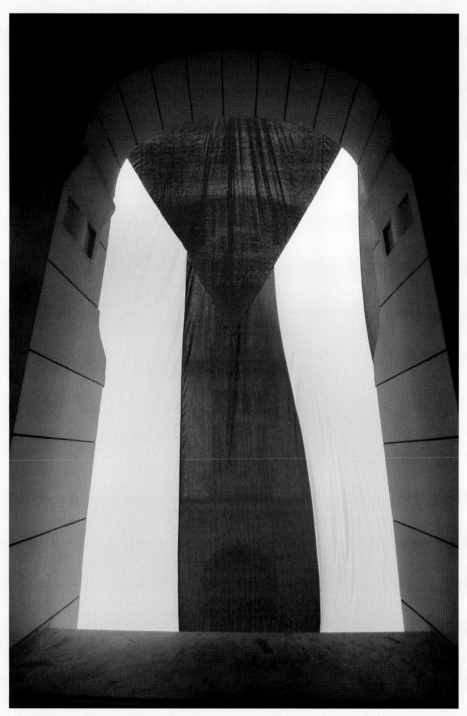

Museo de la Revolución, Havana.

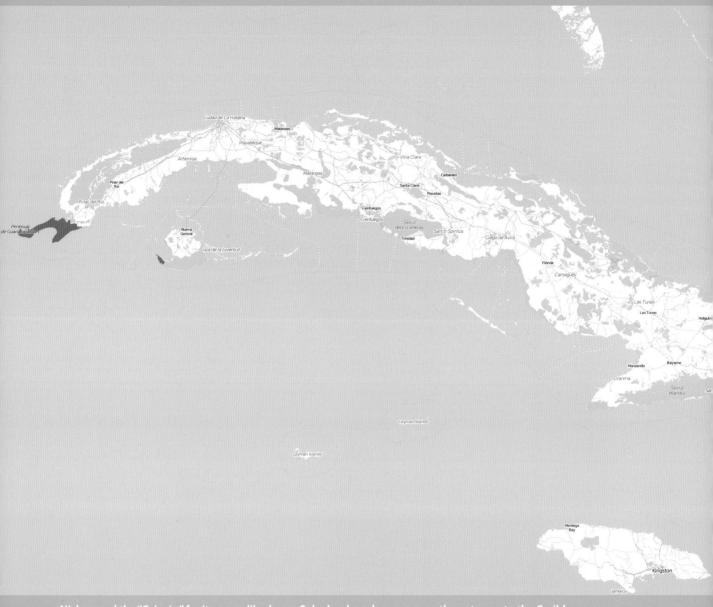

Nicknamed the "Caimán" for its crocodile shape, Cuba has long been seen as the gateway to the Caribbean.
Map created by Hector González.

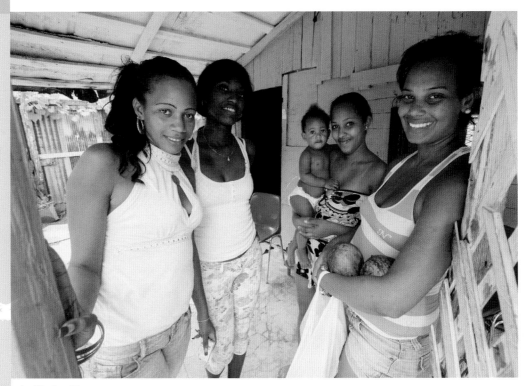

La Timba, Havana.

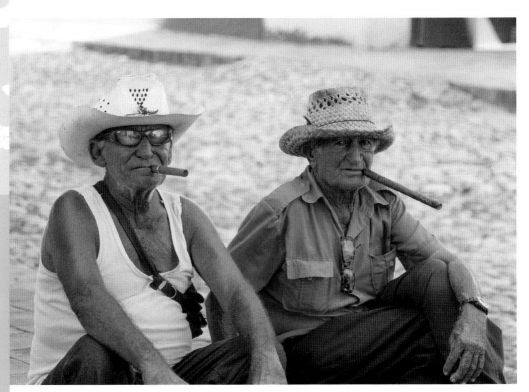

Trinidad, Sancti Spíritus.

"Fellow workers and peasants, this is the socialist and democratic revolution of the humble, with the humble, and for the humble."—Fidel Castro, April 16, 1961, at a funeral ceremony for victims of the Bay of Pigs invasion

"All ships of any kind bound for Cuba from whatever nation or port will, if found to contain cargos of offensive weapons, be turned back. This quarantine will be extended, if needed, to other types of cargos or carriers."—John F. Kennedy, October 22, 1962

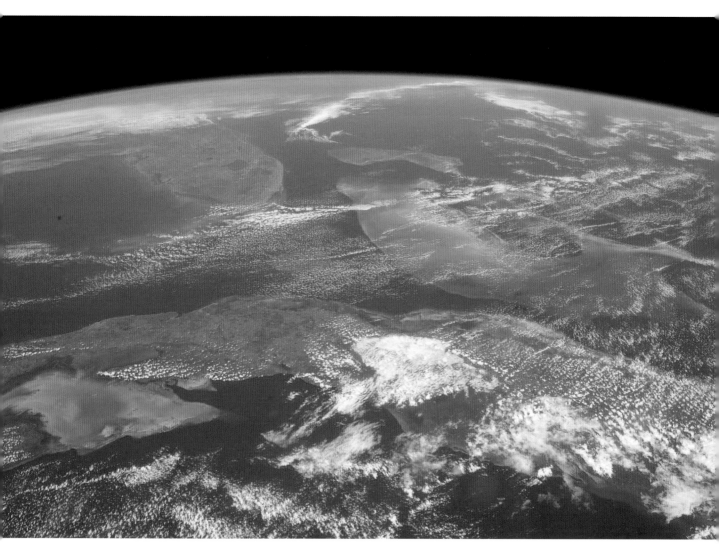

This view of Cuba consists of a composite of satellite images acquired in 2004, part of NASA's Blue Marble Series. Source: NASA Worldview.

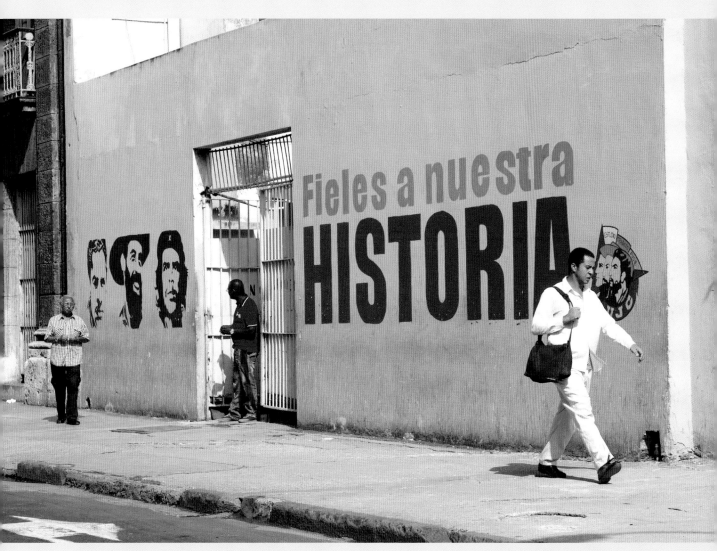

"Faithful to Our History." Centro Habana, Havana.

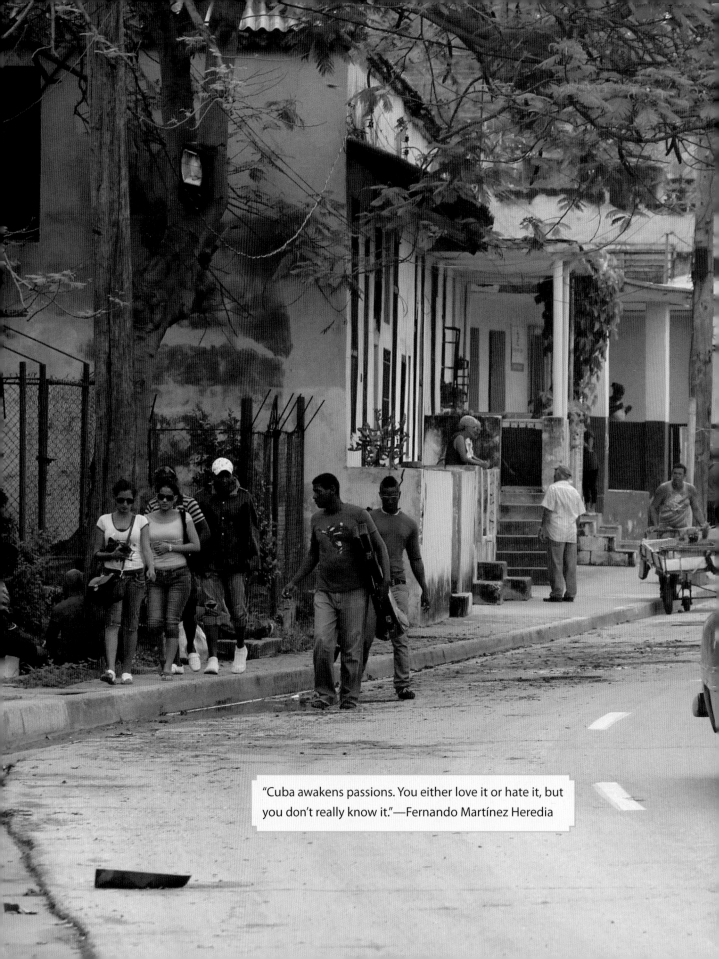

"Cuba awakens passions. You either love it or hate it, but you don't really know it."—Fernando Martínez Heredia

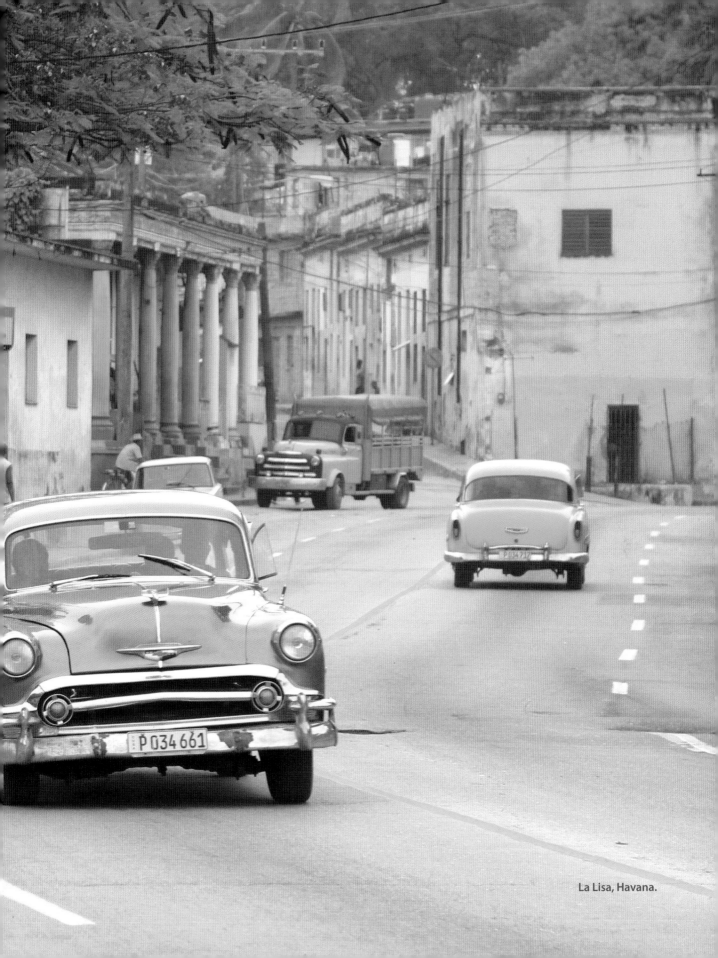

La Lisa, Havana.

Cienfuegos, Cienfuegos.

Contents

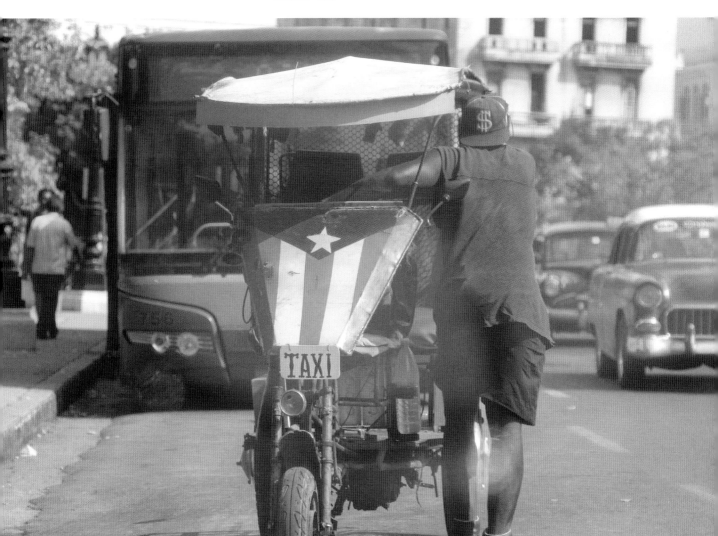

Centro Habana, Havana.

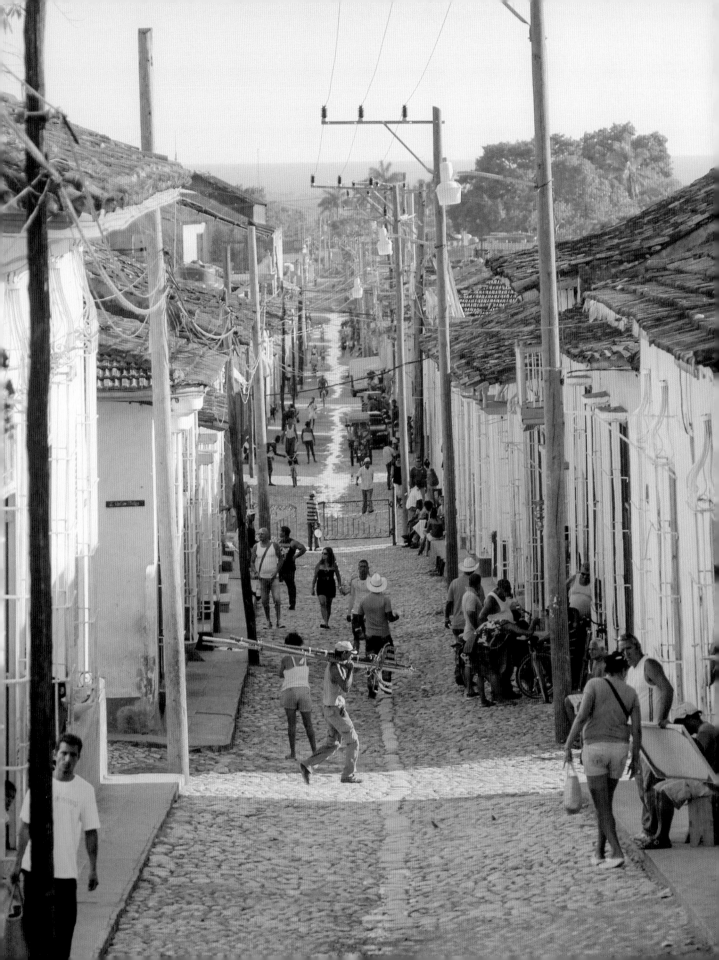

Introduction

The Revolution and El Bloqueo

El bloqueo, the Cuban name for the economic embargo, was imposed by the U.S. government in 1960, and since then the United States has used its political, military, and economic powers to enforce it. This has been the longest and most restrictive trade embargo imposed by one nation against another in modern history. For more than 50 years, el bloqueo has shaped the daily lives of Cubans, who continue to invent, adapt, and persevere in its shadow.

The 1959 revolution brought Cuba a revolutionary government officially led by Fidel Castro, who, within the first two years, nationalized U.S.-owned assets in the island and declared a socialist regime. U.S. government officials, seeing the presence of a socialist country so close to home as a threat in the midst of the Cold War with the Soviet Union, imposed the embargo to quarantine if not subvert the Castro regime. More than 60 years later, the embargo continues and, more than three decades after the breakup of the Soviet Union, Cuba remains socialist. Today the embargo seems anachronistic and difficult to justify to many observers across the political spectrum in the United States. Cuban Americans supporting the embargo, who for decades had the political clout to influence U.S. elections, are now a minority in the Cuban American community. For Cubans and for many others in Latin America, el bloqueo is a constant reminder of U.S. imperialism and the refusal to treat Cuba as a sovereign nation. At the same time, as Cubans on the island often say, the bloqueo continues to provide an excuse used by Cuban authorities to explain shortcomings of the country's state-controlled economy.

In this book, we focus on contemporary Cuba. We use the bloqueo as a way to start a conversation with Cubans of different ages and walks of life who are experiencing the social, cultural, and economic changes transforming the island today. We, of course, recognize that many other systemic pressures beyond the bloqueo have a great impact on people's lives. As a small island, for example, Cuba is highly vulnerable to extreme climate events, natural disasters, and environmental changes such as rising sea levels; along the south coast, some households have

already been permanently relocated as a result of the rising waters. The small island's economy also has a limited natural resource base, which restricts its ability to diversify, prevents the development of economies of scale, and necessitates a dependence on imports of food and fuel.

Today Cuba faces socioeconomic realities of enhanced difficulty. In his first policy speech on July 26, 2007, former President Raúl Castro openly criticized what he labeled a stagnant and highly bureaucratized system. He called for change in the economic model, including decentralization and equal treatment of state and non-state producers. Cuba's new president, Miguel Díaz-Canel, who was born after the revolution and assumed office on April 19, 2018, continues to pursue cautious reform of his predecessor's economic policies, while trying to preserve the country's social structure. A difficult challenge that creates an additional burden is Cuba's demographic crisis: the improved healthcare brought by the revolution has translated into increased longevity. At the same time, the number of working-age citizens has declined due to out-migration, partly fueled by disillusionment among the young, who often lack prospects on the island for using the knowledge gained through Cuba's successful education system in productive ways. Until recently, out-migration had the added incentive offered by U.S. policies like the Cuban Adjustment Act of 1966 that basically stated that anyone who emigrated from Cuba and entered the United States, including U.S. territorial waters, had the right to pursue legal residency and, eventually, U.S. citizenship. This policy was revised in 1995 and came to be known as the "wet foot, dry foot" policy, which meant that Cubans caught in the waters between the two countries ("wet feet") would be sent back to Cuba or to a third country, and those who made it to shore ("dry feet") were offered initial financial support and a path to permanent legal residency. Even though this policy was suspended in January of 2017, which means that Cubans arriving on U.S. soil without a visa are now subject to deportation, the Cuban Adjustment Act remains on the books. Exacerbating the island's demographic woes is the fact that Cuba's fertility rates, far below replacement level, are now the lowest in Latin America. As a result of these changes, Cuba now has the oldest population in the hemisphere, and its population decline is expected to accelerate in coming years.

Despite internal and external pressures, the Cuban regime has created the socioeconomic infrastructure to provide all Cubans with access to the basics of food, shelter, health care, and education. Since the revolution, the Cuban government has given first priority to social and political needs when implementing its economic policies; productivity and efficiency have tended to be an afterthought. The socioeconomic infrastructure does ensure, however, that the island as a whole is, for example, capable of responding with a high level of efficiency to natural disasters. As well, economic changes since the 1990s have allowed the country to

survive the pressures of the U.S. embargo, even with the collapse of primary trade relations with the Eastern Block. Cuba has created a booming tourism industry in partnership with foreign investors, as well as joint ventures, such as nickel mining and rum and tobacco distribution, with Canadian and European companies.

The resilience of the island's residents has deep roots in a history marked by a long and persistent struggle against foreign domination. Spain established ruthless colonial rule of the island in the early sixteenth century. In 1762, Havana was briefly occupied by Great Britain, opening trade with North American and Caribbean British colonies and importing thousands of slaves from West Africa to work in the sugar plantations. After Haiti achieved its independence in 1804 through a slave rebellion that destroyed the world's largest sugar-exporting economy, Cuba became the leading sugar producer. During the 1800s Cuba expanded and diversified the slave trade, developing a brutal slave-dependent plantation economy. As with other islands in the Caribbean with large Afro-descendant populations, slave revolts and the specter of Haiti's revolution initially tempered the elites' enthusiasm for independence. But by the second half of the 1800s, when most Latin American nations had already achieved independence, the drive for independence in Cuba had taken off.

The Cuban national anthem was first performed at the Battle of Bayamo, in the first independence war initiated under the leadership of Carlos Manuel de Céspedes in 1868. Ten years later, the war ended with some concessions, but no independence. The war that would finally result in independence began in 1895, when exiled forces landed in eastern Cuba under the leadership of generals Máximo Gómez and Antonio Maceo, and of José Martí, "The Apostle of Cuban Independence." Martí and Maceo would die before their dreams were realized. Spain was driven out in 1898 during the Spanish-American War, when the United States intervened in the last war of independence and sidelined Cuban leaders during negotiations with Spain. Cubans immediately faced ongoing intervention and periodic occupation by the United States. The Platt Amendment of 1901, imposed by the United States, stipulated a series of conditions that formalized U.S. dominance over Cuba in exchange for the withdrawal of U.S. troops from the Island.

Between 1898 and the revolution of 1959, Cuba remained a quasi-protectorate of the United States, with a plantation-style economy run by U.S. interests and highly corruptible elected governments that rotated with U.S.-supported dictatorships. U.S. interference during the era of General Fulgencio Batista (1952–1959), when Cuba became a safe haven for U.S. organized crime figures, was particularly egregious to most Cubans. Cosmopolitan Havana boasted the world's largest hotel-casino complex outside of Nevada, was the second city in Latin America to offer television, and had an upper and middle class that had become accustomed to the luxuries of U.S. life. This stood in stark contrast to the abject poverty found in

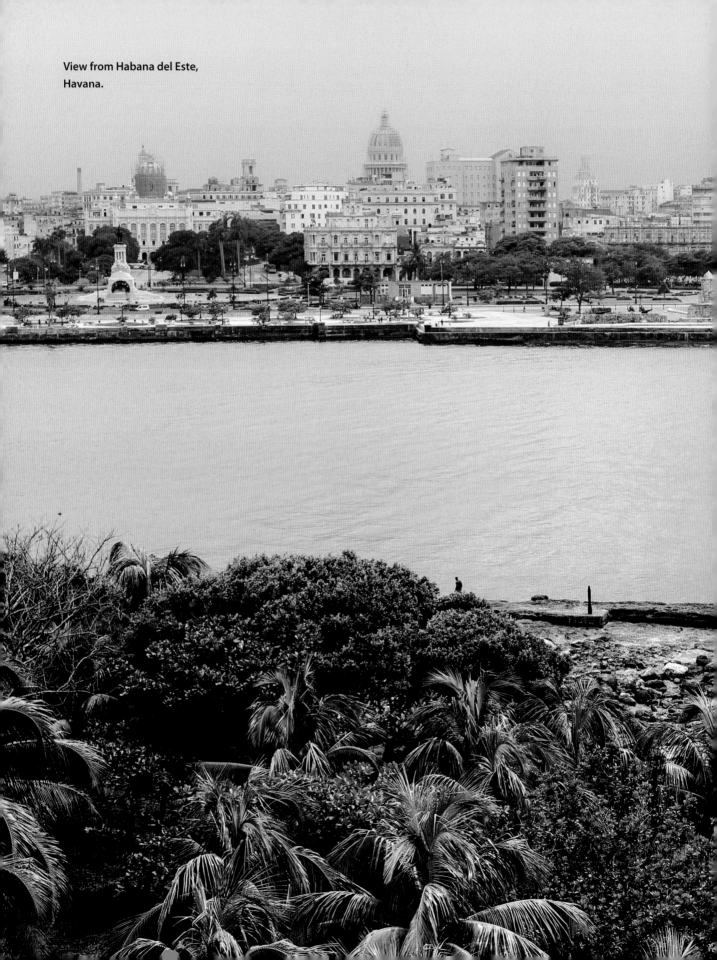

View from Habana del Este,
Havana.

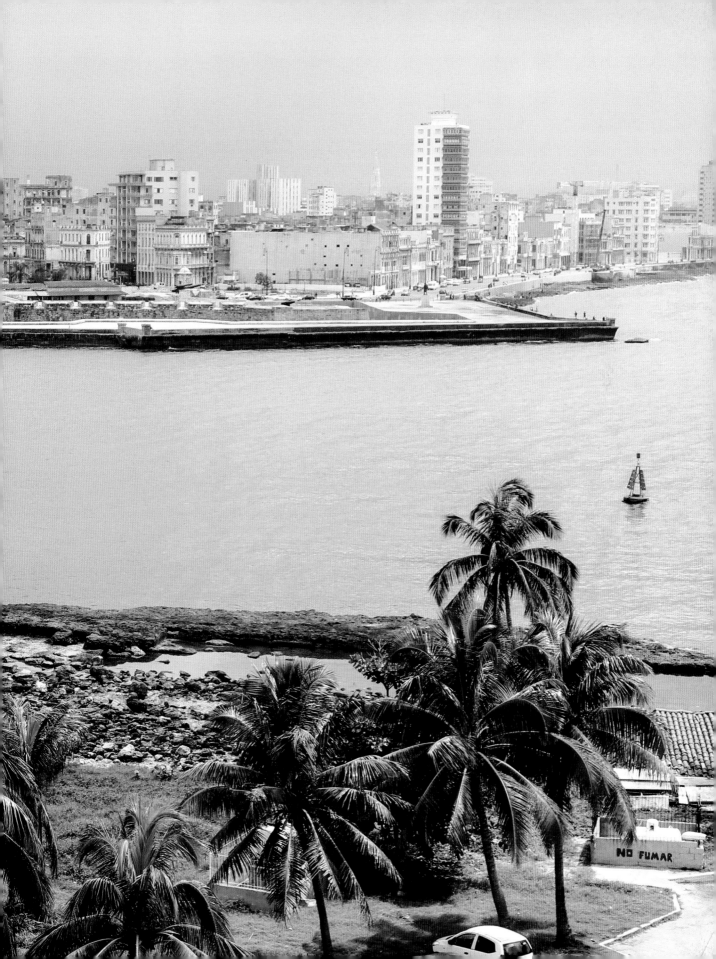

rural areas, where most of the people lived in huts and lacked clean water, electricity, and indoor toilets and where nine out ten almost never ate meat, fish, eggs, or green vegetables. While these inequalities were stark, opposition to Batista and his corrupt regime went beyond these differences. Batista's reign was brutal, with the suspension of constitutional guarantees, press censorship, the closure of universities in the wake of student activism and the ongoing assassination and torture of labor leaders, students, and other opponents. Discontent was widespread, resulting in broad support for the revolution.

Fidel Castro and his revolutionary forces overthrew the U.S.-supported dictator Fulgencio Batista in the 1959 military victory. This marked the moment when Cuba proclaimed its independence from all foreign powers and began to plot its course for a more just society. The 1959 agrarian reform set out to break up large landholdings and redistribute the land to peasants, cooperatives, and the state. Large landholdings, which included those owned by U.S. companies, were expropriated and foreigners were forbidden to own sugar plantations. As Castro and his allies consolidated power, they were immediately met with hostility from the United States, which opened a space for the USSR. When the United States cut the island's sugar quotas in 1960, the USSR stepped in to purchase those 700,000 tons of sugar. Also in 1960, the U.S. government ordered U.S. refineries on the island to refuse to refine Soviet crude oil. When, later that year, Cuba initiated revolutionary programs to nationalize the assets of foreign companies, it was challenged by the United States. Using Cold War rhetoric, the U.S. Central Intelligence Agency began plotting to overthrow Castro's government. This soon resulted in the 1961 Bay of Pigs invasion by a CIA-sponsored paramilitary group comprised primarily of Cuban exiles. The invasion, which was promptly crushed by Cuban troops, was justified by the United States through claims that Cuba's emerging ties with the Soviet Union posed a threat to stability and democracy in Latin America. Cubans, on the other hand, understood the invasion as a direct attack on their national sovereignty, which they vowed to defend at all costs. The Bay of Pigs invasion cemented Castro's image as a villain in the eyes of the U.S. government, but it greatly enhanced his stature within Cuba and in the eyes of much of the world. Cuba had stood up to the United States and won.

Following the defeat at the Bay of Pigs, the U.S. government expanded the Cuban embargo in 1962 and made the sanctions permanent. In response, Cuba accepted the Soviet Union as an ally and adopted a Marxist-Leninist ideology. In practice, this meant that the government took control of industry, commerce, media, and entertainment on the island. All these enterprises were to be managed in the interests of the people, as the state defined itself as representing the more marginalized sectors of the population against the conservative upper classes dominated by the United States. Within the first few years of the revolution, around a

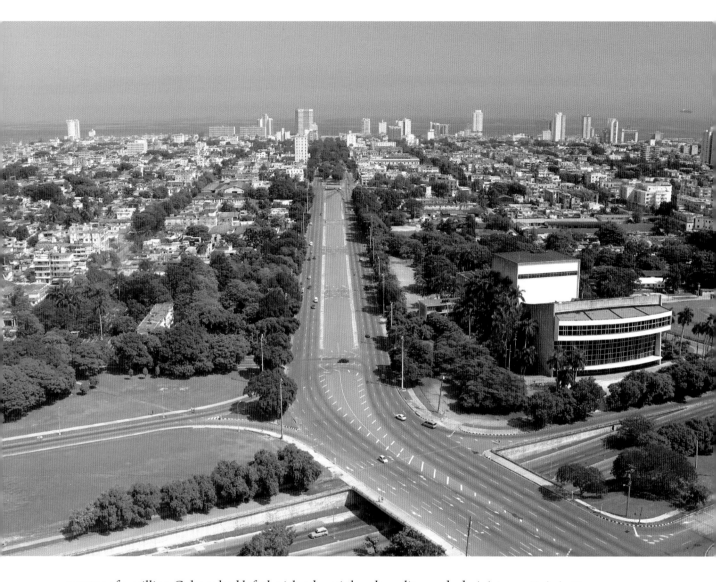

Vedado, Havana.

quarter of a million Cubans had left the island, mainly urban elites and administrative and technical personnel critical to industrial and agricultural production. The island lost 70 percent of its food and consumer goods imports, which came from the United States, and most Cubans on the island suffered severe deprivation as an effect of el bloqueo. The Cuban government needed international partners, and eventually found them as ties with the Soviet Union and its Eastern European allies grew from 1960 onward.

The alliance with the Soviet Union resulted in economic and political overdependence on the Eastern bloc, greatly diminishing Cuba's goal of national independence. With the collapse of the Soviet Union in the early 1990s, its economic support for Cuba ended. What is referred to as the "Special Period in Time of Peace" began, with a precipitous decline in living standards on the island. The

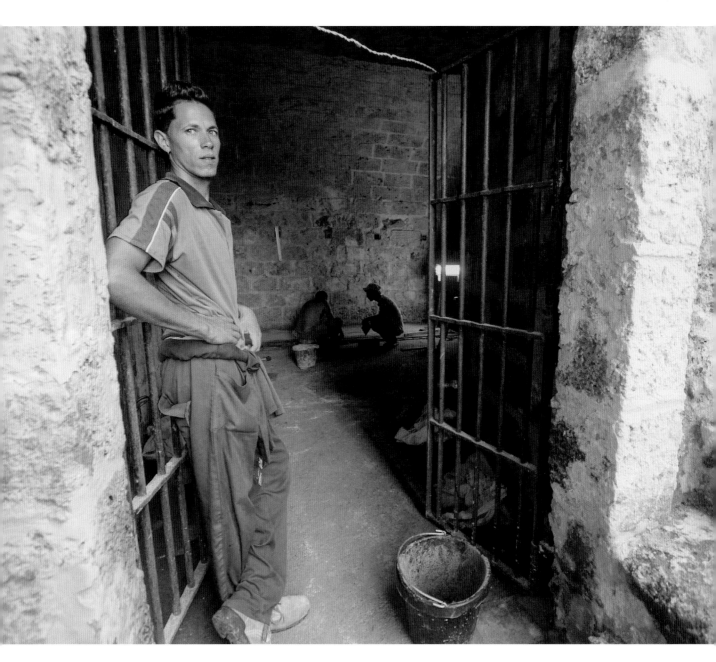

La Jagua, Cienfuegos. Special Period opened the possibility of normalizing U.S.-Cuba relations, but Cuba refused to embrace capitalism, and the ongoing antagonism from the United States deepened.

The United States has steadfastly maintained el bloqueo for more than half a century despite objections from the United Nations General Assembly, which passed a resolution that condemned the embargo in 1992 and every year since. Likewise, international human rights groups including Amnesty International, Human Rights Watch, and the Inter-American Commission on Human Rights, as

well as U.S. humanitarian organizations, have repeatedly declared the embargo to be a violation of the charter of the United Nations, basic human rights, and international law.

To the surprise of much of the world, Cuba has managed to withstand the sanctions of the embargo, despite its severity and its economic consequences. This has happened as Cuba has emerged as a leader in sustainable agriculture and agroecology, and Cuban scientists have become leaders in medical research and biotechnology. Among countless medical breakthroughs, Cubans have developed their own vaccines for meningitis B and hepatitis B, antibodies for kidney transplants, effective medication for the treatment of psoriasis, and an immunological treatment for lung cancer.

The common assumption that Cubans have been stranded in isolation, overshadowed by the United States, discounts Cuba's standing in the international community. Cuban foreign policy has given priority to solidarity with other nations that have suffered under colonialism. As Humberto Miranda Lorenzo, a university researcher in his 50s, explained to us: "The Cuban has been living in solidarity for fifty years, and it's not a huge step from helping your own people to helping anyone who needs it elsewhere. The Cuban army that is out in the world today is an army of teachers, of people who save lives, and who save eyesight. Cubans are in Haiti, in Africa. We are where no one else wants to be, and we don't expect payback." The cornerstone of Cuban international diplomacy is the government's *Misiones Internacionalistas,* the brigades of medical, educational, and sports experts who have traveled around the world. Cuban medical teams, known for their long-term assistance after natural disasters, assumed a leading role in the international battle against Ebola. Cuba provides more doctors, nurses, and health practitioners to the developing world than do all the leading industrialized countries combined. It has also provided tuition, room and board to the over 30,000 international students trained as doctors at its International School of Medicine, which opened in 1999. In addition, its contribution to global education through literacy campaigns has become a model throughout the developing world.

Although Cubans are often quick to criticize bureaucratic inefficiencies and obstacles that complicate their daily lives, they are proud of the achievements of the revolution. For many Cubans, these criticisms reflect a desire to see problems addressed within the current system rather than a call to adopt a capitalist system and move toward US-style politics.

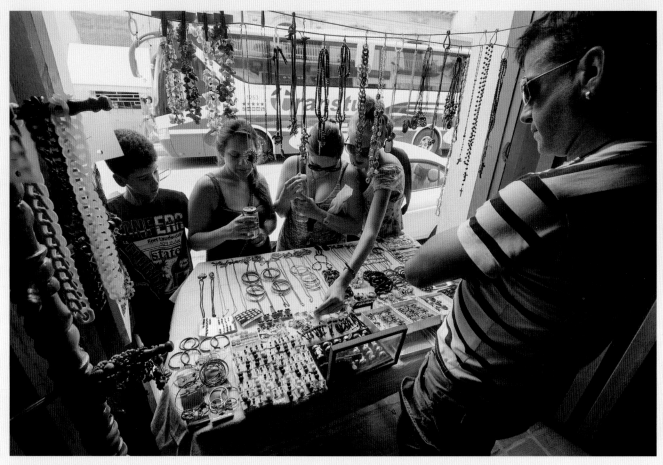

Santa Clara, Villa Clara.

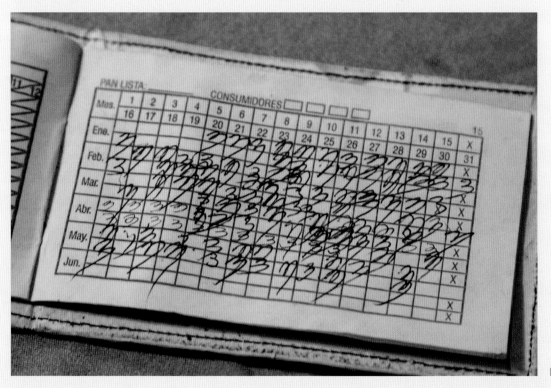

Ration book, or *libreta*.

The embargo produced consequences unforeseen by its authors. Cubans have survived as a people and a nation through their ability to adapt, become self-reliant, and innovate. This self-sufficiency is now a matter of national pride. In the face of scarcity, Cubans created tools, such as agricultural implements from leftover bicycle parts, as well as consumer goods like picture frames from old CD cases and dolls from shampoo bottles. Even with the economic difficulties, Cuba remains a safe country; social solidarity is pervasive, street crime is rare, and illegal drug use is almost nonexistent. Even though Cuba is surrounded by the largest exporters of illegal drugs in the Americas (Colombia and Mexico); the most important transit countries in Central America and the Caribbean; and the largest consumer market, the United States, Cuba's production and consumption of illegal drugs is negligible. In fact, it is often praised by Washington as one of its most dependable allies in opposing the decriminalization of narcotics. Today, Cubans continue to challenge the common wisdom of international politics and uneven development as they struggle to invent their own form of participatory democracy and their own economic path.

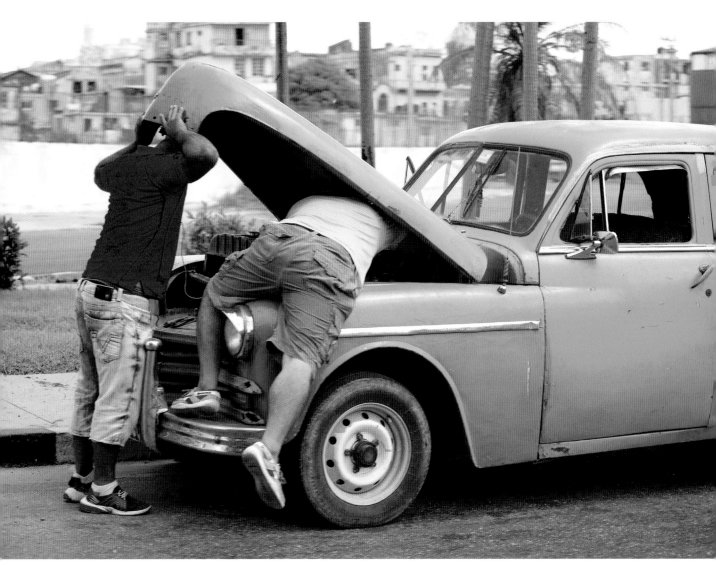

Havana.

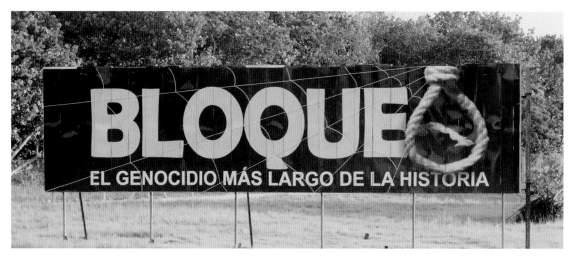

Vedado, Havana.

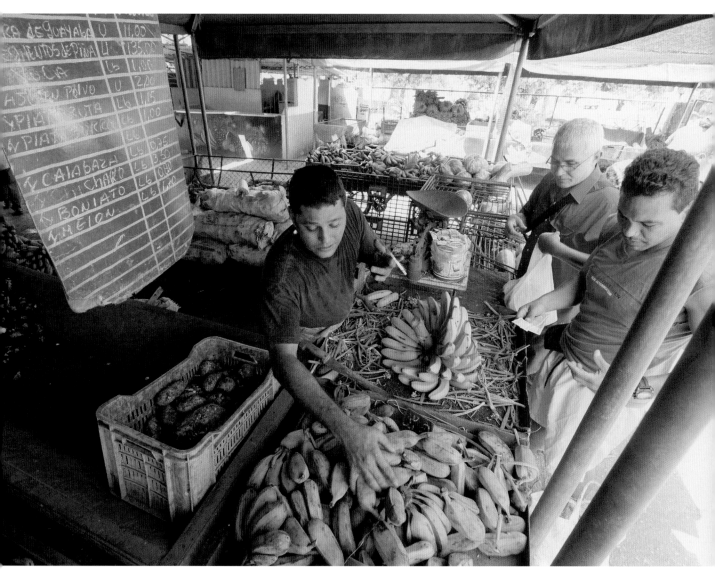

Havana.

One innovation designed to address critical social needs in daily life is ration books, or *libretas* (see page 10). Implemented shortly after the revolution and never intended to be permanent, they were designed to ensure Cubans access to a wide range of basic necessities, from rice and cooking oil to school uniforms, at low and subsidized prices.

Habana Vieja, Havana.

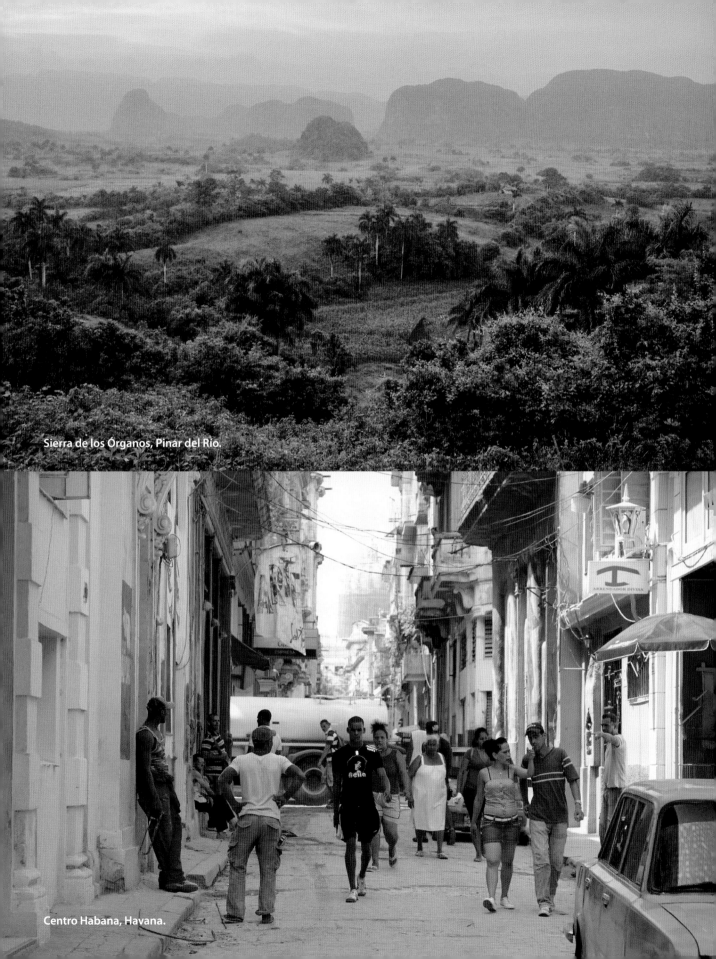

Sierra de los Órganos, Pinar del Río.

Centro Habana, Havana.

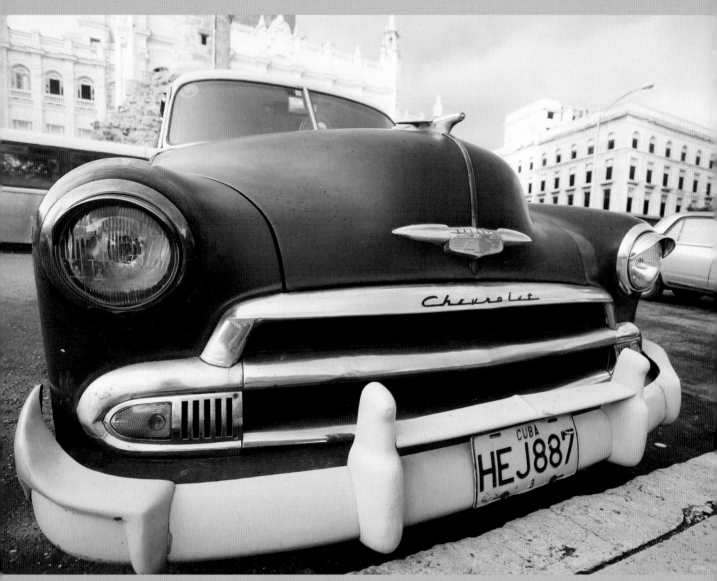

Centro Habana, Havana.

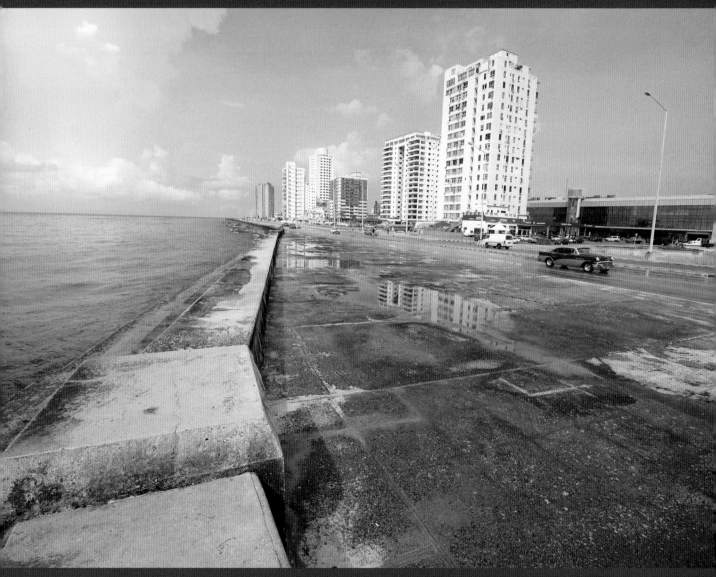

Vedado, Havana.

Centro Habana, Havana.

Havana

Havana, city of dreams, means something different to everyone.

Founded in 1519, Havana has always been Cuba's face to the world. Once the threshold of the Spanish empire in the Americas, it became and remains today a cosmopolitan city located at the crossroads of the Caribbean. Alive with the energy of the twenty-first century, Havana today respects its past. The city was originally centered on the bay, and some of the most recognizable views of the skyline highlight its fortresses, such as El Morro, built by the Spanish in 1589 to defend the city against buccaneers, pirates and French corsairs who harassed Spanish ships and ports, seeking Spain's New World treasures. Havana's "window to the sea" is the world-famous *malecón.* Dotted with monuments to heroes of the independence wars of the nineteenth century, the malecón was built during the early years of independence. Cooled by sea breezes, it is now a favorite hangout for *habaneros* [residents of Havana] and visitors alike, and a spot for fishing, impromptu music sessions, or watching the sunset. Like many habaneros, Estrella Álvarez Varela, a computer mathematician in her early 50s, loves the malecón, "with its variety of architecture despite the level of deterioration that is also caused by the climate." As Havana is a coastal city, she adds, the climate's "corrosive aggressiveness is pretty strong, requiring massive resources in order to protect [the malecón]."

The growth of the city appears in the layout and architecture of its neighborhoods, creating streetscapes rich in history. Mayra María García, a record producer and Havana resident, talks about her city and its diverse neighborhoods:

There are *barrios* [neighborhoods] that are more cosmopolitan, like Vedado; there are barrios that are chic, like Miramar, which is a neighborhood not so much of the upper class, but a neighborhood designed for a social class that moves *en cuatro ruedas* (by car), like we say, not on foot. There are barrios that are very urban, like Centro Habana, where everything is densely packed and where large waves of migrants arrived from the east of the country. There are also barrios like Habana Vieja that are enchanting. I say that those are the barrios of the beautiful spirits of ghosts that we inherited from colonial times.

There are also very marginal barrios, that are painful to us all, but that exist, that are there, alive, and that every day show us survival strategies.

The historical center of Habana Vieja (Old Havana) was declared a UNESCO Heritage Site in 1982, just as the preservation program directed by Eusebio Leal Spengler in the City Historian's Office began to take off. Hundreds of landmark buildings have been restored over the years, and the recent Plaza Vieja project was one of the largest. One of the four original plazas of the city, the Plaza Vieja, or the Old Square in Havana, was first laid out in 1559, where it was the site of public events and festivals, as well as commerce. In the mid-twentieth century, it was turned into an underground parking lot, but its buildings have since been beautifully restored. Today, among the museums, galleries, and restaurants on the Plaza, a primary school serving neighborhood children continues to occupy prime real estate. This is part of a state cultural policy designed to preserve local infrastructure and minimize gentrification. Nevertheless, outside the restored areas, which have become top destinations for tourists, of Havana's 15 municipalities, the

Map of Havana, created by Hector González.

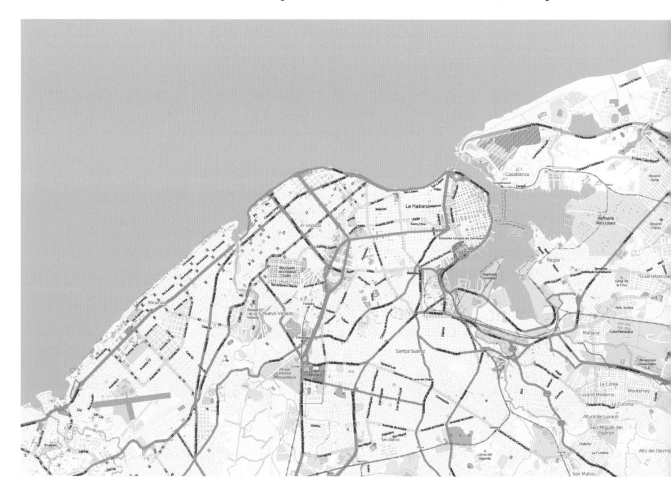

Portraits of Cuba

Habana Vieja neighborhood has the highest concentration of poor housing and overcrowding.

Marianao, Havana.

The tropical climate can be particularly detrimental to Havana's historical structures. The hurricane season runs from June through November, and heavy rains often result in the collapse of buildings that have not been maintained.

Lack of resources to rebuild or maintain housing infrastructure is always in the minds of habaneros. Domestic production of building materials is inadequate, and the bloqueo has meant that the closest and most natural source of building materials, the United States, is off-limits. People make their own substandard materials, but successful innovations are usually celebrated, like the case of a Marianao resident who obtained a patent for paint that he invented and manufactures in his home. The paint works well and is relatively inexpensive. The government has implemented a series of loans and grants to allow those most in need to make repairs and, under the new *lineamientos,* the 313 guidelines stemming from the Sixth Party Congress in 2011, brigades of *cuentapropistas* (self-employed people) can now be hired to make repairs, and more licenses are being issued to modify and repair homes. Despite recent reforms aimed at facilitating repairs and new construction, the city struggles. Strolling the sidewalks, it is easy to notice more recent ad hoc

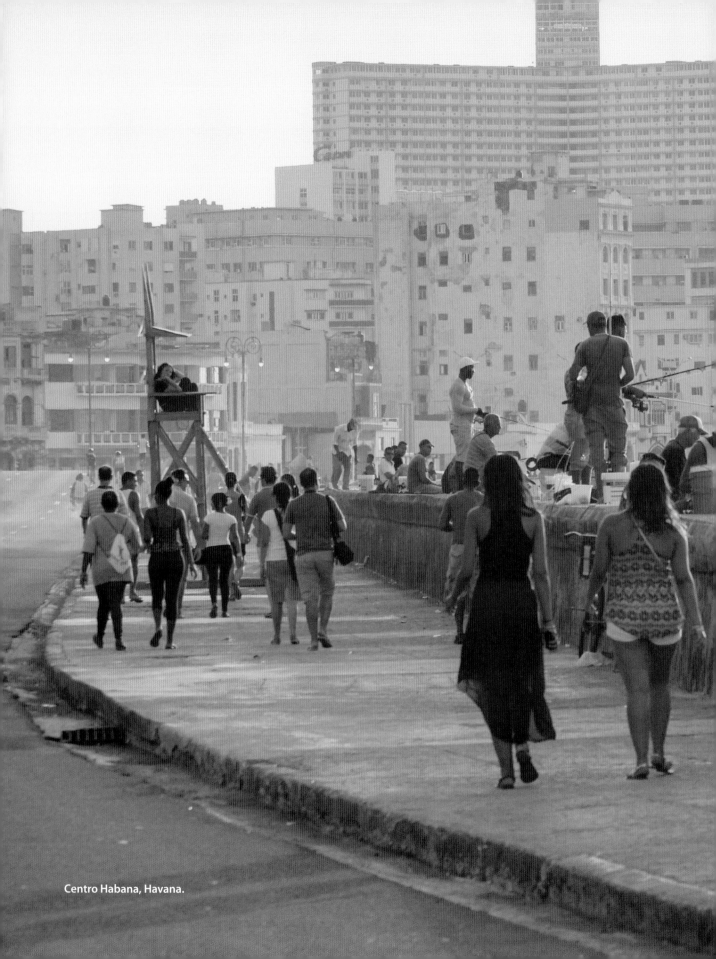
Centro Habana, Havana.

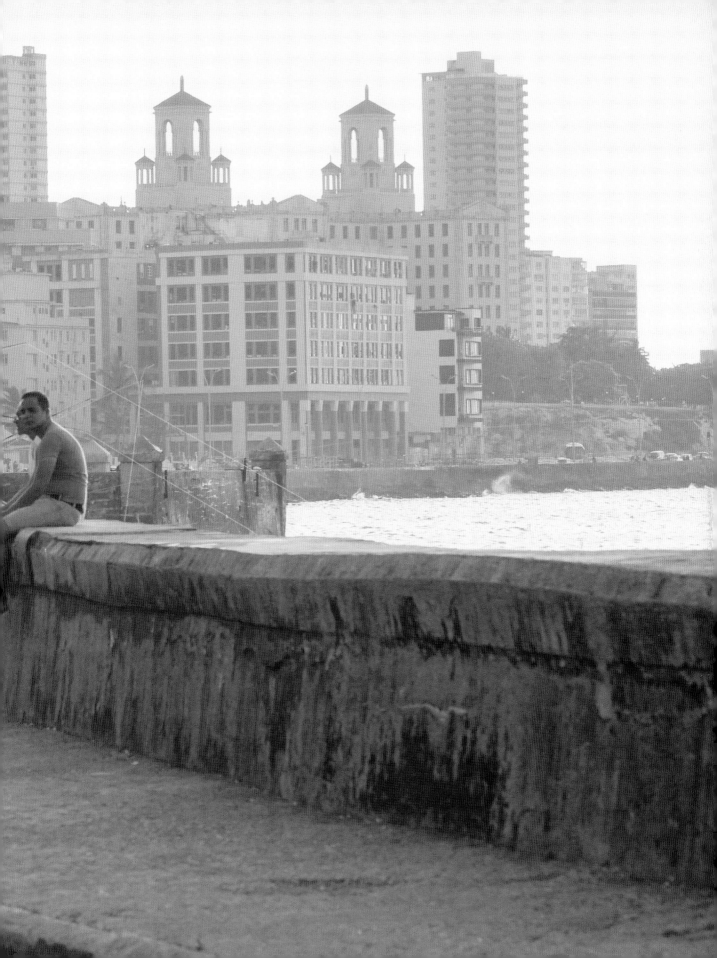

innovations designed to address a shortage of housing, with the conversion of garages to small apartments, rooms built on balconies and roofs, and the *barbacoas* (lofts) that divide old mansions horizontally, turning one floor into two.

In 2010, the Cuban government began to issue licenses for small businesses. A year later the lineamientos, designed to update the framework of the nation's economic and social policies, allowed the government to reduce the size of the state sector by shifting workers into non-state sectors and expanding employment in the private sector. Immediately, the number and variety of cuentapropistas increased, as did the sounds and sights of the street. Signs advertising cell phone repair shops and cafeterias, newly painted *casas particulares* (bed-and-breakfasts), and pizzerias proliferated. Street cries of those seeking to purchase anything from old refrigerators and perfume bottles to gold jewelry, or selling *galletas* (crackers) or common household products, echoed throughout the neighborhood. Vegetable vendors, cobblers, and manicurists set up shop on porches and driveways, and those residents lucky enough to have a window looking onto a busy street opened businesses without leaving home.

The constraints of the U.S. embargo, ironically, helped to create one of the most iconic images of Havana and Cuba: the 1950s U.S. automobile. In Havana many commute via *máquinas,* vintage U.S. cars that run fixed routes that stop to take on or drop off passengers at any point along the way. Brightly painted convertible vintage U.S. cars are also used to shepherd tourists through the city. Ironically, the expansion of private businesses and the broad legalization of private car sales have combined to increase the number of U.S. cars on the streets, as many have been brought out of storage and repaired. These classic cars share the streets with *bicitaxis* (manually powered bicycle taxis), commonly used to transport people within neighborhoods, and the *cocotaxis* (three-wheeled auto rickshaws) popular with tourists. Also on the streets are Russian cars of the 1970s and 1980s, Chinese buses, and, outside of the city center, horse-drawn carts and trucks that have been converted to carry passengers to destinations on the outskirts of the city. Few post-revolution U.S. cars are found, and German, French, South Korean, and Chinese models dominate the roads.

Despite the decades-long U.S. embargo, Havana's sophisticated nature appears in the makeup of its residents, the mixture of languages being spoken by tourists strolling along the malecón, and the range of film festivals, conferences, and cultural and athletic events that take place annually and draw participants from around the world. At the same time, Havana is made up of barrios, where neighbors know each other and walk to their community *panaderías* (bakeries), *bodegas* (local stores), and *agromercados* (farmers' markets), and children rarely need to venture more than a few blocks to reach their schools.

What makes Havana are the city's residents, known as *habaneros.* In Havana, life happens in the street, as neighbors call to each other from balconies; apartment-dwellers shout out to stop vendors as they pass by, lowering a bag from the window to pull up freshly baked bread; and games of dominos are played under trees. Like Gladys Esther Sol Moreno, retired schoolteacher, proudly says, "In Havana you can find everything, given how cosmopolitan it is. You find the true Cuban, the *cubano reyoyo,* the quintessential Cuban. Sometimes you walk down the street . . . and sometimes I just wish I were a photographer . . . the habanero on those streets is very unique yet he or she is just a normal person, folkloric, authentic in so many ways, the habanero has such a joyful presence . . . I am so proud of the *pueblo habanero.*"

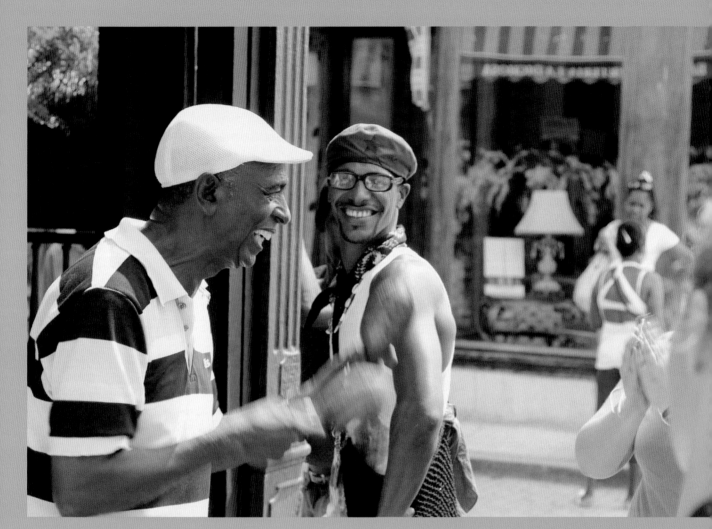

Habana Vieja, Havana.

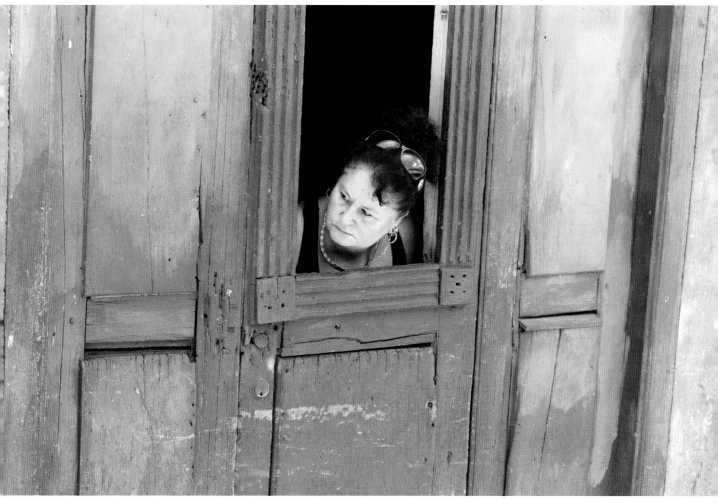

Neighborly curiosity.

Abel Pérez Álvarez, 33, medical technician, also lights up when we ask him about habaneros. "As the song says, 'In Havana there's a bunch of crazies.' The habanero, and the Cuban in general, is a congenial, friendly, sharing person. You can meet a Cuban in the street and you don't know them, first time you see them, and from one moment to the next, they can become your friend for life."

Habana Vieja, Havana.

"Habaneros, happy, friendly, gregarious, witty. Mmmm, some are foulmouthed, others are well educated. Mmmm, most like *la pelota* (baseball). We are just as likely to yell from the middle of the street up to the fifth floor, or from one corner of the street to the other. We crank up the volume of the music to make sure that we bother everyone. We are capable of helping anyone who has a problem, anyone who falls in the street, women who have to get off the bus. I feel it now, because I am beginning to need help, and I always find someone who extends a hand when I am trying to get off the bus. In general, I feel that habaneros, like all Cubans, are very warm."—Anonymous woman, 60

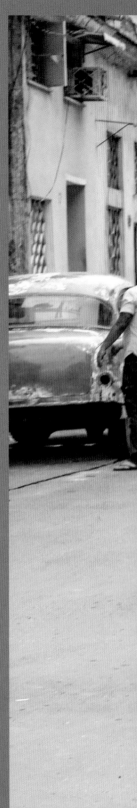

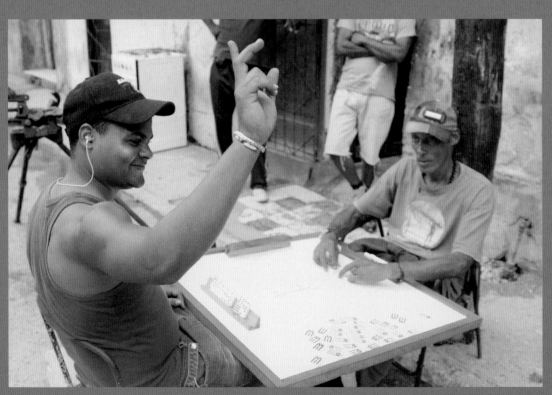

Centro Habana, Havana.

Vedado, Havana.

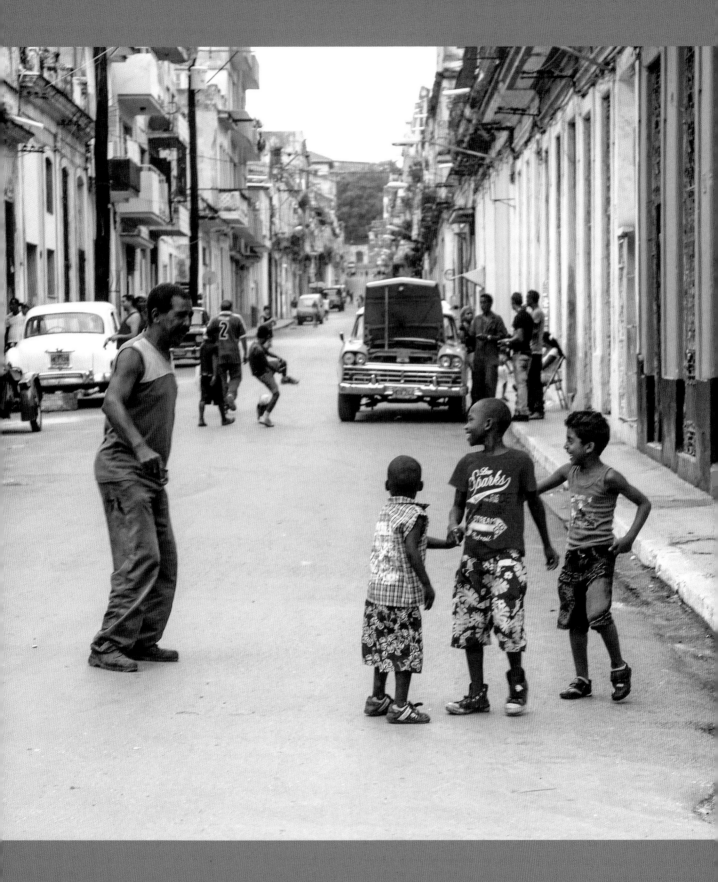

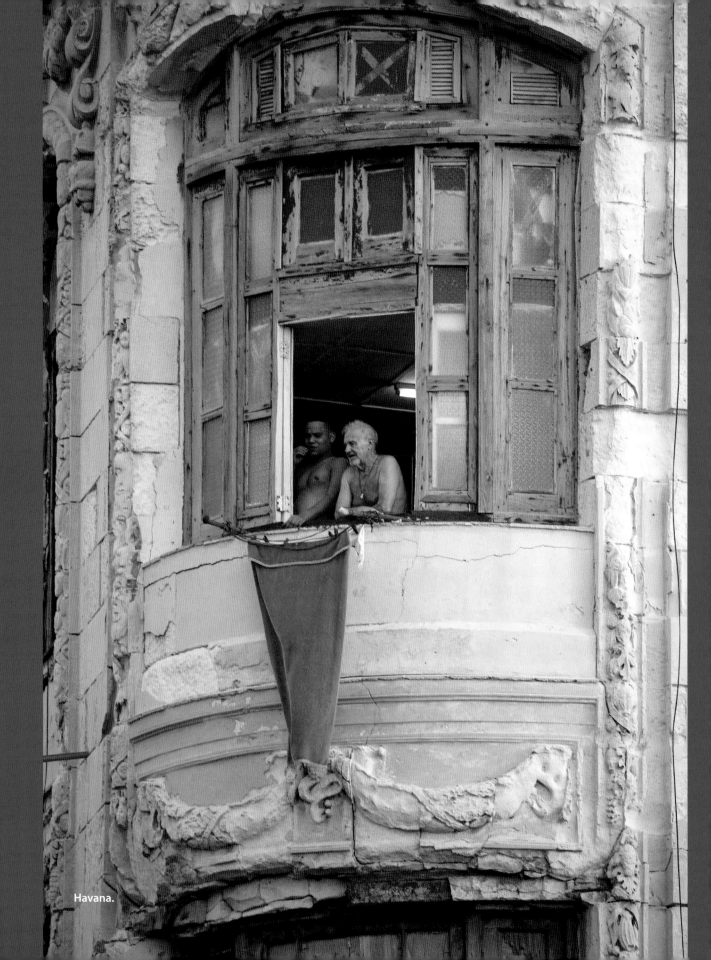

Havana.

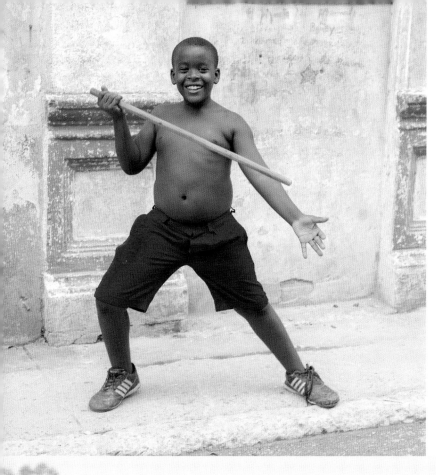

"The habanero has a strong sense of place, of belonging to the city, but the habanero is an urbanite who is almost a small towner in the sense of not being cosmopolitan. The habanero does not feel part of an exclusive culture, but instead, has a strong sense of inclusiveness."—Boris Martín, 30, historian

Left: Centro Habana, Havana.
Below: Marianao, Havana.

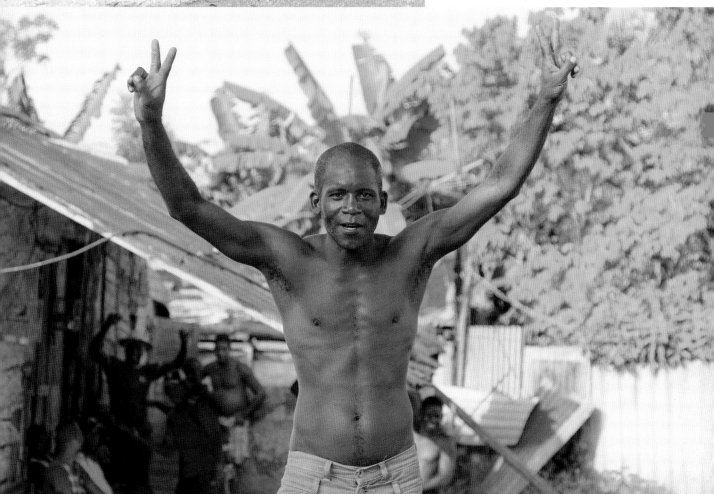

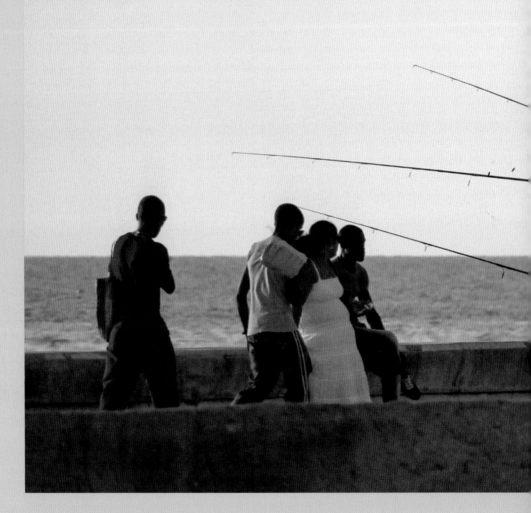

Malecón, Havana.

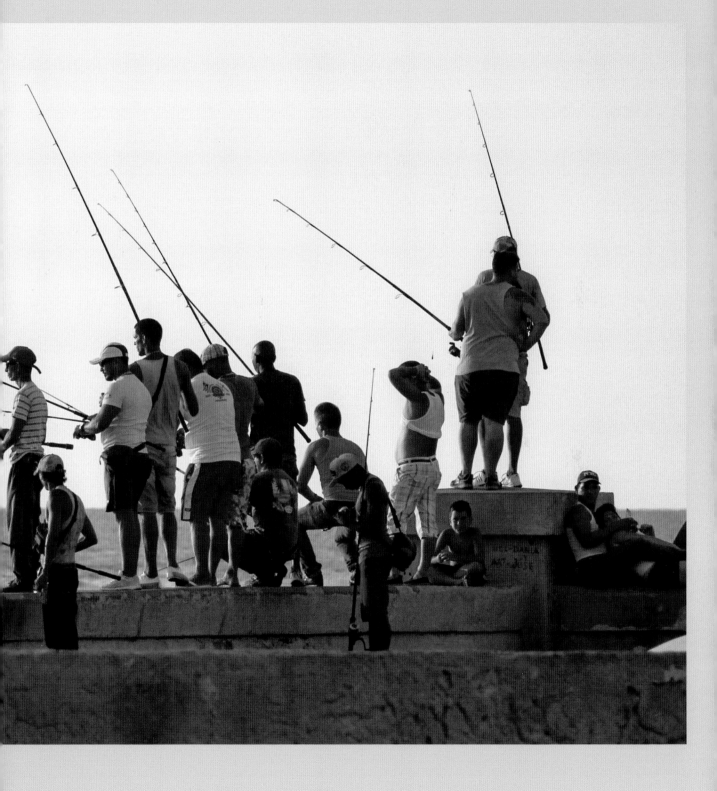

The Streets

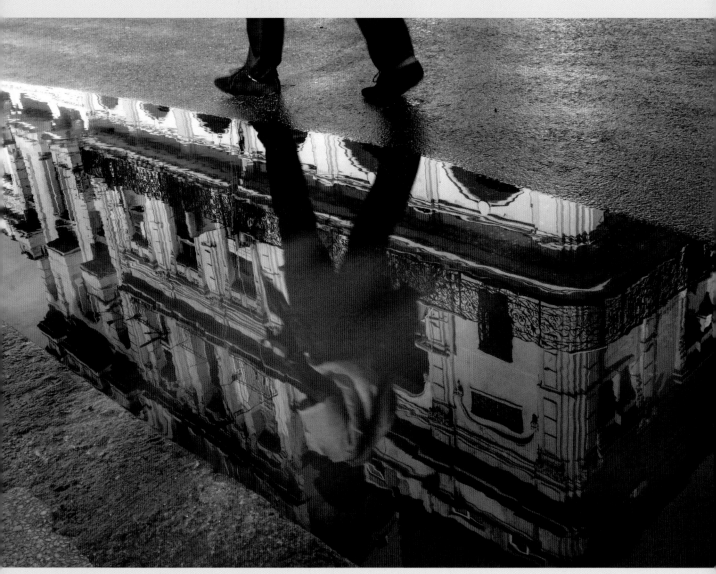

Havana.

Parque Central, Havana.

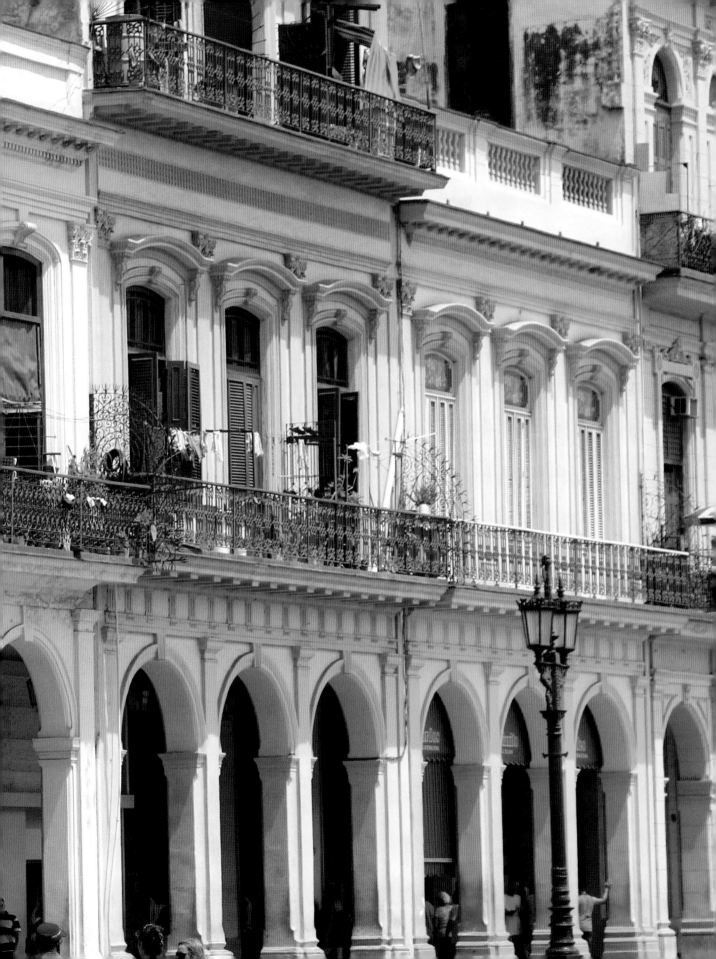

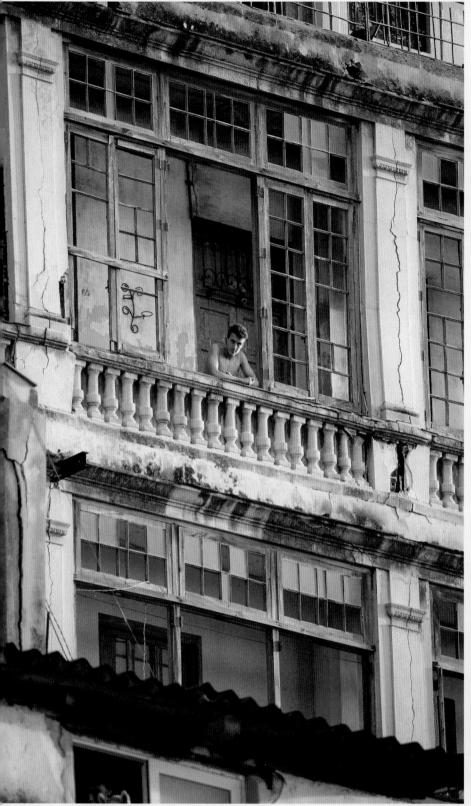

Centro Habana, Havana.

Malecón, Havana.

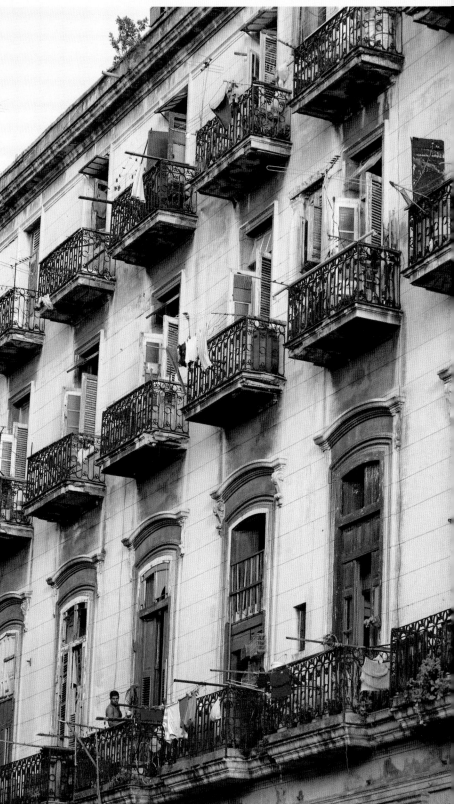

Havana.

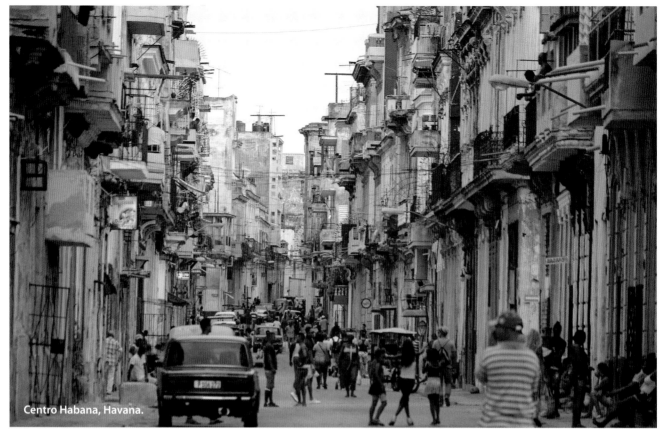

Centro Habana, Havana.

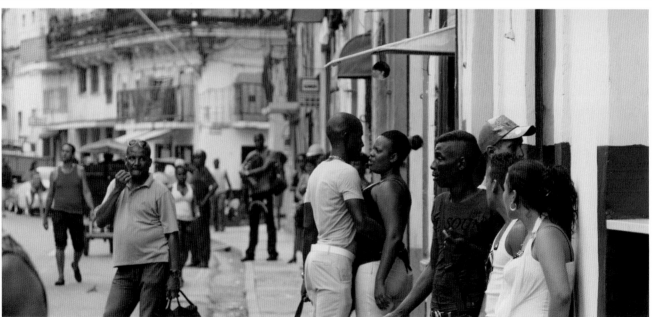

Centro Habana, Havana.

"The streets of Havana are full of potholes and standing water. But they are also full of people who sing and laugh a lot despite the difficulties. You can't assess the streets just based on the pavement; streets are a human construction made by those who inhabit them."—Humberto Miranda Lorenzo, PhD, 51, university researcher

"The balcony has a tremendous impact on the life of habaneros. Balconies inspire communication among neighbors. The *chisme* (gossip), as we say. From them, people talk to each other and neighbors communicate: 'Hey! Did you see *fulano?* He went out with *mengano.*' Or 'Hey, they just unloaded potatoes at the market. Run over there before they are all gone!'"—Anonymous woman, 60

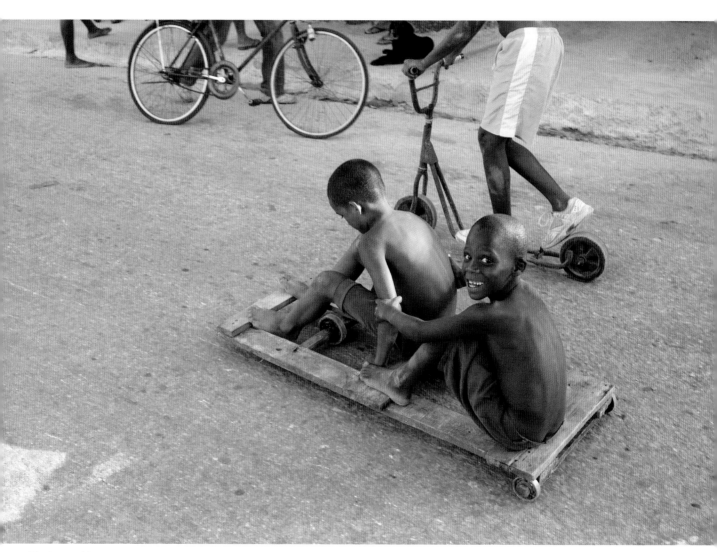

Marianao, Havana.

"The streets say a lot. In each vintage house, each corner, each bend, each courtyard, each passageway of Havana, there are so many stories . . . to me, it is a marvelous place and, at the same time, it is a place where many people live and where some people don't have a lot. But despite everything, we appreciate the joyful moments that are part of everyday life."—Abel Pérez Álvarez, 33, medical technician

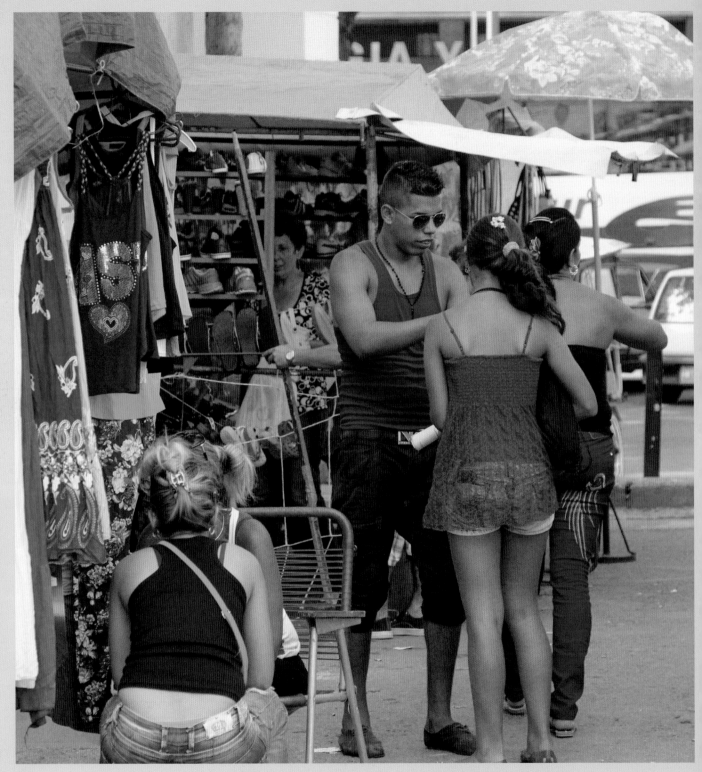

Havana.

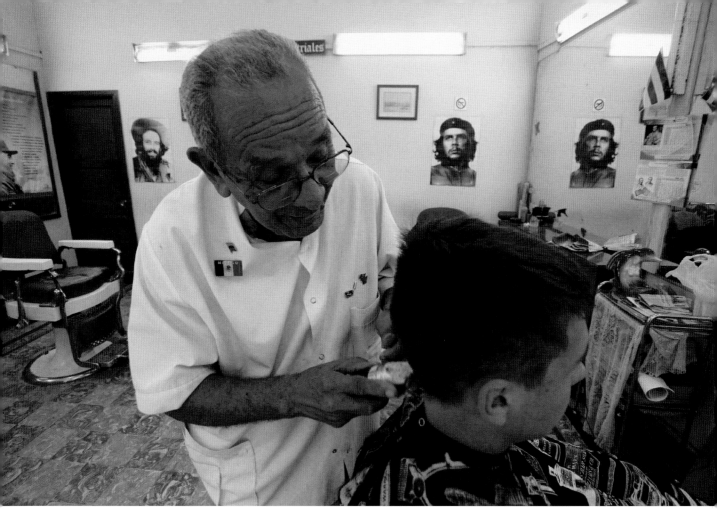

In 2010, barbers and beauticians were among the
first groups to be allowed to rent space from the
government in order to run their own businesses.
Habana Vieja, Havana.

Havana.

Architecture and Neighborhoods

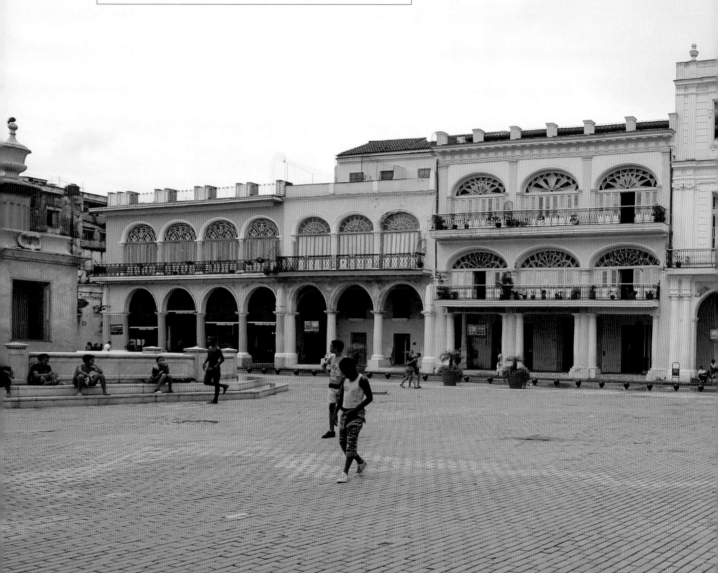

Children take over the pavement for a game of soccer.
Habana Vieja, Havana.

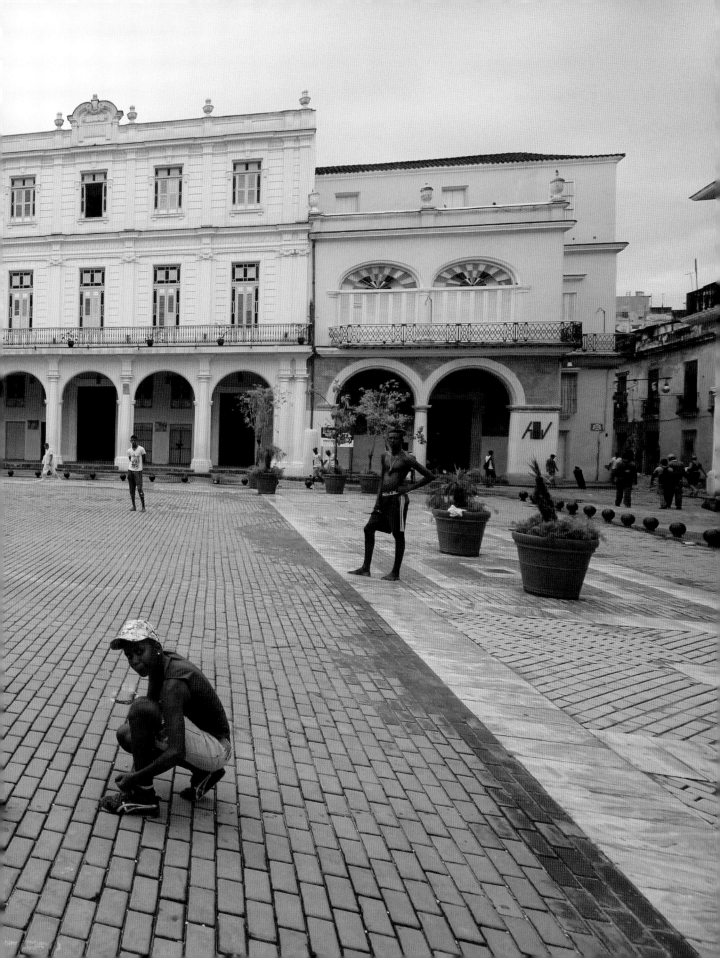

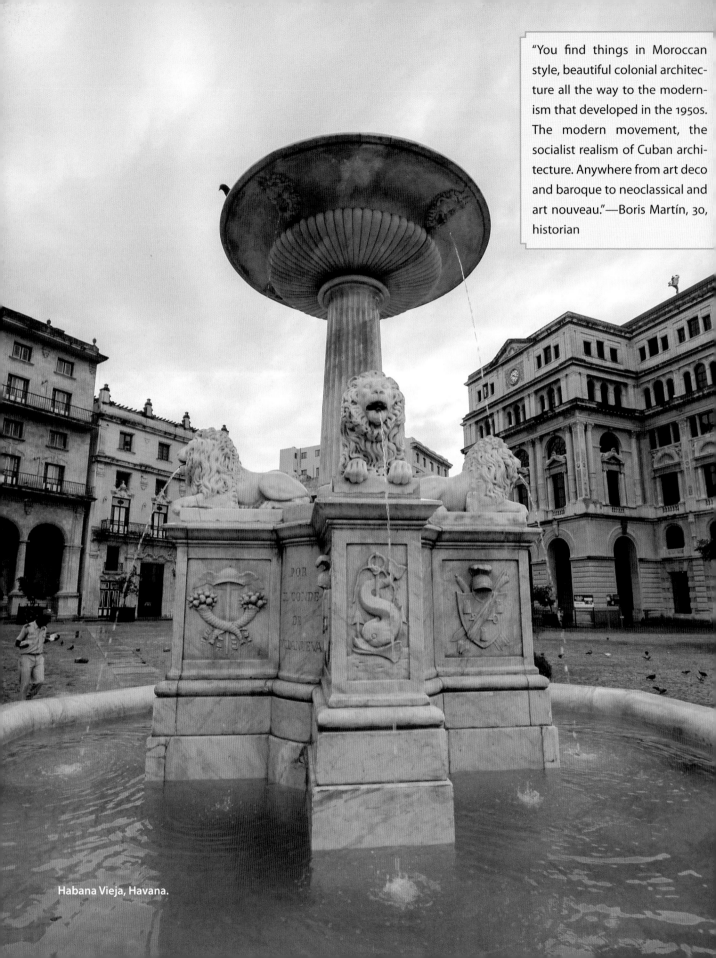

"You find things in Moroccan style, beautiful colonial architecture all the way to the modernism that developed in the 1950s. The modern movement, the socialist realism of Cuban architecture. Anywhere from art deco and baroque to neoclassical and art nouveau."—Boris Martín, 30, historian

Habana Vieja, Havana.

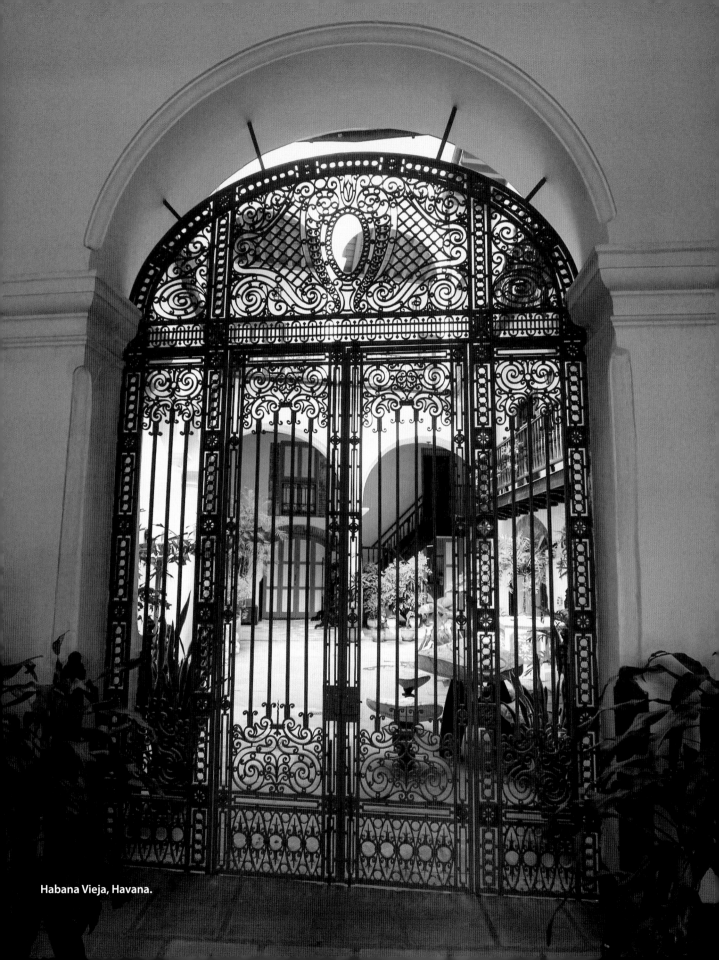

Habana Vieja, Havana.

The Cementerio Colón was founded in the Vedado neighborhood in 1878 and is still in use today. One of the world's greatest historical cemeteries, it is the resting place of many of Cuba's famous citizens, like the writers Dulce Maria Loynaz, Nicolás Guillén, and Alejo Carpentier.

"Some of the architecture and infrastructure are a reflection of U.S. hegemony during the early part of the twentieth century. *El Capitolio's* design and its name evoke the U.S. Capitol building. It was built by a U.S. firm, and, as every habanero knows, it is four meters higher than the one in the United States. We also have a Fifth Avenue in Miramar, where you find the mansions and the country club of the wealthy elites of the 1950s."—Luis Olivas, 39, tour guide

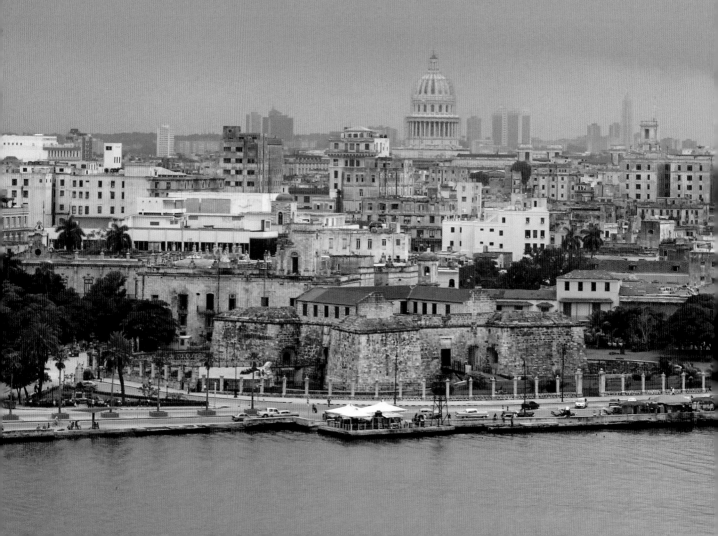

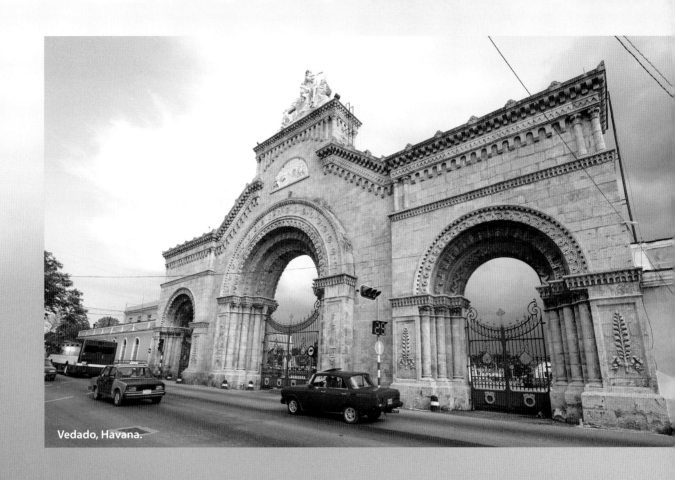

Vedado, Havana.

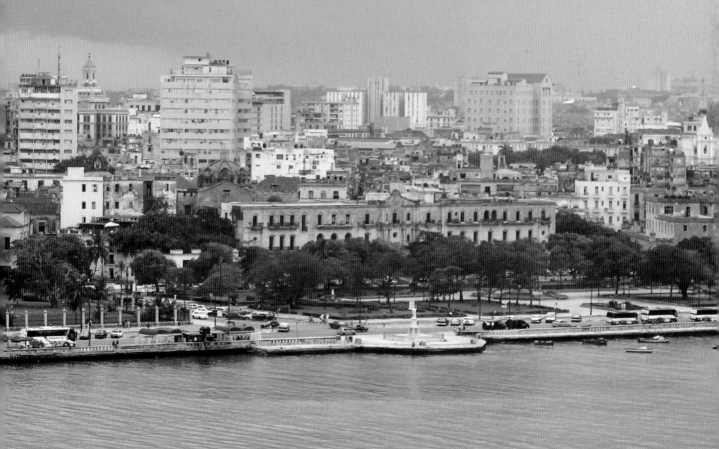

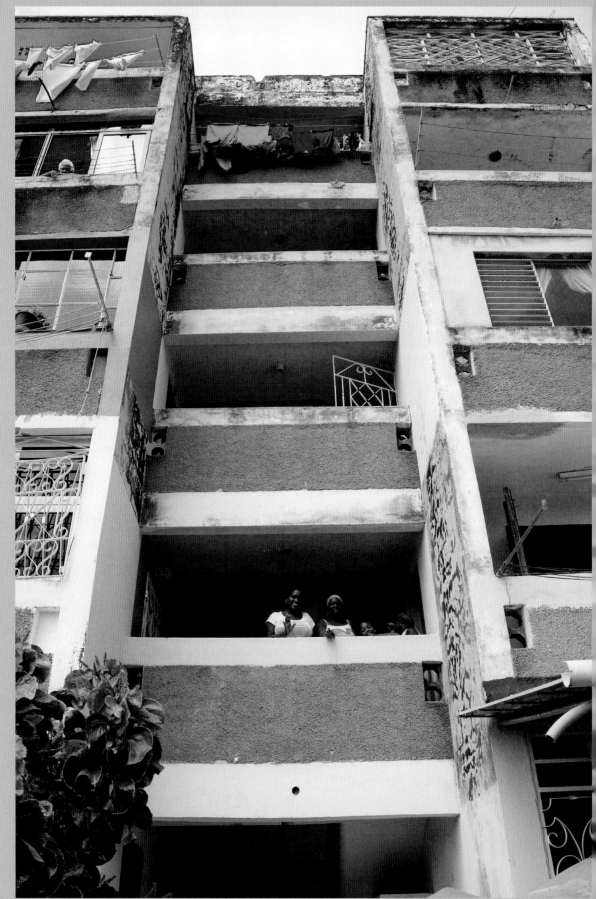

Alamar, Havana.

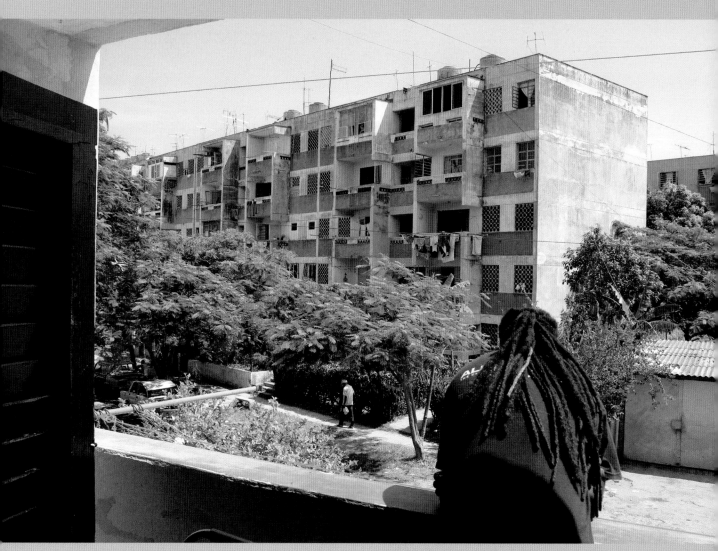

Alamar, Havana.

Cubans often refer to the large concrete apartment blocks built after the revolution as *edificios rusos* (Russian buildings), in reference to the architectural style imported from the Soviet Union. These apartments give a particular character to sections of the city.

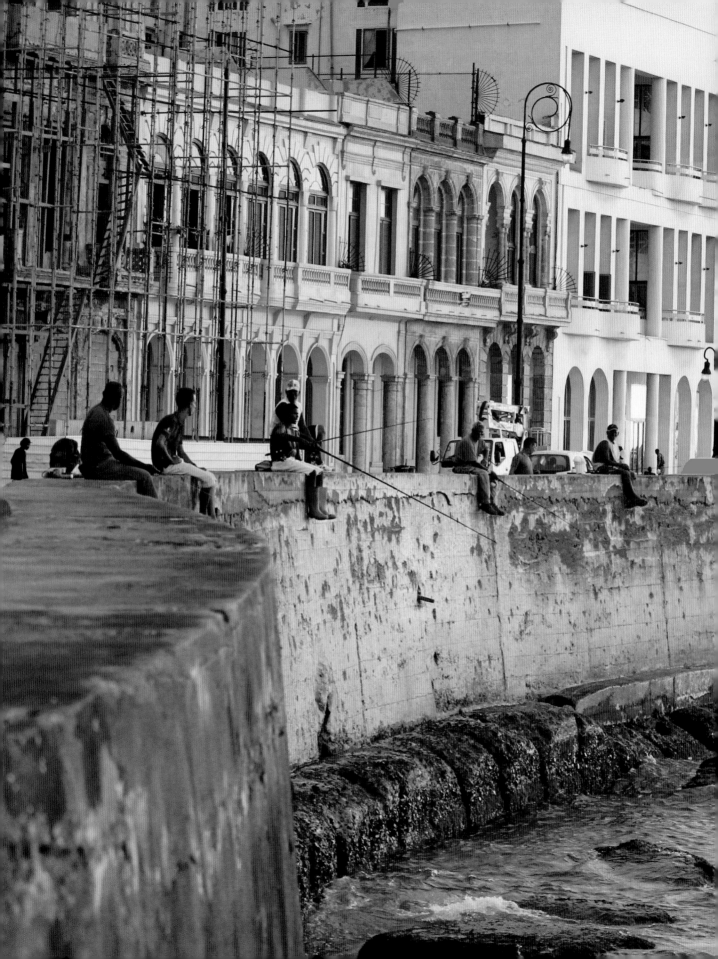

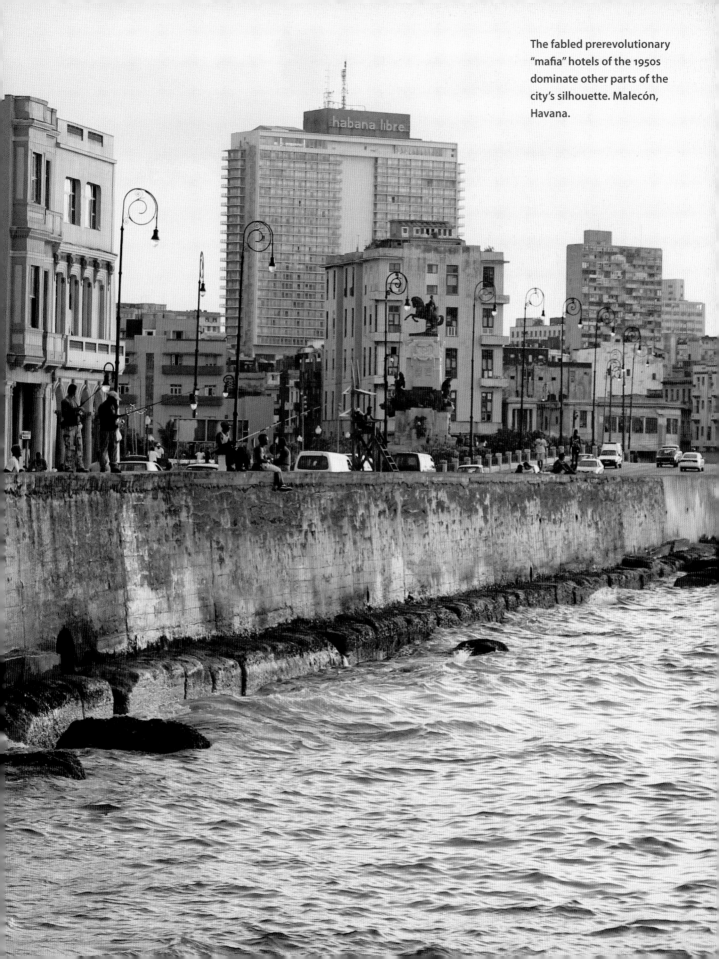

The fabled prerevolutionary "mafia" hotels of the 1950s dominate other parts of the city's silhouette. Malecón, Havana.

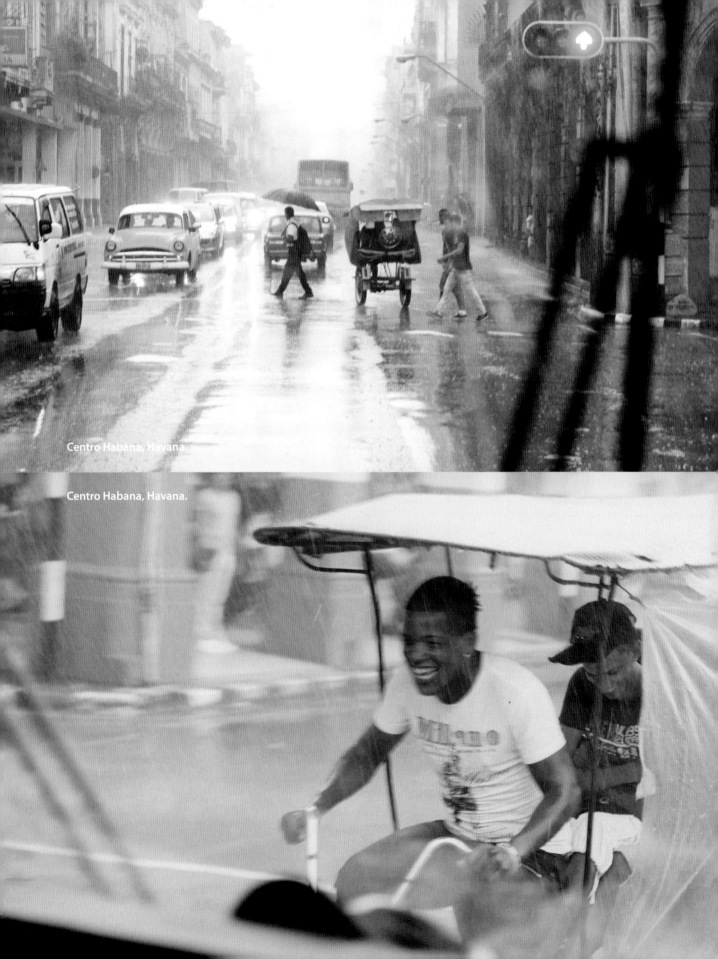

Centro Habana, Havana.

Centro Habana, Havana.

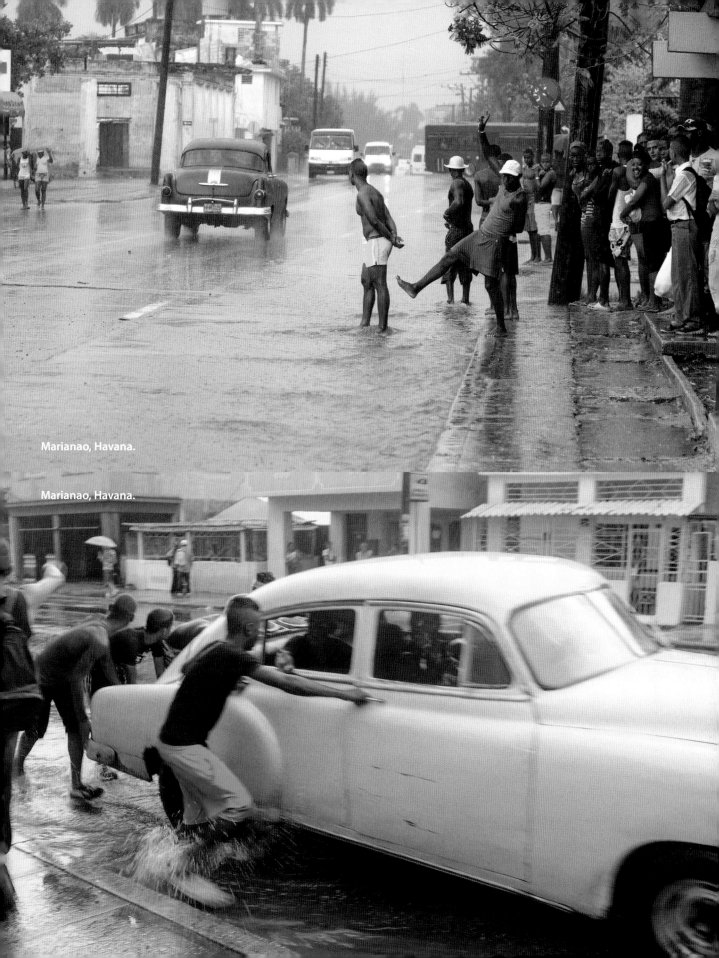

Marianao, Havana.

Marianao, Havana.

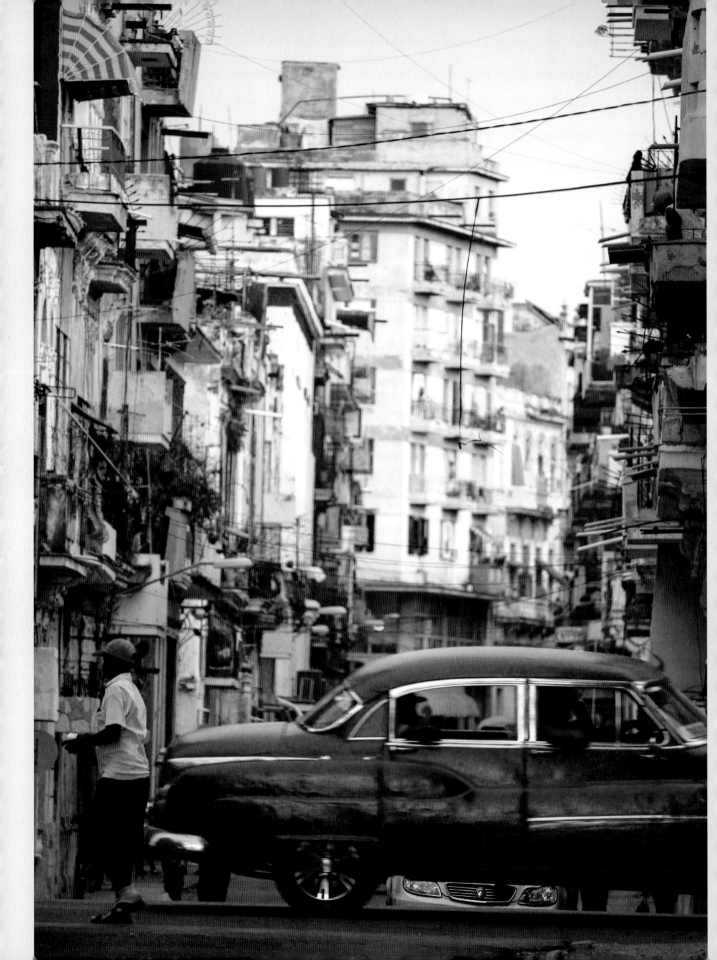

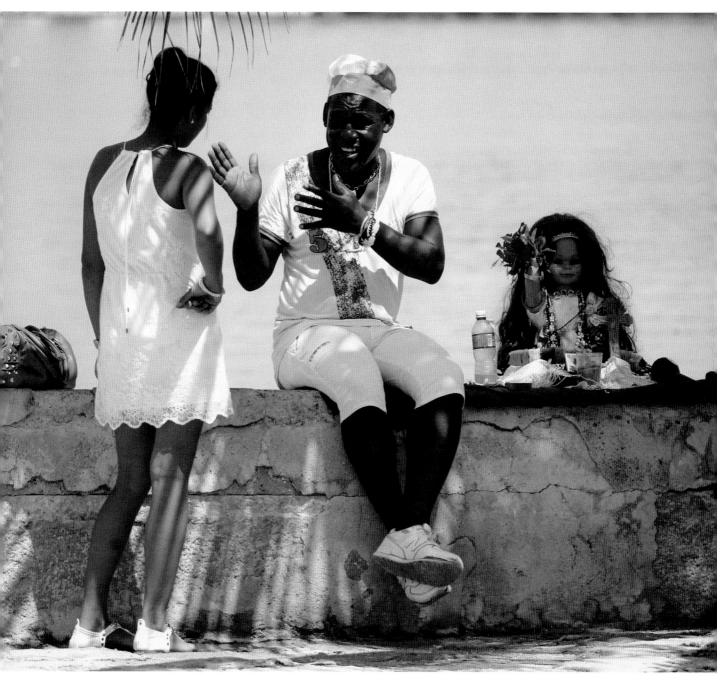

Regla, Havana.

Havana is a showcase of eclectic architecture, which varies not only from neighborhood to neighborhood but block to block and house to house, representing a rich history of cultural and architectural styles. Centro Habana, Havana.

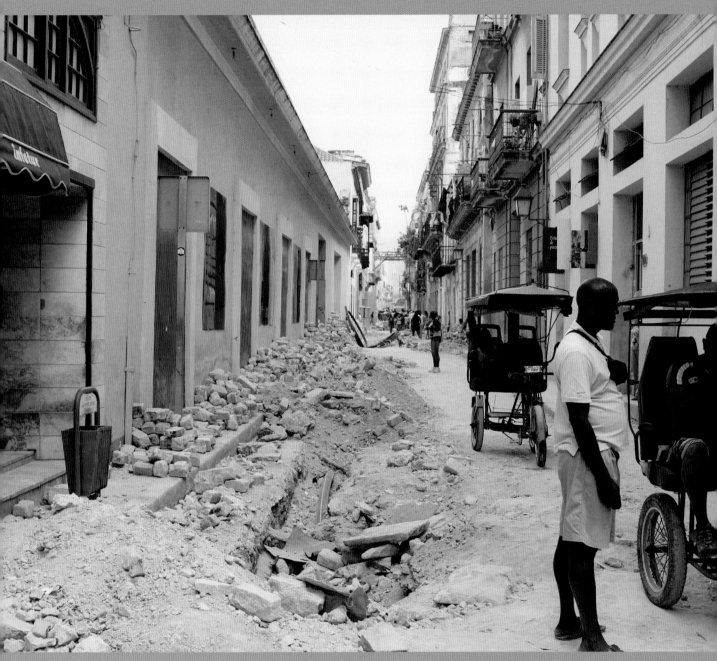

Habana Vieja, Havana.

"From an architectural perspective, the streets of Havana are interesting, and it is sad that so many years of neglect have left today's Havana, a marvelous city, in ruins, where the streets are its loudest commentator."—Liz, 38, schoolteacher

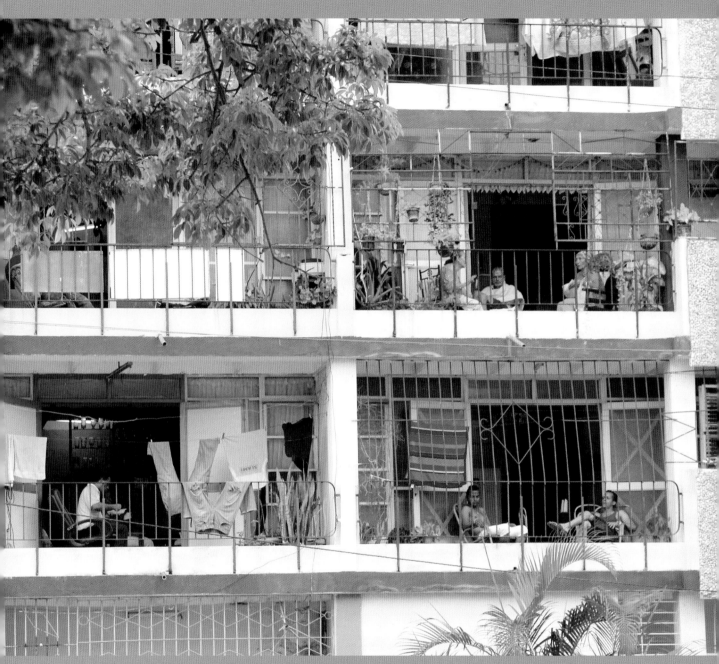

Havana.

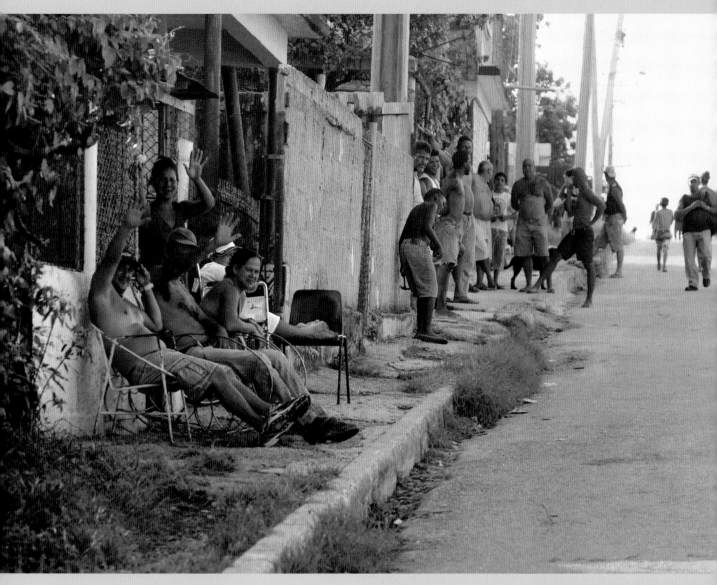

Marianao, once a suburb of Havana, is home to the first neighborhood built for the express purpose of housing the working class in the early twentieth century. Marianao, Havana.

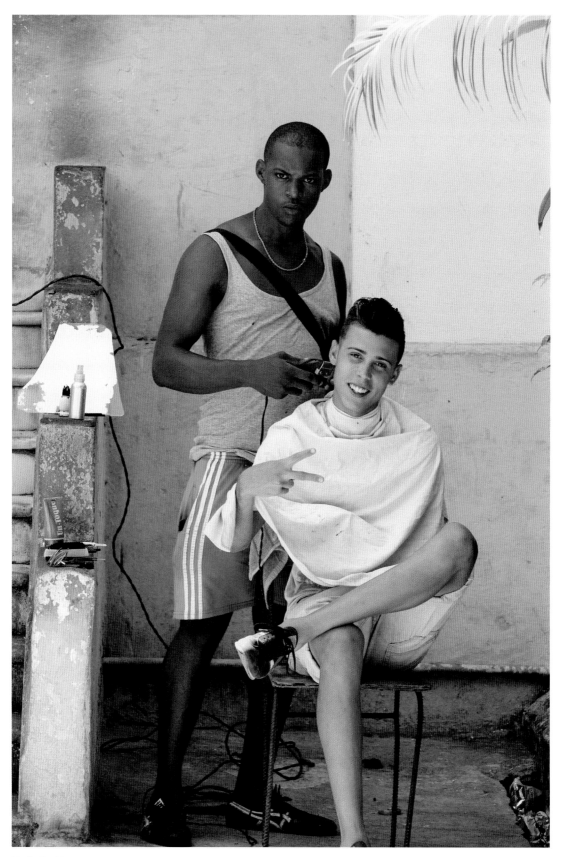

Vedado, Havana.

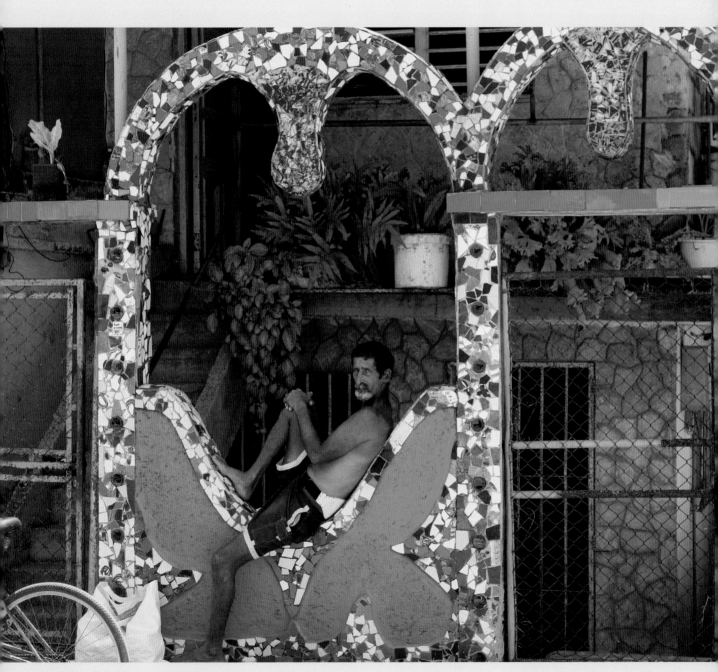

Jaimanitas, Havana.

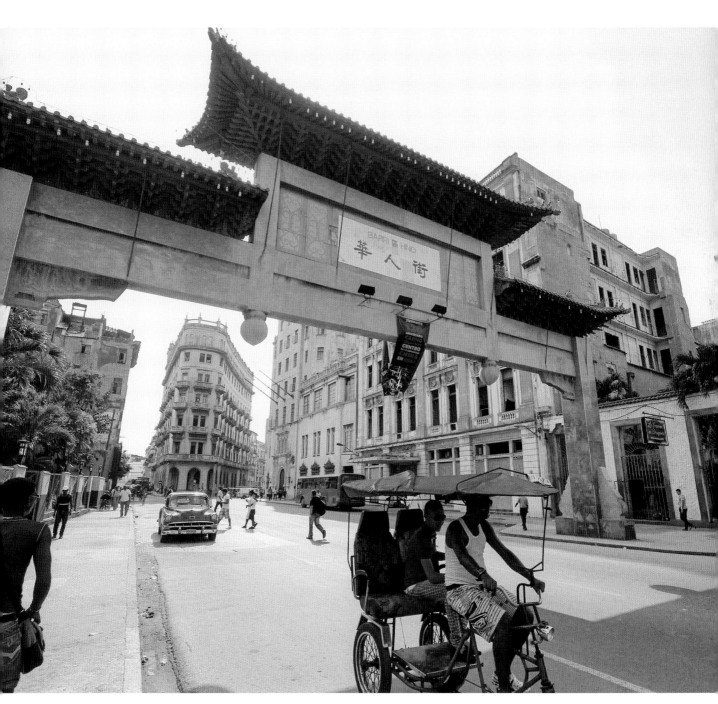

Barrio Chino was one of the oldest and, at one point, perhaps the largest "Chinatown" in Latin America. The Chinese first arrived in Cuba as contract workers in the mid-nineteenth century and were joined later by compatriots fleeing discrimination in the United States or civil wars in China. The neighborhood is a shadow of its former self, as after the revolution many Chinese Cubans left for the United States or elsewhere. Centro Habana, Havana.

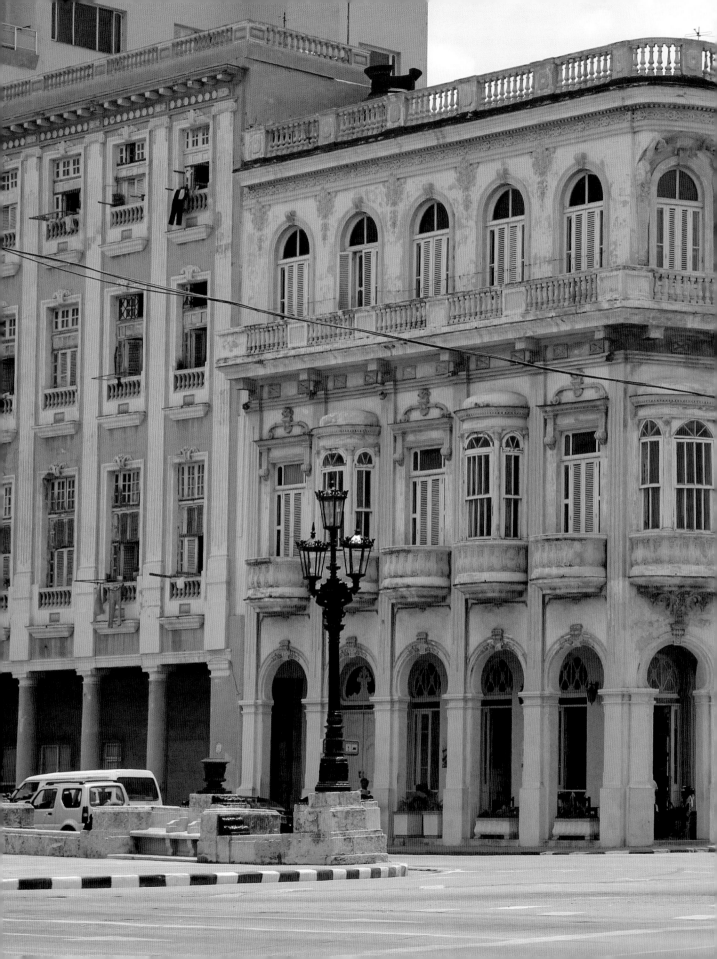

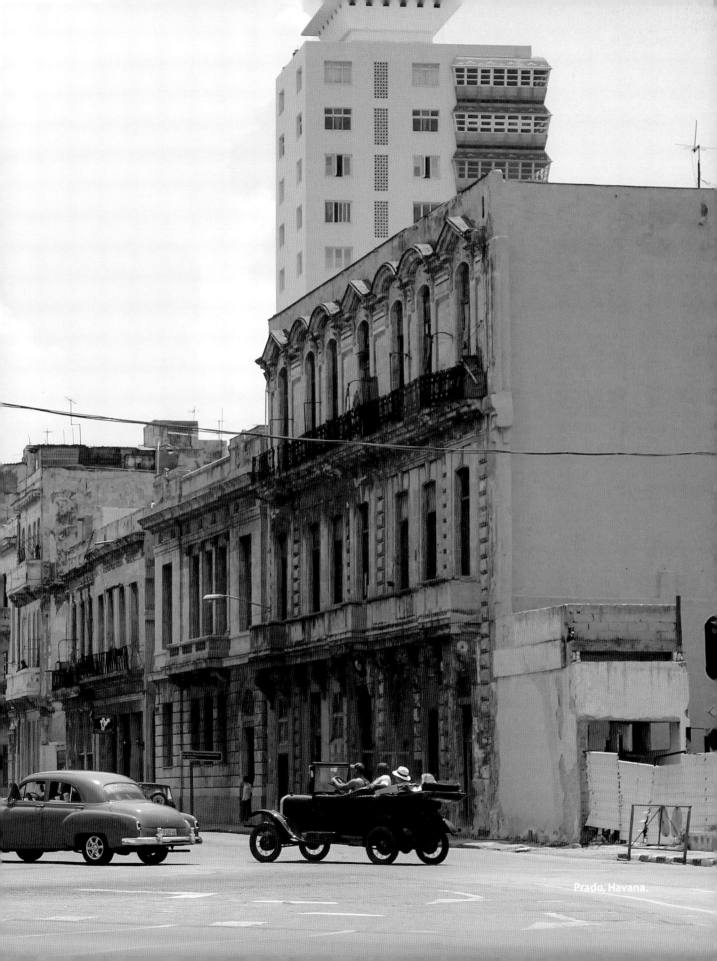

Prado, Havana.

Transportation and Automobiles

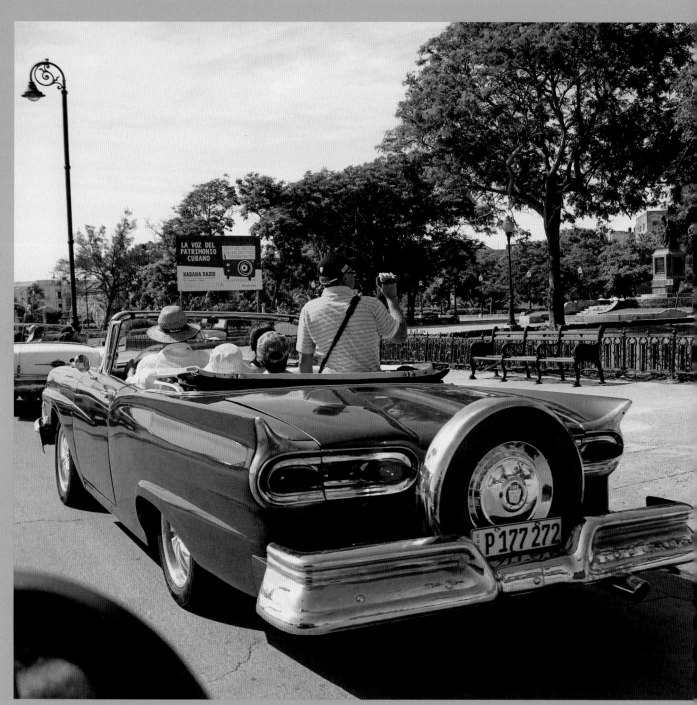

Havana.

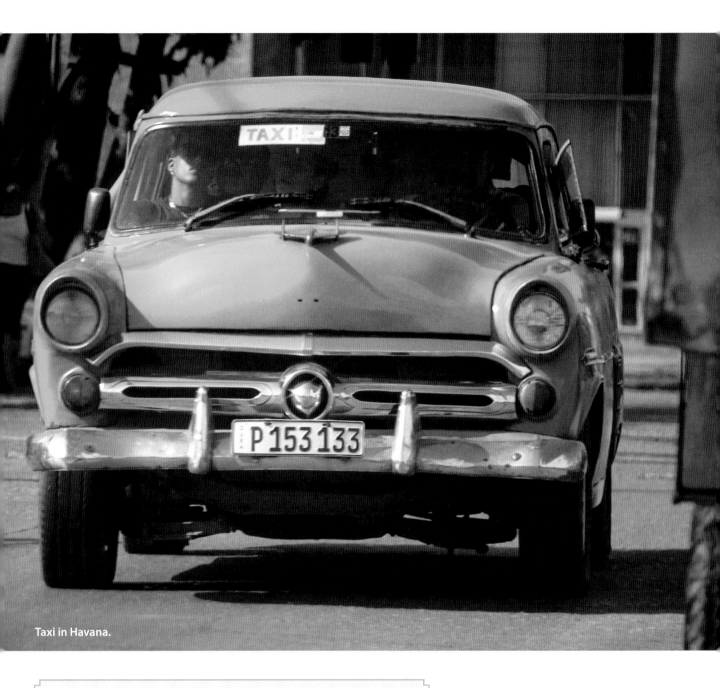

Taxi in Havana.

"I think that outsiders tend to look at the historical value of American cars that are 60 or 70 years old and that are still running all over the place. But for us, they are not jewels that belong in a museum or that some millionaire is keeping in a garage. These cars offer a service and show Cuban ingenuity."—Humberto Miranda Lorenzo, 51, university researcher

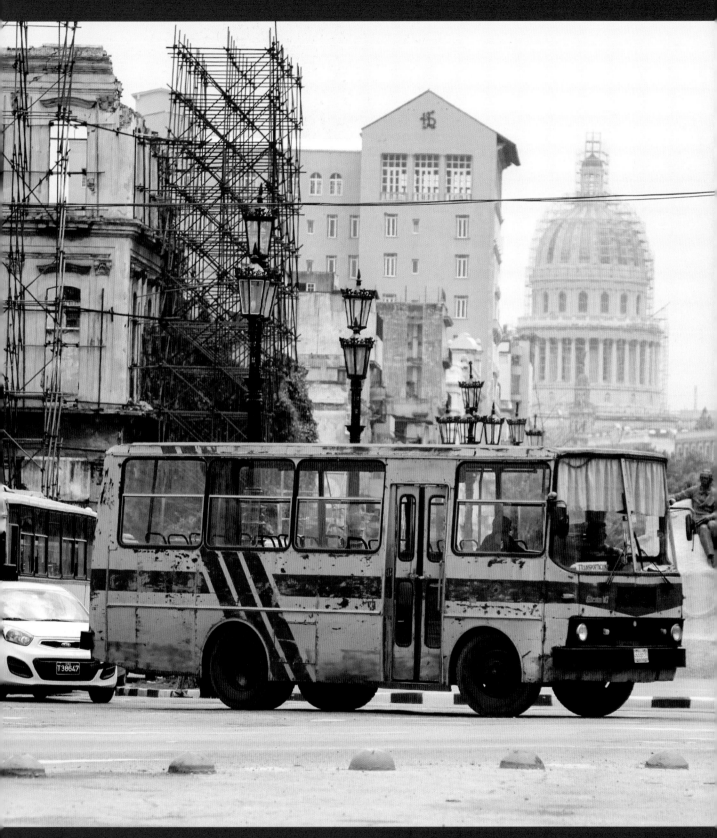

Prado view, Havana.

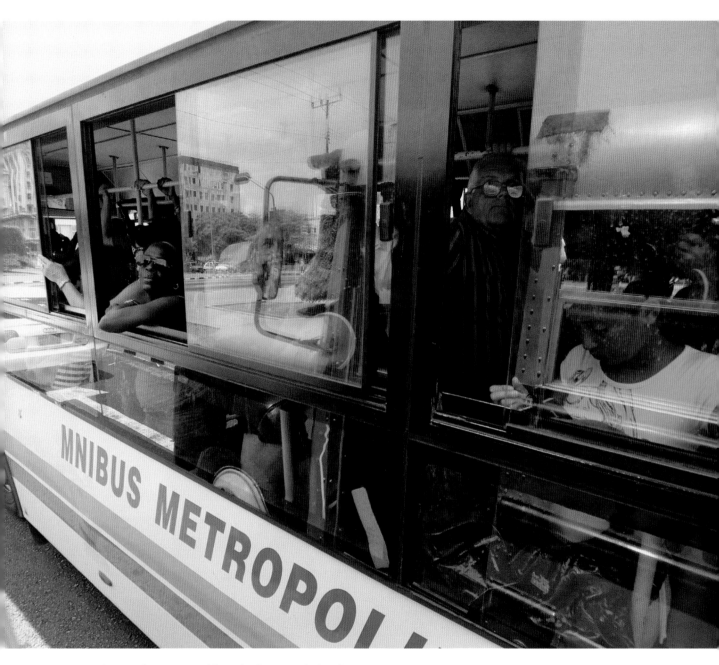

Havana's metro bus system, although often crowded and requiring long waits, is affordable to all, at a cost of five cents. A new and more limited system of smaller buses with air conditioning and guaranteed seats, run by a cooperative group, has a fare of twenty cents. Vedado, Havana.

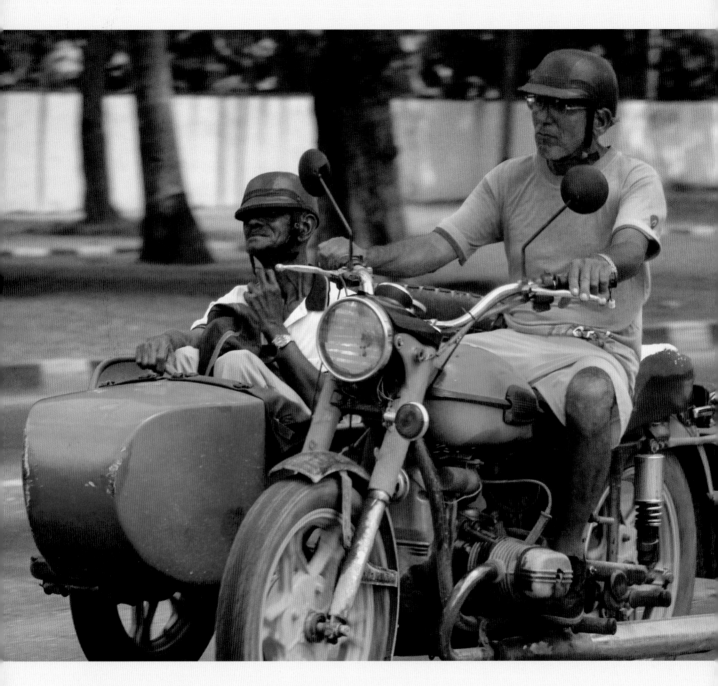

Seatbelts may be scarce, but one law that is strictly followed is the helmet law for motorcycle drivers and passengers. Vedado, Havana.

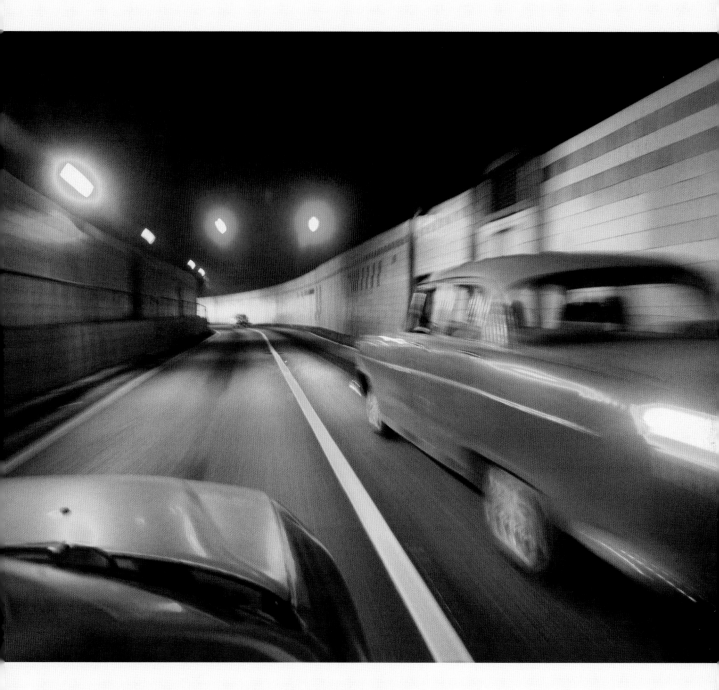

Built in the 1950s during the Batista dictatorship, Havana's bay tunnel links
the old city to the coast east of the bay with newer suburbs and beaches.
Túnel de la Bahía, Havana.

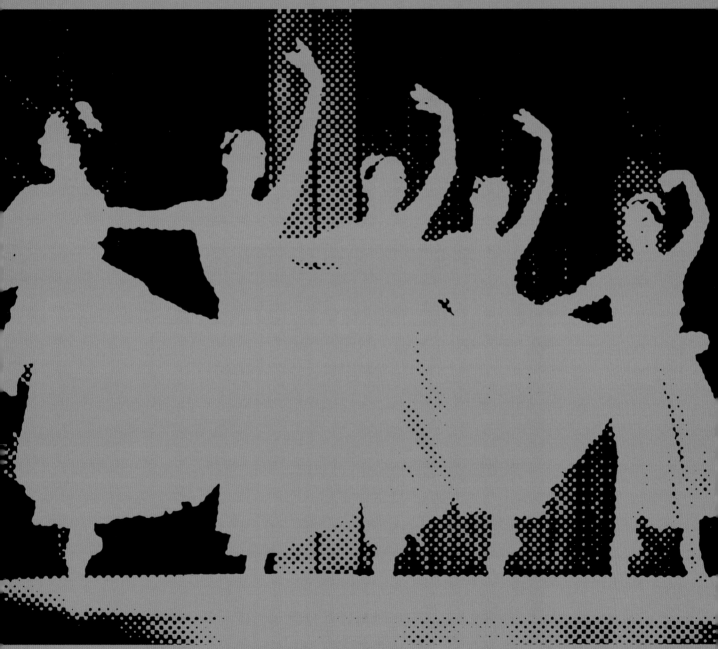

Havana.

Culture, Religion, and the Revolution

Cuba has a culture that has been able to digest history and give it a new reading, a new life, a new exposition. Cuban culture is an *ajiaco* [stew], as we say here. And in that ajiaco we find diverse cultural variants and manifestations of the arts, in theater, film, and music.

MAYRA MARÍA GARCÍA, 50, RECORD PRODUCER

Before the revolution, many of Cuba's artists were in exile, and those who remained on the island often found themselves with economically insecure lives on the margins of society. Cuba's commercial entertainment industry was show business, profitable and exclusive to those who could afford it. Success in the commercial marketplace required catering to the tastes of the ruling class in an atmosphere of political repression. After the triumph of the revolution, the leaders elevated artistic discipline, creation and expression into core values of the new Cuba. The revolutionary state vowed to increase financial support to boost Cuba's cultural programs, placing culture within the reach of the masses, democratizing the arts, and promoting different forms of artistic expression to elevate Cuban culture to international recognition.

With the support of the revolutionary state, the arts became more than cultural expressions in Cuba. They also signified commitment to revolutionary values, which meant that those artistic expressions deemed to be "against the revolution" were penalized. The parameters of what is considered anti-revolutionary have often been unclear, however, and they have changed considerably since the early 1960s and the 1970s. The 1970s were known as the *Quinquenio Gris* (the five gray years) or the *década negra* (the black decade), and many Cuban intellectuals and artists were marginalized and their work was censored. The Nueva Trova, a genre of singer-songwriter, was initially repressed, and renowned *trovistas* like Pablo Milanés were sent to labor camps. By the mid-1970s the Nueva Trova had received full government support, and Milanés as well as other trovistas like Sara González and Silvio Rodríguez became icons of revolutionary ideals not only in Cuba, but across Latin America.

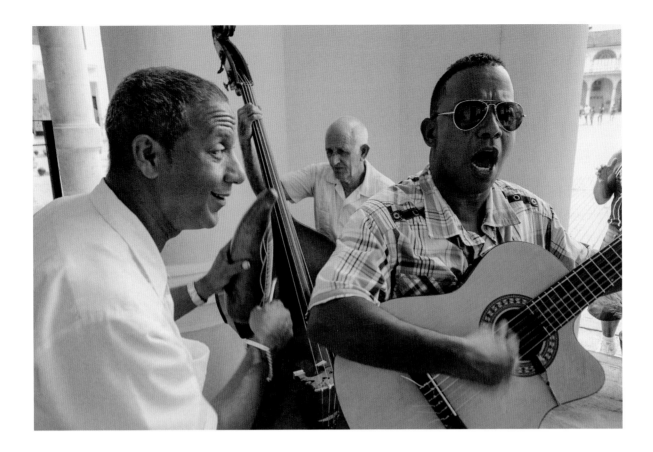

Musicians entertaining in Havana.

Although it has moved far from the repression of the early 1970s, contemporary Cuban culture continues to be at the center of struggles over the boundaries of artistic freedom. As actress Isabel Suárez Méndez explains, "Theater is very controversial because of the problems that Cubans are living through, and the more the problems, the more outspoken the artistic product. A lot of good stuff is coming out, despite the lack of resources. A lot of things that are wrong are being criticized, and at the same time, theater is trying to find a positive angle."

In Cuba, participation in the arts is accessible to everyone, both as performers and spectators, with a system of state schools that has produced almost all of the country's top musicians, dancers, and actors. The Ballet Nacional de Cuba, the National Ballet, and its late founder, the great *Prima Ballerina Assoluta* Alicia Alonso, are renowned throughout Latin America. Dance students from Cuba and the rest of Latin America dream of being able to study at the Cuban National Ballet, the official school of the company, which has performed around the world for over 50 years. Its home is the Gran Teatro de La Habana (Great Theater of Havana), built in the early 1900s. The theater went through an extensive three-year restoration process and reopened in 2016, adding Alicia Alonso to its name. Going to the Gran Teatro to see the Ballet Nacional is an unforgettable experience.

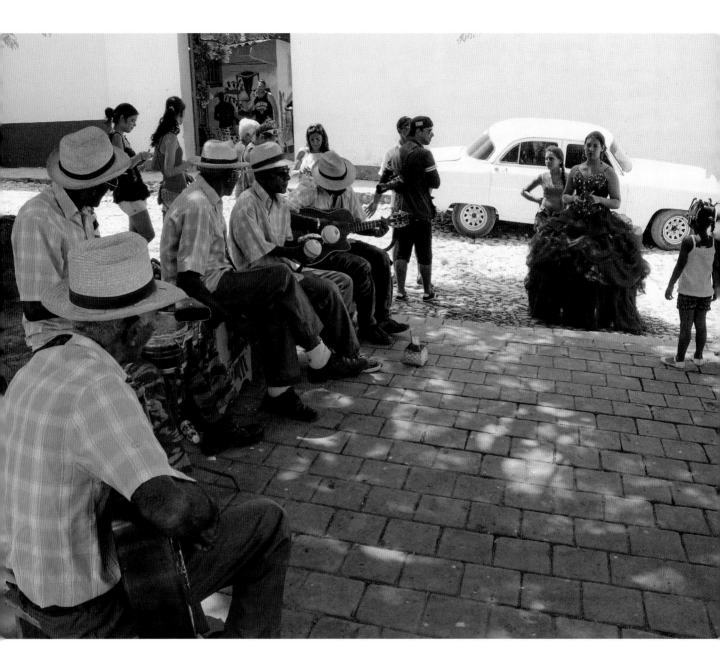

Performances like *Las Máscaras de Shakespeare o Romeo y Julieta* (Shakespeare's Masks, or Romeo and Juliet), photographs of which are presented in this chapter, are spectacular in every detail, including choreography, music, staging, costumes, and, of course, the technique, discipline and skill of every dancer. This is Cuba, the best in the midst of material scarcity and accessible to all—while the cost of a ticket in the orchestra section is about US$30 for foreigners, for Cubans, the cost is only 30 pesos, or US$1.20. The government subsidizes tickets to arts events for its citizens, including the entrance price to anything broadly construed

Quinceañera in Trinidad, Sancti Spíritus.

as culture—museums, sports, theater and music. Even during recent economic changes, the policy of the revolution remains consistent: education, health, culture, and sports are seen as basic rights guaranteed by the state. The story of Alicia Alonso and the presence of the Ballet Nacional de Cuba are a testament to government support. After leaving Cuba in 1956, Alonso returned three years later, and, with the financial backing of the Cuban government, Alonso, with her first husband and her brother-in-law, reopened the Alicia Alonso Ballet Company, renaming it the Ballet Nacional de Cuba.

The Teatro Nacional de Cuba, or National Theater, is one of Havana's most important cultural venues for theater, dance, drama, music and visual arts. Located next to the Plaza de la Revolución, laid out during the Batista era, this prominent modern building first opened in 1979 to host a gala for the delegation to the Sixth Summit of the Non-Aligned Movement—the group of nations not formally aligned with or against any major power bloc. Decorated with works by Cuban artists, the Teatro Nacional brings together the cultural and artistic diversity of the island's different regions and genres of music, dance and theater. The building is also home to a discotheque that offers one of Havana's few regular late-night drag shows. Performances at the Teatro Nacional make it clear that Cuba is much more than just Havana.

In particular, it provides a significant venue for the promotion of Afro-Cuban folkloric performances, such as the theatrical musical dance performance Addé Ará (Corona de la Tierra—Crown of the Earth) by Raíces Profundas. This folkloric dance company has performed for over four decades and its members specialize in expressions of Yoruba, Arará, Bantú and Carabalí origin. Shown in the Teatro Nacional's Covarrubias Hall, named after "the father of Cuban Theater" Francisco Covarrubias (1775–1850), Addé Ará is powerful and perfect in every detail as it tells a story based on *patakíes,* Afro-Cuban mythical legends, where the deities Changó and Ochún scuffle to bring back harmony to a village that had lost its ways.

Without question, the ajiaco, or stew, of Cuban daily life and culture includes religion. During colonial times, Spain imposed Roman Catholicism on the Ciboney, Taino, and Arawak indigenous populations. Over the course of the salve trade, more than one million African slaves imported by the colonists to establish plantation economies brought with them religious practices and beliefs, mostly Yoruba from southwestern Nigeria and the adjoining parts of Benin and Togo. Unable to preserve their religions intact, yet refusing to relinquish their own beliefs, different religious strands blended into syncretic religions. The most widespread of these, founded on Yoruba beliefs, is Santería. Luis, a civil engineer and part-time musician in his mid-20s, tells us that Cubans in general value folkloric ballet and dances related to Yoruba deities: "everyone, not only black people, appreciates

Art for tourists.

these traditions. It's something that has expanded quite a bit and goes hand-in-hand with the [Afro-Cuban] religion; both are connected. When people practice the religion, they become familiar with the dances."

Music and dance are ubiquitous in Cuba. Extending beyond the theater, music and dance echo in streets and bars, in people's houses, hotels, at the *malecón,* and in state cultural centers such as the Palacio de la Rumba, the Salón Rosado de la Tropical, and the Casa de la Trova. Throughout Cuba, Casas de la Música offer live performances and popular dancing venues, and it is common for anyone wandering the city to be accompanied by a soundtrack that varies as one moves through different neighborhoods. "Here in Cuba," emphasizes Abel Pérez Álvarez, "almost everyone is a musician, and if not, they have at least tried it. Music in Cuba defines our character. It's in our blood, in our roots, and it represents us wherever we are." Home of the rumba, son and bolero, and the more contemporary timba, Cuba celebrates its African roots through music with influences from colonial Spanish

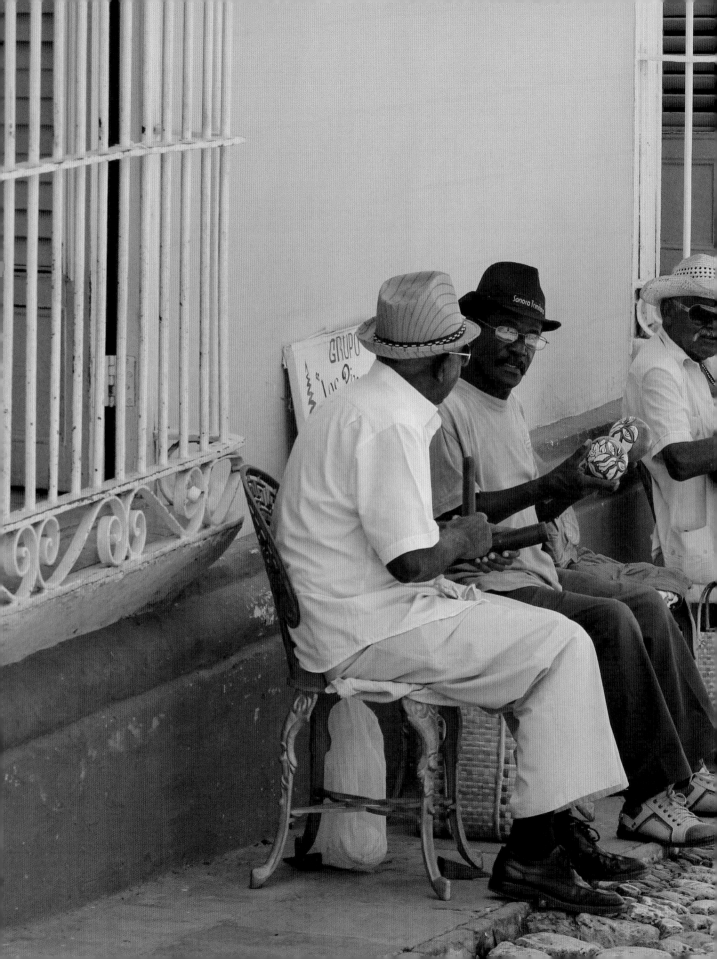

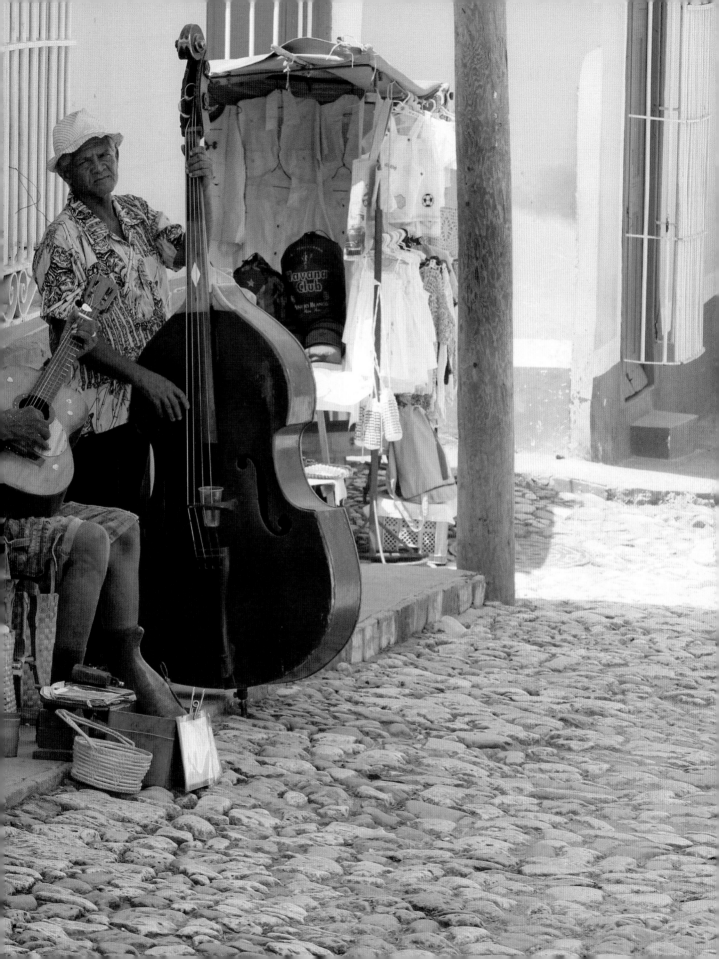

romances, the French Caribbean tumba francesa, Jamaican reggae, and North American Jazz. Aficionados can dance to live music until dawn, the government sponsors free outdoor concerts and intimate *peñas culturales* (cultural gatherings), and the sounds of a *toque de santo* (a calling of the saints via drums) can often be heard spilling from a private patio.

The bloqueo also has a pervasive effect on art and culture. It is not just an economic factor, or a political feature, or social obstacle; el bloqueo touches all aspects of everyday life. So, of course, Cubans talk about the impact of el bloqueo on music and the arts. Luis tells us that "music in Cuba has great significance. I imagine that as Cubans, with all the problems and difficulties that we have, music stimulates us; it helps us cope with everyday problems." He adds that "the impact of the bloqueo can be seen in the fact that there are no shops where you can find a great variety of musical instruments; a lot of instruments, like drums and drumsticks, are handmade by craftspeople." Gladys Esther proudly says that "with or without bloqueo, Cuba is a musical powerhouse. As [one of Cuba's most famous exiles] Celia Cruz used to say, 'Salsa is not salsa, it is my Cuban son.' In Cuba, there is much musical talent. If anyone has musical talent and hasn't developed it, it is because they haven't wanted to."

Artistic expression as part of the social revolution can also be seen in neighborhood projects that use art to create community spaces. The town of Jaiminitas, located on the outskirts of Havana, has become a unique public art project. Ceramist and painter José Antonio Fuster, in partnership with the local community, started to cover the neighborhood's walls and buildings with art in 1994, in the midst of the most severe phase of the Special Period. As Mariano, one of the Fuster Residence guides, tells visitors, "Fuster started his project in his driveway and today it covers the walls, roofs, parks and sidewalks of the neighborhood. His idea was to use art as a way to lift people's spirits during a difficult time in our history." Fusterlandia is now a tourist hotspot, which has allowed neighbors to open up stores that sell handicrafts and art.

El Mejunje de Silverio ("Silverio's mixture"), a cultural center located in the city of Santa Clara, started three decades ago with the mission of including everyone in the production and enjoyment of different forms of art and entertainment. The center opens every day of the week, presenting all genres of music and theater, hosting art exhibits and providing activities for children, the elderly, college students, and the LGBTQ community. El Mejunje has been involved in community health programs like HIV prevention and has worked against social discrimination and homophobia for decades. El Mejunje was Cuba's first official forum for *espectaculos de transformismo* (drag shows) and has been at the forefront of LGBTQ rights. For founder and director Ramón Silverio, El Mejunje has an important mission: "I believe that the important issue is that we all need to unite, and this

isn't a Cuban problem, it's a problem of humanity. There are many things that we need to protect, and if we are united we can make a better world where there is greater understanding among human beings."

Sports or physical culture, like culture, health, and education, is considered a basic right by the revolutionary government. The state runs a system of sports academies that have contributed to Cuba punching above its weight in international competitions such as the Olympics. Athletes often became vanguards of the revolution during its early days, and success in sports has contributed greatly to national pride and international prestige. Baseball, which in Cuba is as much a cultural representation as music and dance, is embedded in the national DNA and remains Cuba's most popular pastime. Organized baseball started in Cuba in 1878 when the Cuban league was formed by the Almendares, Habana, and Matanzas teams. The first game was between Almendares and Habana, with Habana winning 21 to 20. The teams represented towns and gave expression to community pride. Victory brought bragging rights and shouts of "Wait 'til next time!" from the losers. The revolutionary state's commitment to sports led to the abolition of professional sports on the island in the 1960s. This meant that all leagues and teams were seen as amateur, in correspondence with the revolutionary principles of equality.

Baseball is the sport for which Cuba is most recognized internationally, but the island is renowned in international sports competitions and associations beyond baseball. Cuba sends coaches of Olympic sports such as boxing, wrestling, judo, and track and field to help train athletes in other developing countries around the world. Since the 2010 World Cup, soccer has been much more present in public spaces. Young habaneros play the game in the street and take over basketball courts for soccer, dreaming of a future in the European leagues, and the emblems of clubs such as Barcelona and Manchester City adorn bicitaxis, cafeterias, vegetable kiosks, and homes around the island. This younger generation shares cosmopolitan ties to these soccer clubs with global reputations.

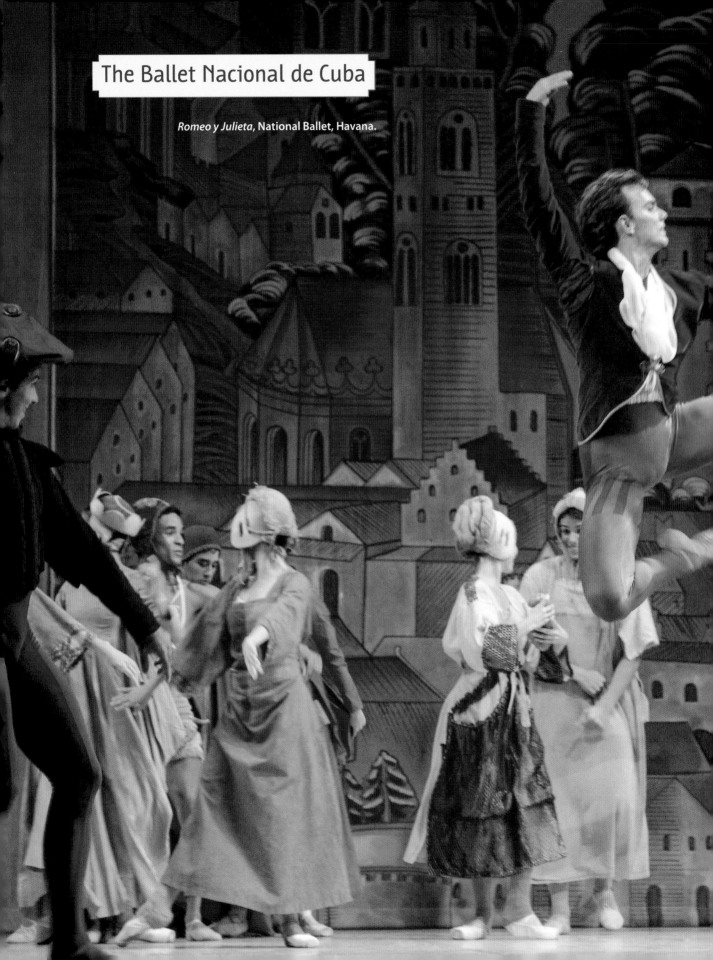

The Ballet Nacional de Cuba

Romeo y Julieta, National Ballet, Havana.

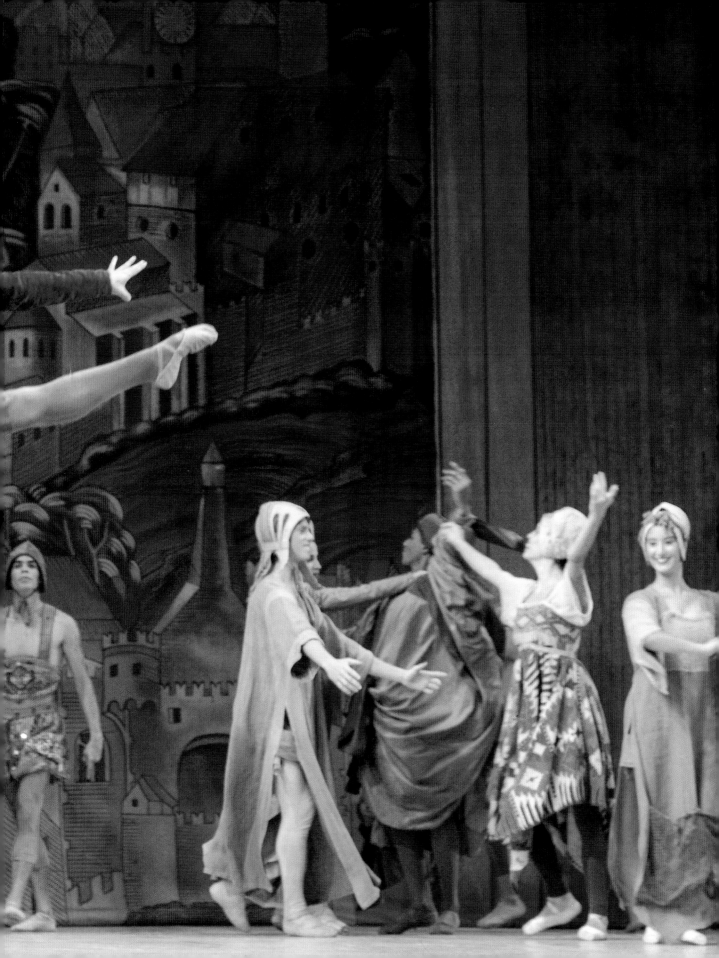

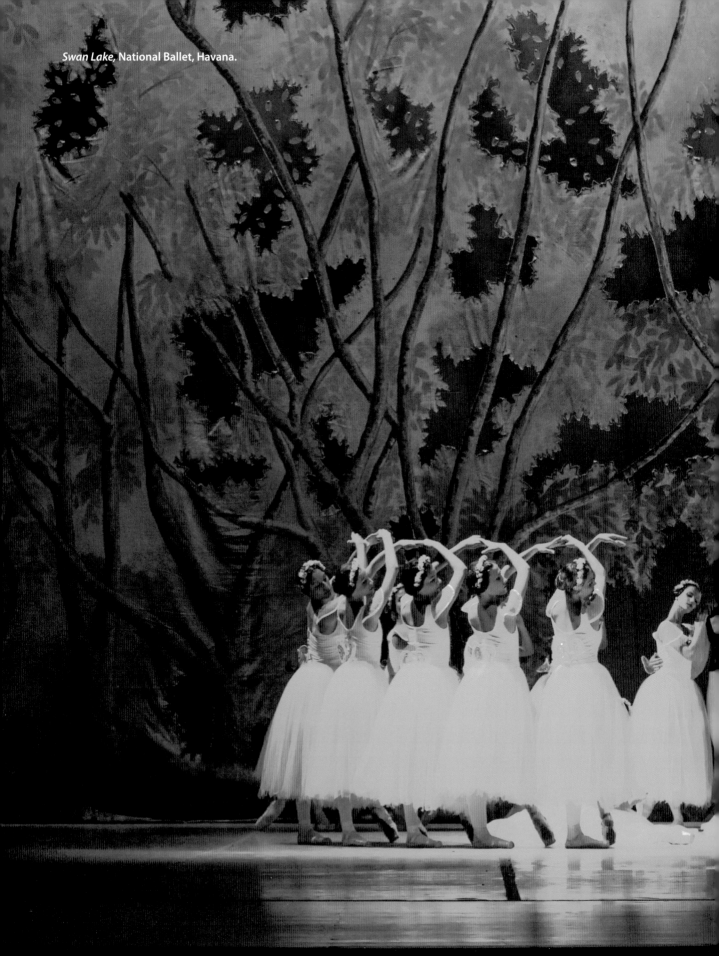

Swan Lake, National Ballet, Havana.

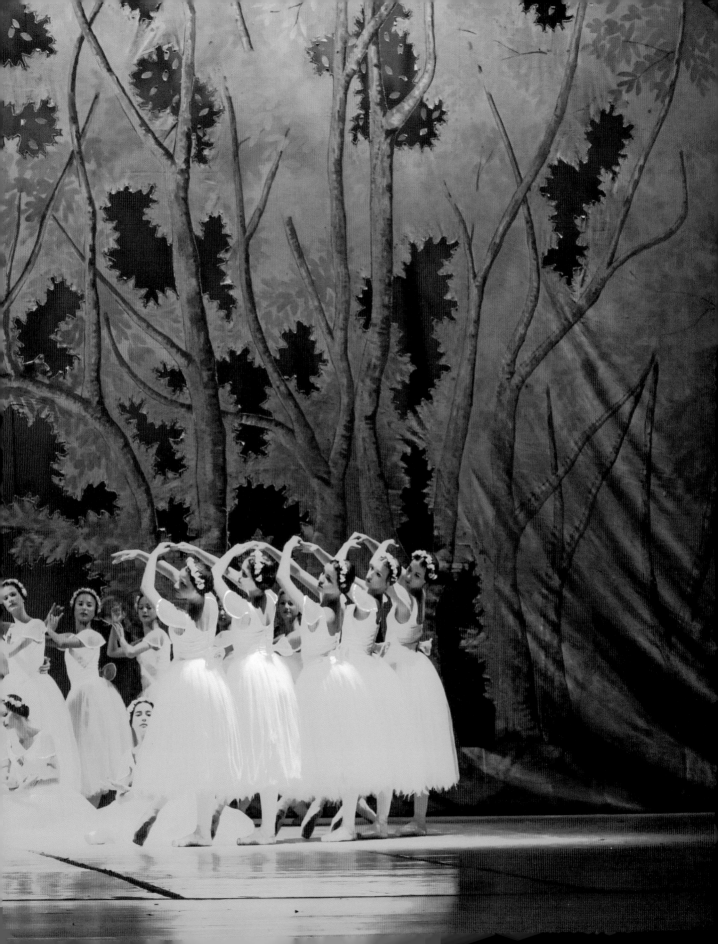

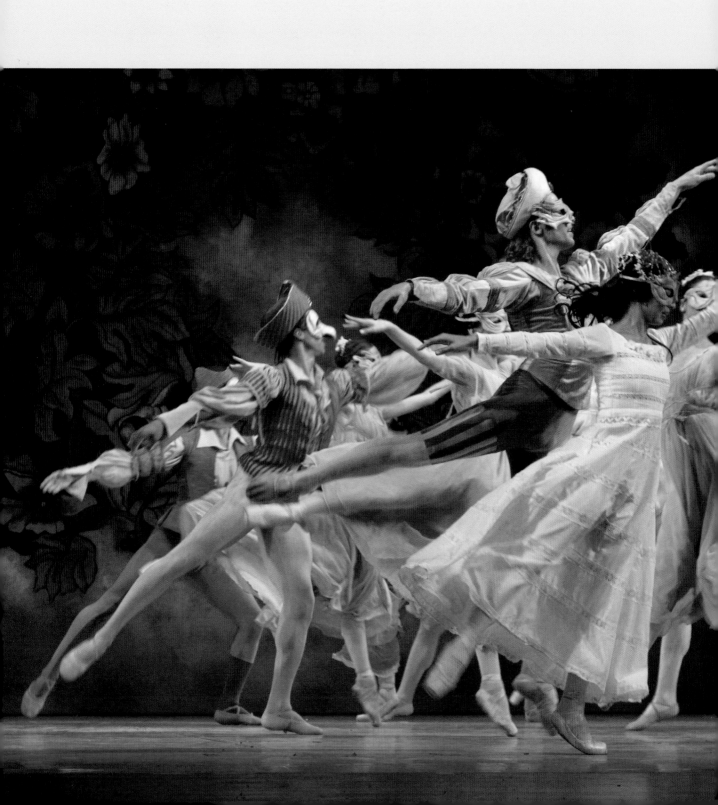

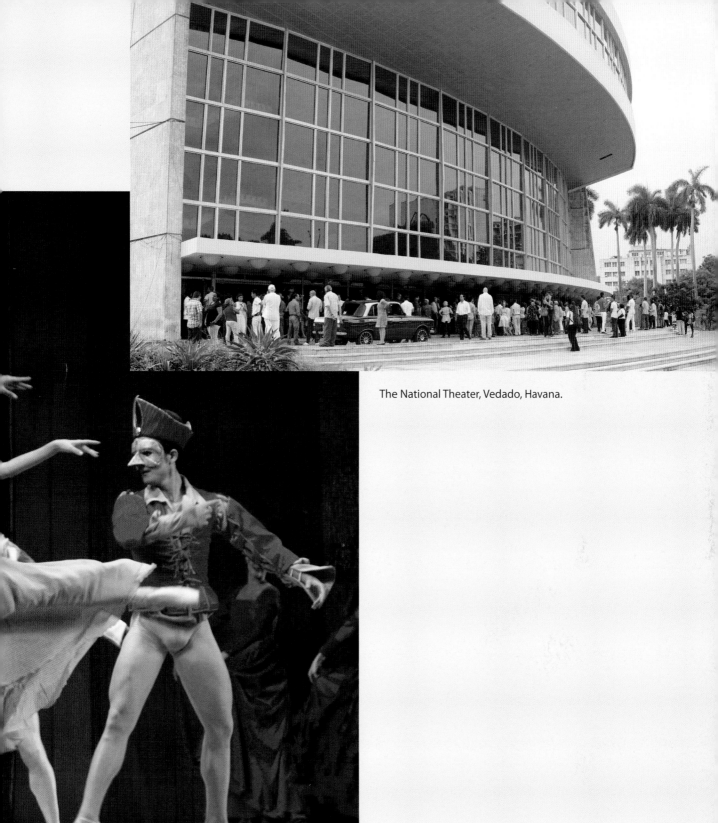

The National Theater, Vedado, Havana.

Romeo y Julieta, National Ballet, Havana.

National Theater

Ochún, Vedado, Havana.

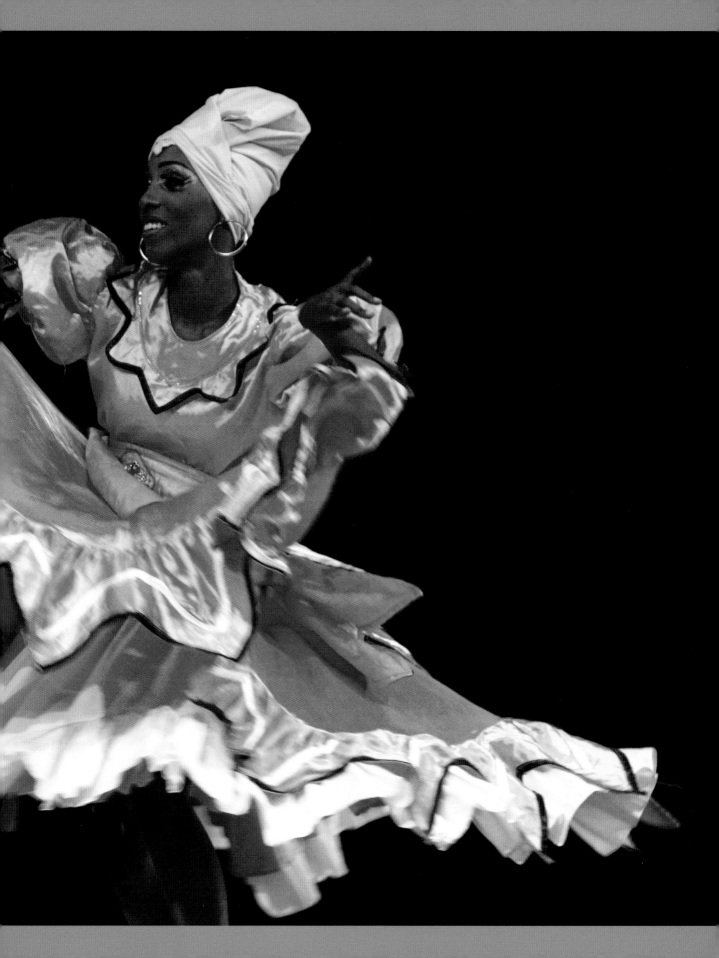

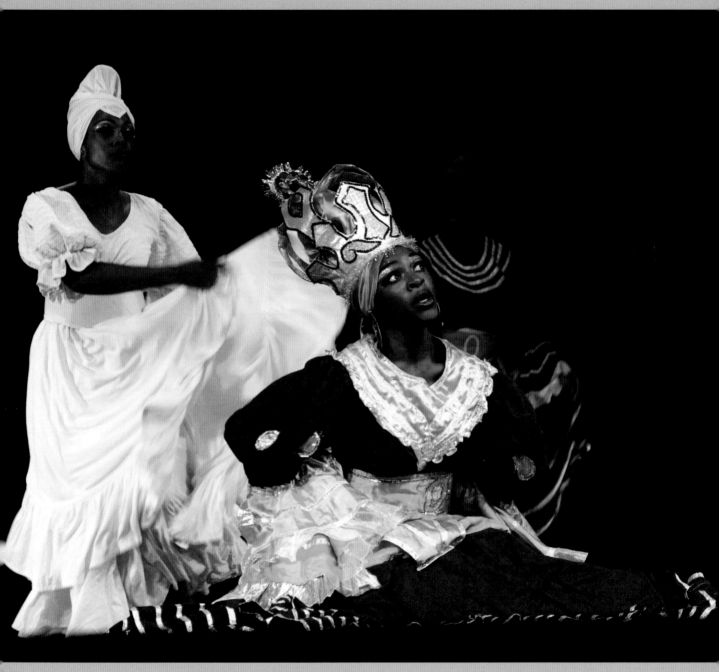

Yemayá, Vedado, Havana.

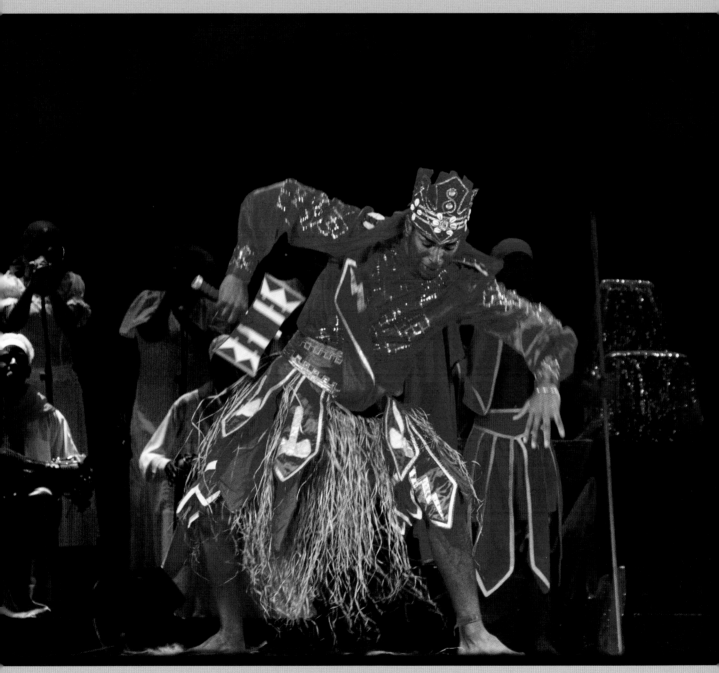

Eleguá, Vedado, Havana.

Religion

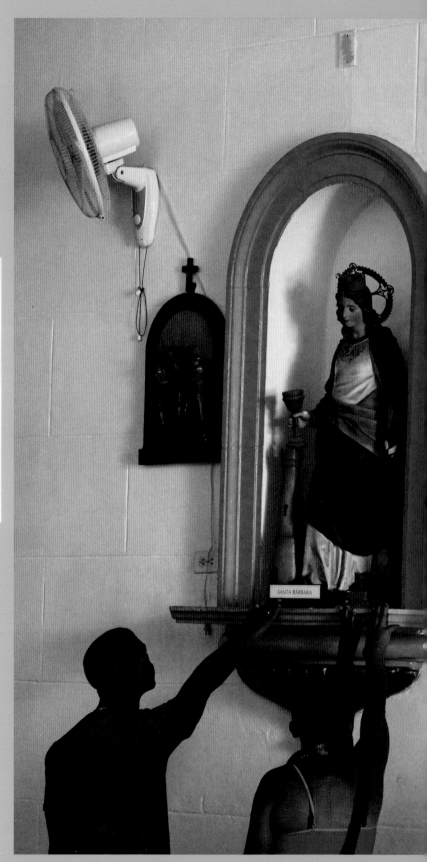

"Like Cuban architecture and nationality, religion is very eclectic but also very pragmatic, it is inclusive at all times. It is so much ours that it stops being African, Spanish, Catholic, or Yoruba. It is so complex, and at the same time it is so simple in terms of our identification with it, so much so that it ends up being a part of everyone. From those who call themselves atheists, but who can be superstitious, to those who are deeply religious, like the priests or the *babalao*. Religion is an element of Cuban cohesion."—Boris Martín, 30, historian

SANTA BÁRBARA

Regla, Havana.

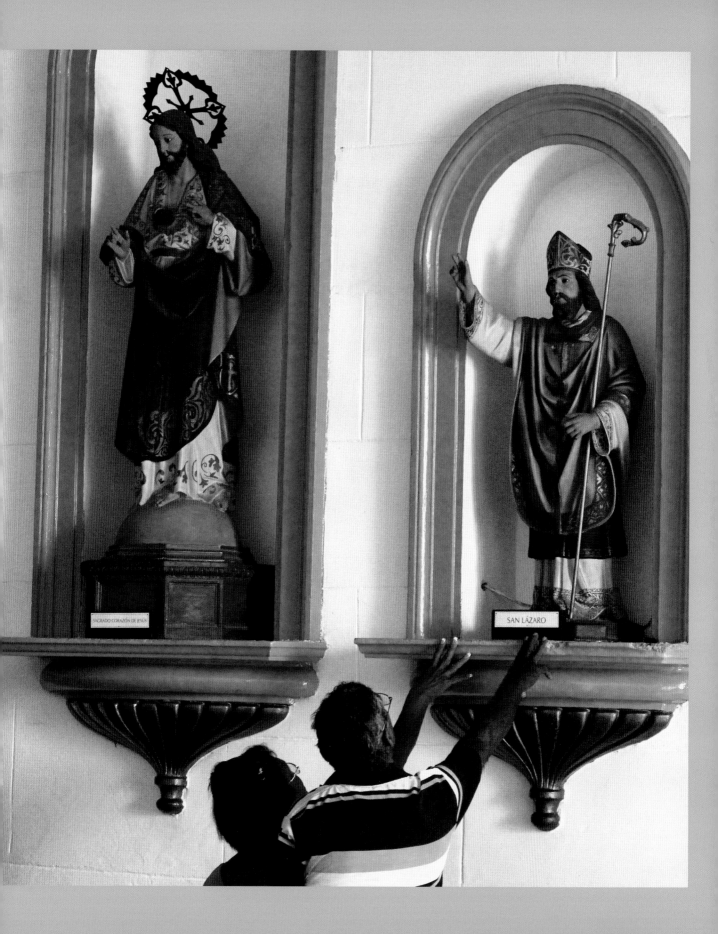

The acceptance of Afro-Cuban religions is also tied to the revolution. As Lázara, a Santería practitioner in her late 40s, explained to us, "In 1992 the constitution condemned religious discrimination. Before that, Afro-Cuban religions were only practiced at the level of the family. Since 1992 Santería and Abakuá, an Afro-Cuban male-only mutual aid society, have their own organizations at the national level. In that sense, the revolutionary project has been antiracist."

"In Yoruba terms, the *aché* (life-energy) is everywhere in all things and nature. It grows or decreases depending on the behavior of the individual, but there is no notion of sin. It's harmony, not a static equilibrium. Life is action and struggle. As we struggle, our aché increases. That is why most slaves would not commit suicide, because in life you must go through all stages on earth. And as such you are complete in old age and ready to pass successfully into the next world."—Norma, 29-year-old dancer

Everyday religion includes beliefs incorporated from Cuba's African heritage.

Initiates into Santería, symbolically reborn through ceremony, dress entirely in white for the first year of their commitment and must observe a restrictive series of obligations and prohibitions during that time. The colored beads indicate the crowning orisha.

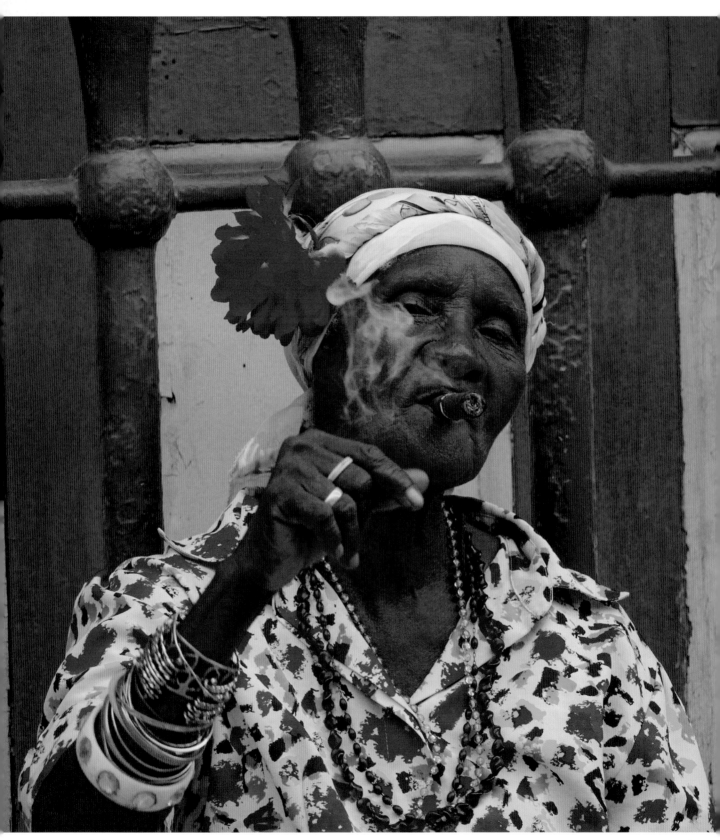

Trinidad, Sancti Spíritus.

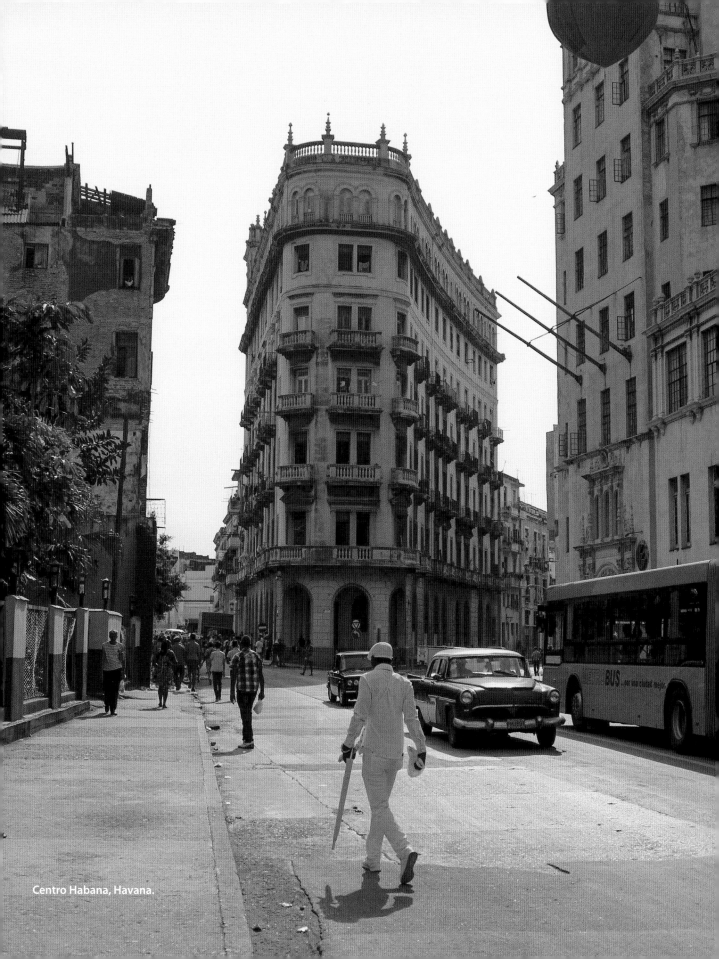

Centro Habana, Havana.

View from a balcony, Havana.

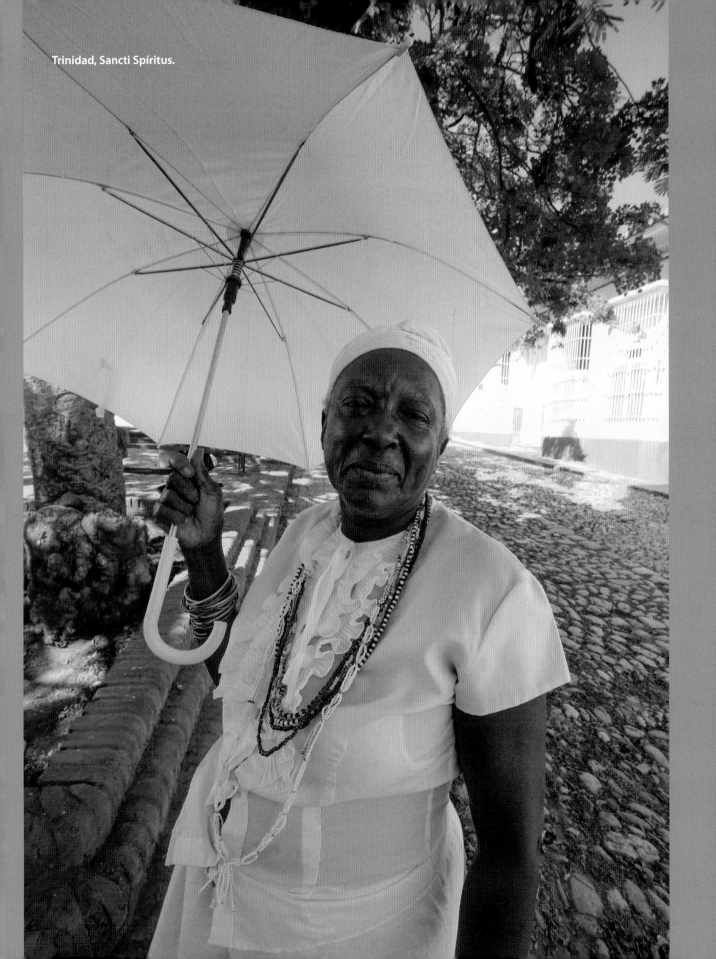

Trinidad, Sancti Spíritus.

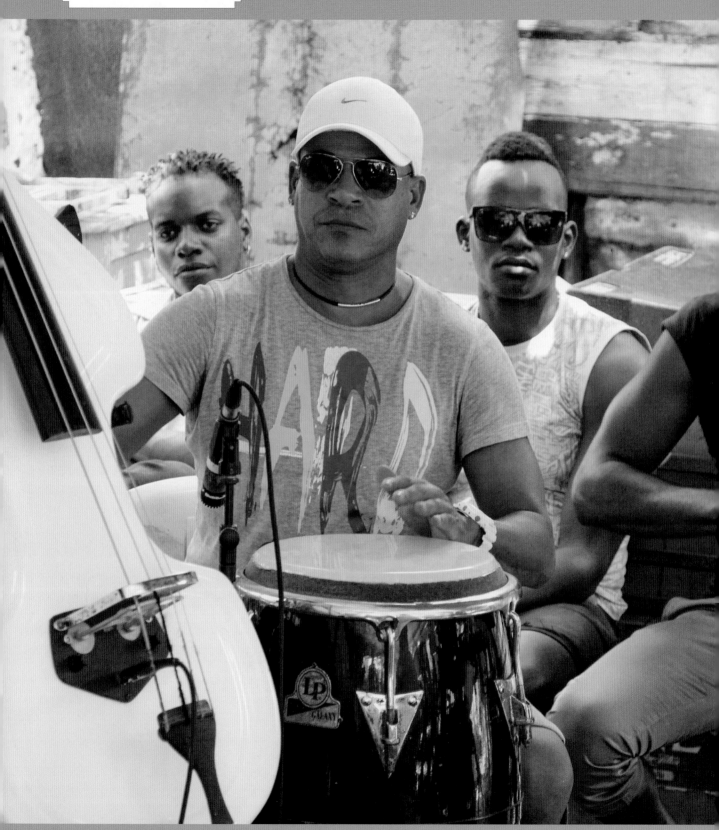

Music and Dance

Vedado, Havana.

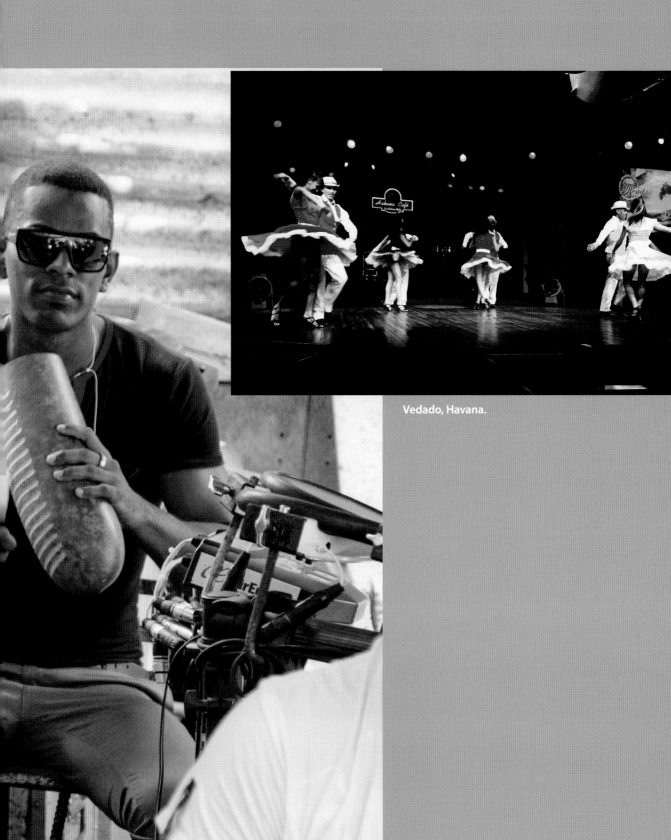

Vedado, Havana.

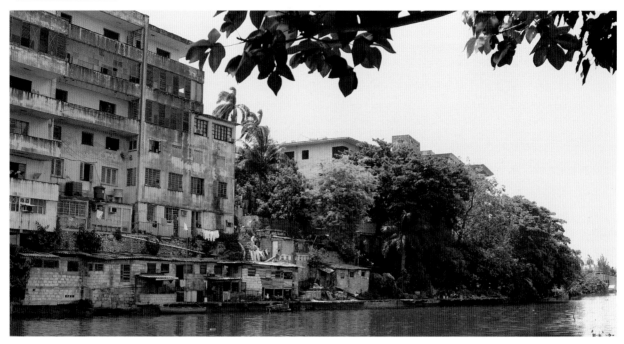

Playa, Havana.

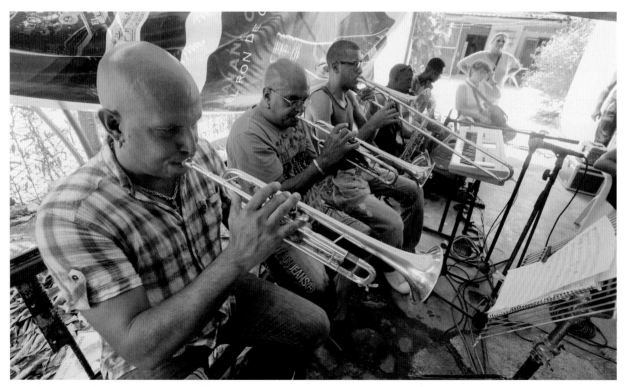

The Charanga Habanera, a timba ensemble and a popular orchestra in Havana, rehearses in a tent in El Fanguito, a marginal Havana neighborhood. There, among the people of El Fanguito, the Charanga members find the most current slang, which they use in their songs, drawing fans even closer. Vedado, Havana.

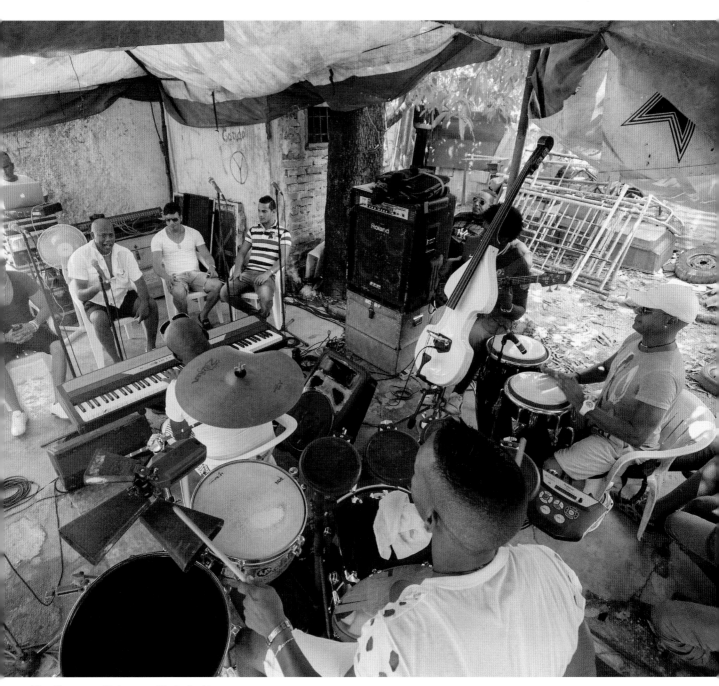

The Charanga Habanera. Vedado, Havana.

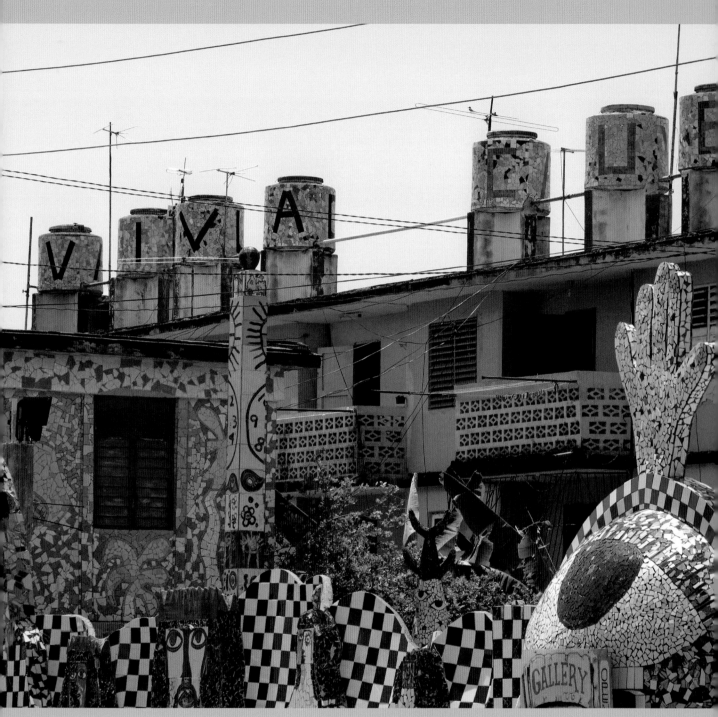

Jaimanitas, Havana.

Jaimanitas, Havana.

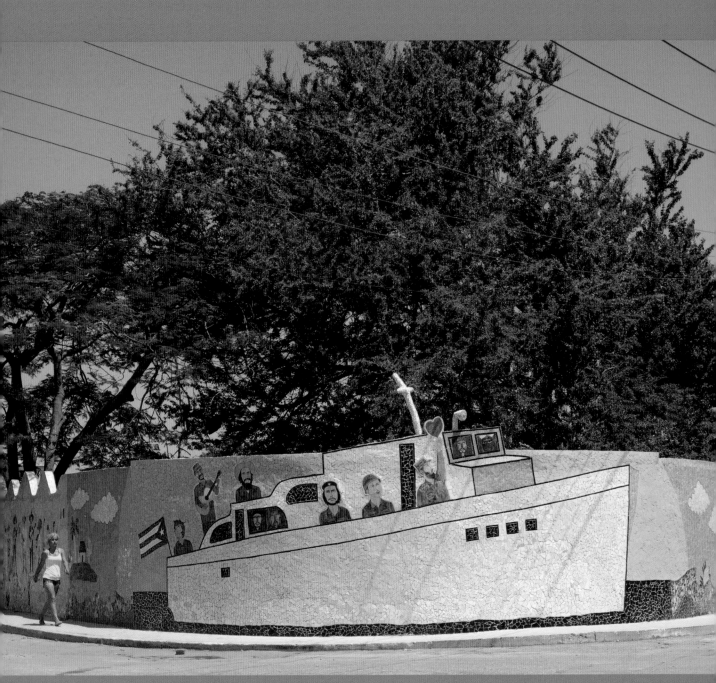

Jaimanitas, Havana.

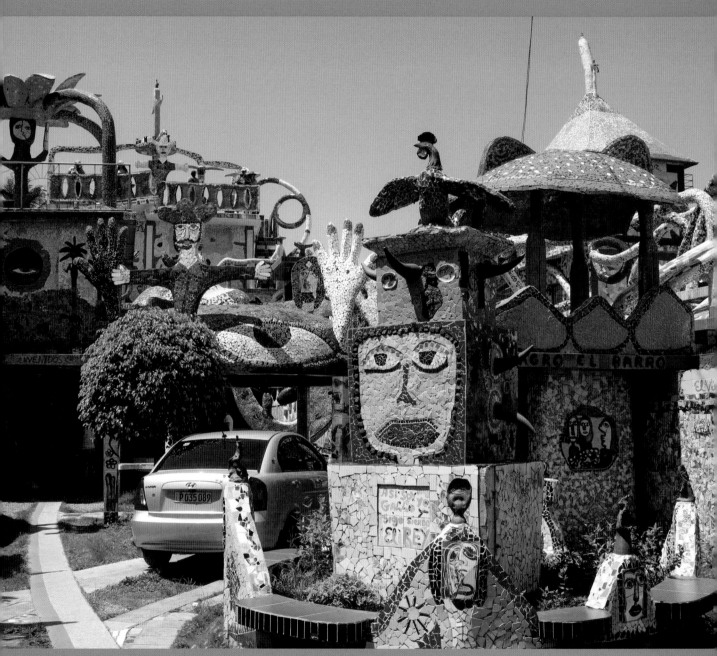

Jaimanitas, Havana.

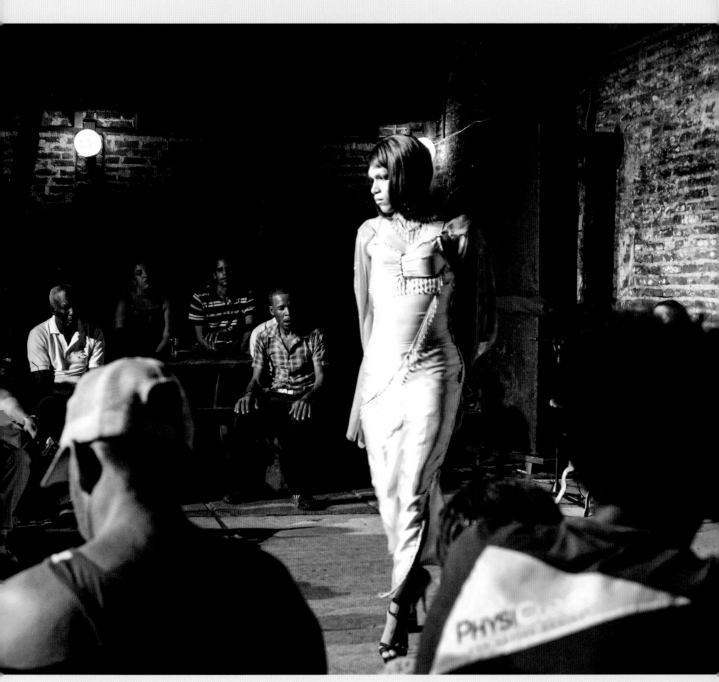

Santa Clara, Villa Clara.

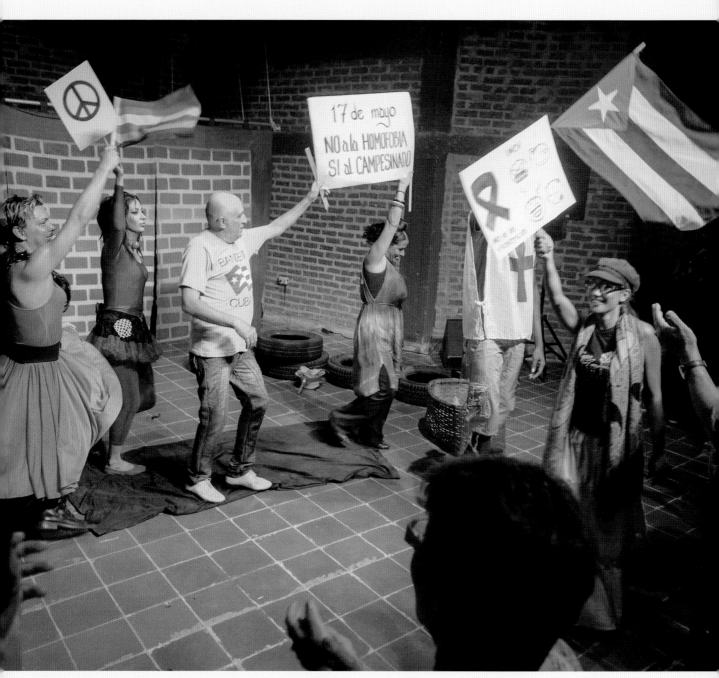

Santa Clara, Villa Clara.

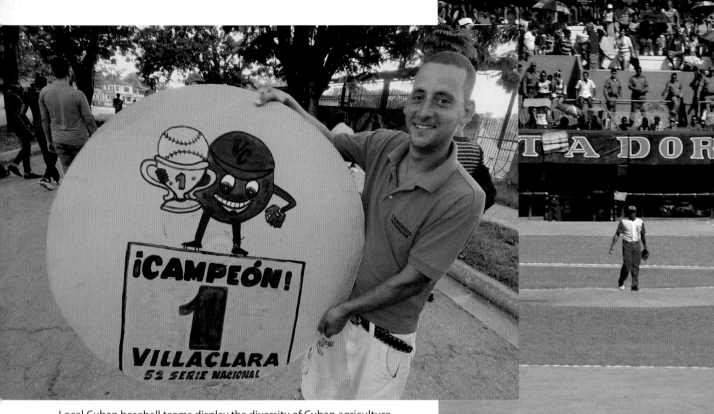

Local Cuban baseball teams display the diversity of Cuban agriculture in their team names. The Pinareños come from a region that produces tobacco. Nicknamed the Vegueros, the tobacco farmers, they wear green to represent the color of tobacco leaves. The Naranjas, or Oranges, from Villa Clara, are named for and wear orange to recognize the citrus fruit cultivated in that region. They used to be the Azucareños, the Sugars, because the region also grew sugarcane. A former baseball team from the henequen-producing region in Matanzas was called the Henequeneros. Santa Clara, Villa Clara.

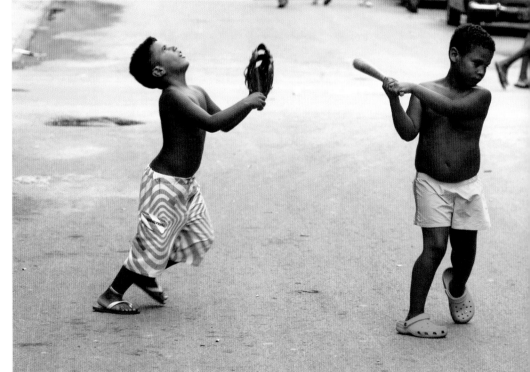

Santa Clara, Villa Clara.

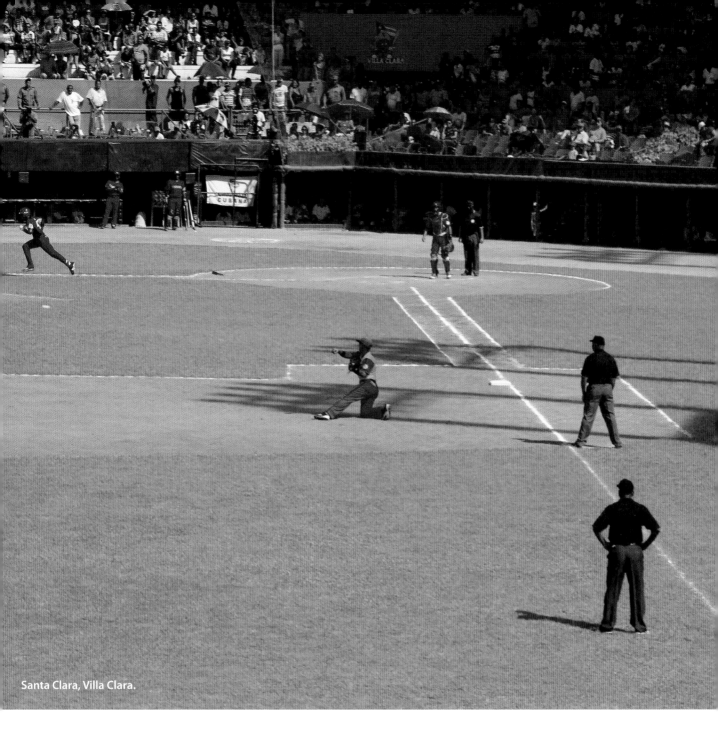

Santa Clara, Villa Clara.

Marianao, Havana.

Billboards and Murals

Upon arriving in Cuba for the first time, many visitors experience a strange feeling of liberation. This sense comes from the relief of not being subjected to the constant visual assault of advertising that one immediately feels upon arrival in any city of any country in the Americas. Billboards in Cuba are prominent, but unlike billboards everywhere else, they do not display commercial advertisements.

As elsewhere around the world, billboards, or *vallas,* occupy a fundamental public space. Since the 1960s, however, vallas and murals in Cuba have had two central functions related to state goals. One is to make history present and to promote the social and political ideals and successes of the revolution. Vallas and murals also demonstrate the presence of the Cuban state throughout the island. They have been used as one of many media tools to promote public health and sanitation campaigns, to raise awareness of global problems, or to foster cultural pride. Thousands of billboards fleck the island, in all cities and towns and on major roads and highways. They invite passersby to look, pay attention to the message, and reflect on the values promoted by the Cuban socialist regime and revolutionist supporters. The vallas also compel outside visitors to become conscious of how, elsewhere in the world, societies have normalized the inescapable visual intrusion of capitalism into people's daily lives. Cuba's billboards reveal the political, economic and social transformations that have swept the country since the 1959 revolution, reflecting a coherent expression of a clearly defined policy by the revolutionary government to limit any imposition of commercial advertising on Cuban society. Except for signs found on storefronts, no commercial advertising has existed since the revolution, at least in public spaces. As the non-state sectors grow, the state will need to grapple with businesses' need to advertise beyond the glossy brochures and internet sites aimed at international tourists. For now, the incursions are small: a telephone number on a motorcycle delivering pizza, a restaurant ad in a program at a dance performance, or fliers offering repair services or a home for sale stapled to a telephone pole.

The photographs of billboards in this chapter represent thematic tendencies and include murals of the revolution that, as Cuban researcher and historian

Reinaldo Morales Campos points out, started as *"un grito en la pared"* (a scream on the wall): expressions by university students and other social groups involved in the revolutionary struggle. Like billboards, murals often communicate an official message and contribute to the social and political production of revolutionary identity, history and memory. Because these billboards represent state policy, their themes have shifted over time, and those presented here are largely representative of the campaigns and issues that emerged from 2013 onward.

Some billboards and murals commemorate significant historical moments and revolutionary leaders, like those bearing the slogan "All for the Revolution." This shows the logo of the *Unión de Jovenes Comunistas* (UJC), or the Young Communist League, the youth wing of Cuba's Communist Party, at its center. On the right side of the billboard is an image of three young men who embodied the ideals of the revolution. Each of them is a hero: Julio Antonio Mella co-founded the Cuban Communist Party and the Federation of University Students in the 1920s and was assassinated in 1929 in Mexico. Ernesto "Che" Guevara, the Argentine Marxist revolutionary, physician, author and guerrilla leader, became an icon of the revolution and suffered execution in Bolivia in 1967 by the CIA-backed Bolivian military. Camilo Cienfuegos served as one of Fidel Castro's top commanders. He died in 1959.

Other billboards highlight the roots of the revolution, such as one commemorating the births of Antonio Maceo and Che Guevara, who shared the same birthdate. One of the leaders of the independence movement against Spain in the late nineteenth century, Maceo is shown with revolutionary leader Guevara. Some billboards tell the story of the 1953 attack on the Moncada Barracks in Santiago de Cuba by rebels led by Fidel Castro. This attack marked the beginning of the revolution; the revolutionary movement took its name, Movimiento 26 de Julio (M-26), from the date of the Moncada attack. Other billboards offer reminders of the 1961 Bay of Pigs Invasion, when a CIA-sponsored counterrevolutionary military group made up of around 1,400 Cuban exiles landed on the south coast in Bahía Cochinos, Playa Girón in an unsuccessful attempt to overthrow the government of Fidel Castro. As one approaches Playa Girón today, billboards note the site of Fidel's headquarters and the "first defeat of Yankee imperialism." Memorials line the road, marking the places where Cubans were killed in the invasion, right up to the Museo Girón, which is located at a battle site. Here, the government commemorates the defeat of the invasion, displaying photographs, historical artifacts, and a short documentary film that shows the defeat of the US-sponsored forces.

There are also images and slogans that focus on the accomplishments of the revolution, like one reading "Yo soy el MAESTRO" alongside an image of a young man and a lantern. The lantern is a recognized symbol of the 1961 Cuban Literacy Campaign, which in one year almost completely eradicated illiteracy in Cuba.

Prior to 1959, the country's official literacy rate was around 60 percent, with much lower rates in rural areas. By the end of 1961, with the participation of approximately 100,000 Cuban youth, as well as teachers, workers and other adults, the literacy rate had increased to 96 percent. As narrated in Catherine Murphy's 2012 documentary *Maestra,* "It was a year that each Cuban who knew how to read and write would teach one who didn't." Other billboards celebrate women—"Women are in all epochs of history because they are the history of all epochs." This billboard offers a reminder that women are central to Cuban history, from Ana Betancourt and Mariana Grajales, national heroines in the war of independence from Spain, to Celia Sánchez and Vilma Espín Guillois, Cuban revolutionaries, feminists, and professionals. Billboards also celebrate "revolution within the revolution" and the Federation of Cuban Women, formed in 1960 to address women's issues and work toward gender equality. Today women represent the majority of college students and administrative workers in the country, and Cuba ranked second worldwide in terms of women's representation in parliament in 2014. Billboards that acclaim athletes as "champions of the people" also show the importance of sports as a basic right promoted by the revolutionary government.

Billboards also record the achievements of the revolution in the field of health care and often promote public well-being campaigns. One billboard reads, "For our health and the hygiene of our neighborhoods: Focal Duos, Present!" This sign refers to ongoing mosquito eradication campaigns at the local level in which health workers, always in pairs, conduct door-to-door visits. Billboards change with government priorities, urging the conservation of electricity, calling for discipline, efficiency, and productivity, and reassuring the public of the state's commitment to socialism.

Cuba's interest in humanitarian internationalism and global concerns are often displayed on billboards as well. Reflecting Cuba's support for other nations, one board states that "Solidarity consists not of giving what one has in excess, but in sharing what one has." Billboards also relay environmental messages, like "Conserve it, it is your duty," referring to the planet Earth, or "Only human will can save the world." Others present famous quotations from world humanitarian leaders, such as Mahatma Gandhi's "You should be the change that you want to see in the world." Others reflect simple messages encouraging polite behavior and good manners: "PLEASE, it is so easy to say."

As discussed in chapter six, with the expectation of greater numbers of visitors from the United States and increasing reliance on tourism as an income-generating activity, billboards bearing the slogan "*Auténtica Cuba*" (Authentic Cuba), produced by the Ministry of Tourism, also abound. These billboards show pride in the country's historical cities, like Habana Vieja, Trinidad, Sancti Spíritus, and Camagüey. These billboards have appeared recently and are part of a campaign to

diversify tourism, directed at the tourists who are now visiting the island "before it completely changes" as relations between Cuba and the United States evolve.

Both dominant and unique, billboards and murals throughout the island create a distinctive sense of place and community. In the words of historians, vallas and murals in Cuba "serve as constant reminders that the state is present, promoting welfare, safety, history lessons, and socialist ideology for the masses." Today, Cuban billboards also incorporate that symbol of social media, the hashtag, such as #cubaesnuestra, reaffirming that the future of Cuba is for Cubans to decide, and #yosoyfidel, signaling a continued commitment to revolutionary ideals. They also play an important role in making the revolution timeless, by mixing messages from the past with messages from the present and the future, like the billboard that shows the bee hummingbird (*Mellisuga elenae),* the smallest living bird, weighing less than two grams and only found in Cuba. Next to the *zunzuncito,* its colloquial name, is a quotation from José Martí that reads: "The most elemental truths fit under a hummingbird's wing."

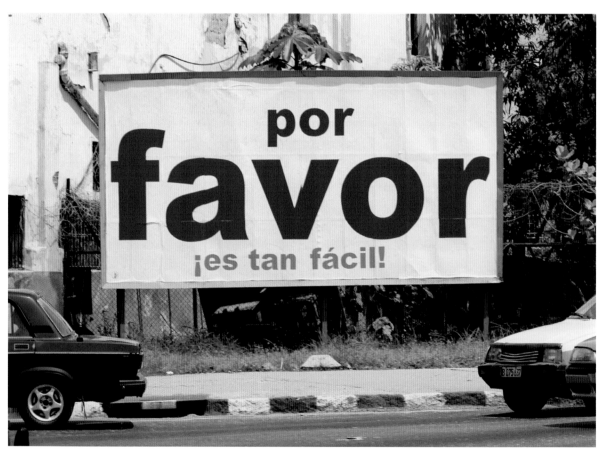

"PLEASE, it is so easy to say!" Santiago de Cuba.

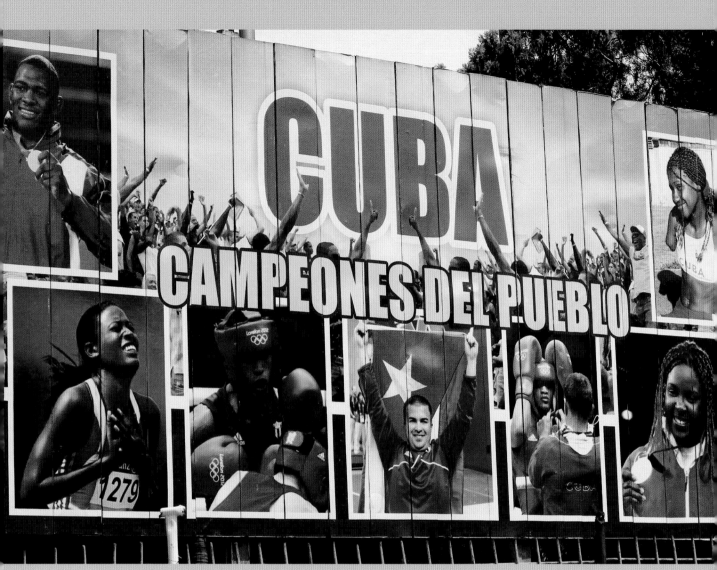

"Cuba, Champions of the People." Ciudad Deportiva, Havana.

Although commercial advertising is all but nonexistent, billboards and murals illustrating Cuban history and the slogans of various revolutionary campaigns are found throughout the island. Havana.

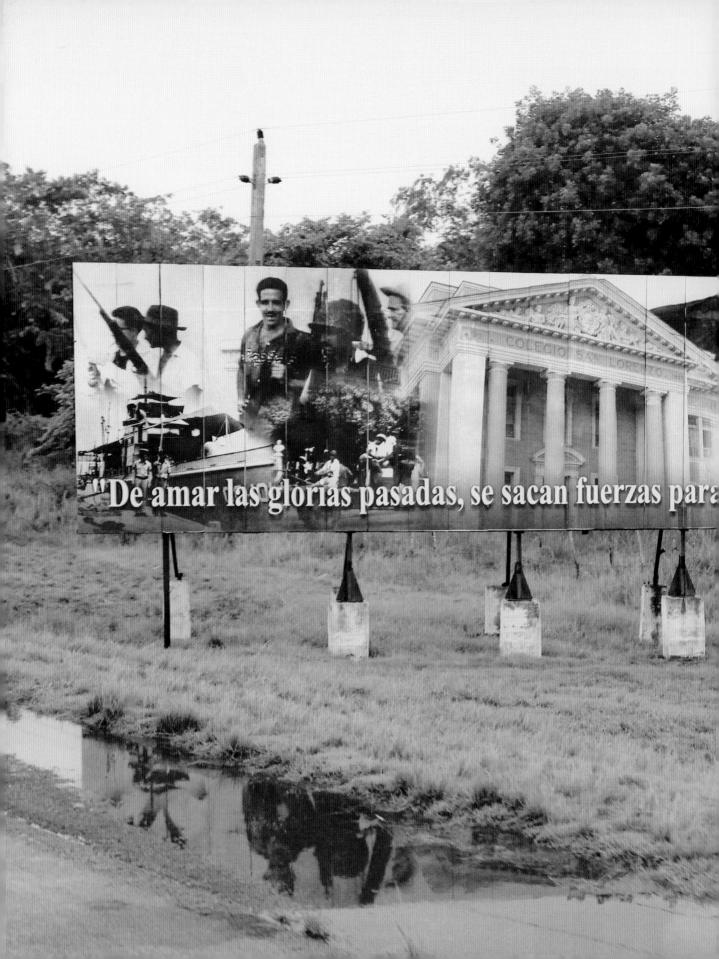

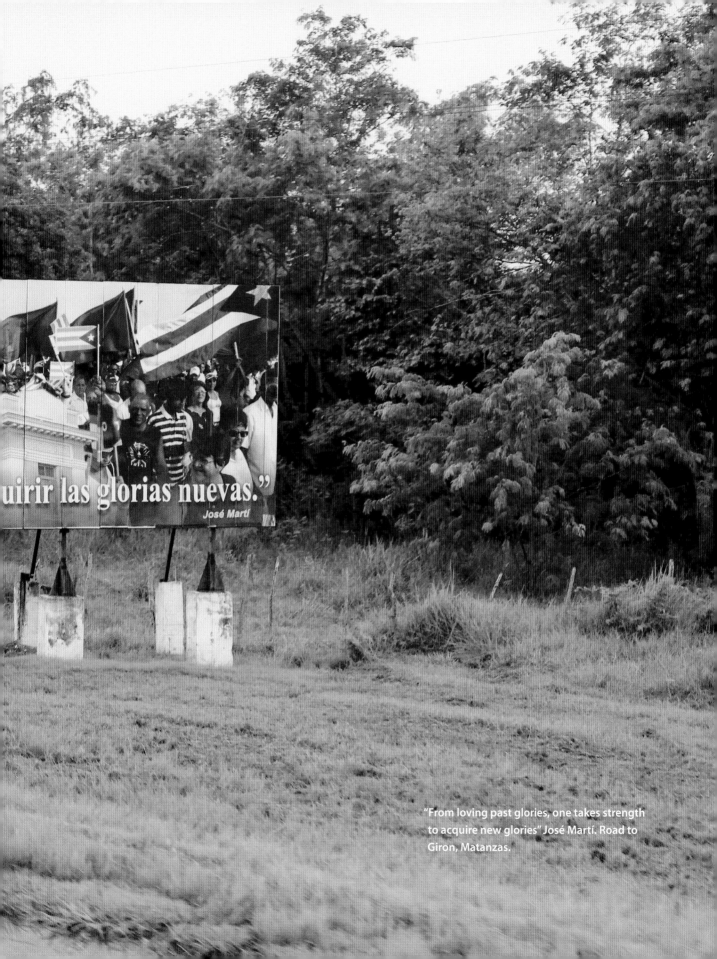

"From loving past glories, one takes strength to acquire new glories" José Martí. Road to Giron, Matanzas.

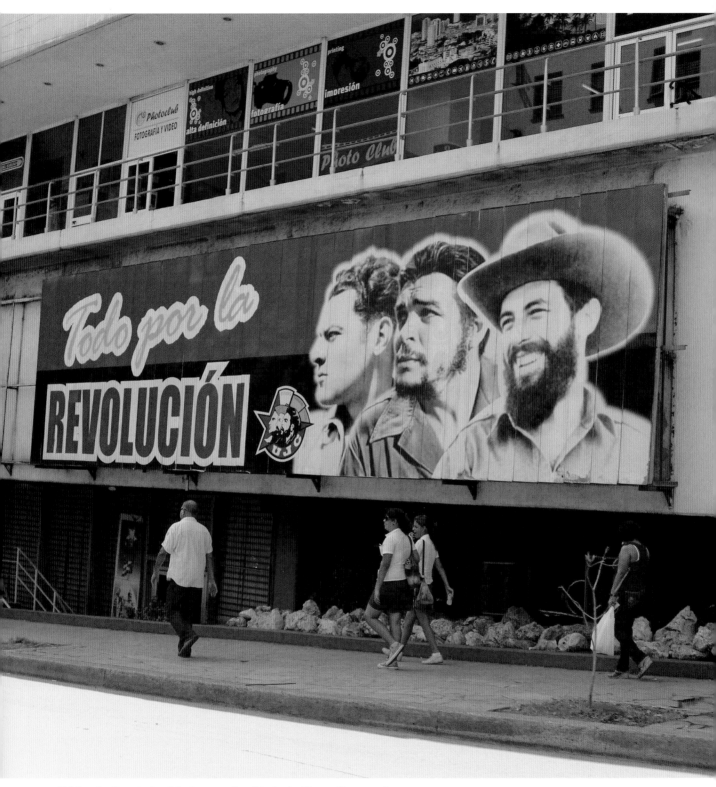

"All for the Revolution." Active membership in the Young Communist
 League (UJC) exceeds 600,000. Vedado, Havana.

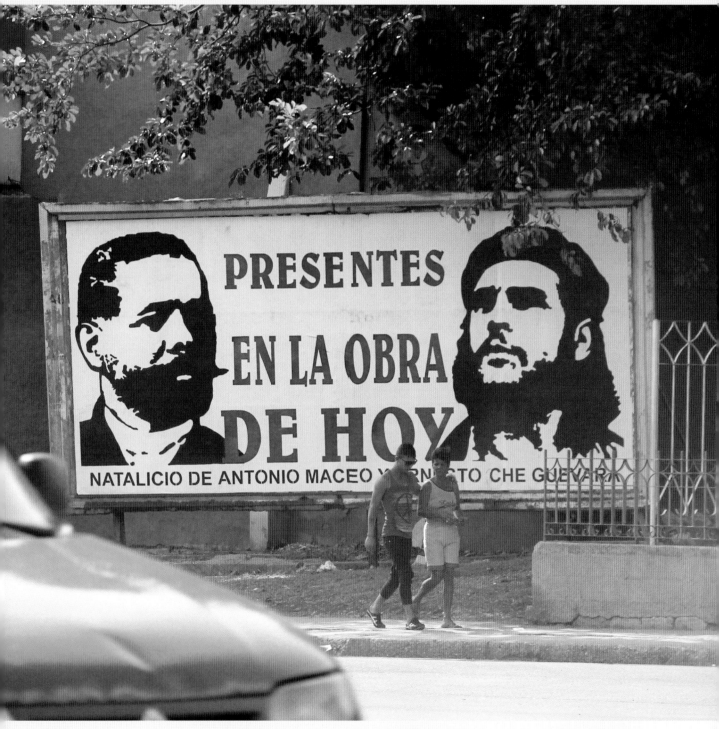

PRESENTES EN LA OBRA DE HOY

NATALICIO DE ANTONIO MACEO Y ERNESTO CHE GUEVARA

"Present in today's mission. Anniversary of the Birth of Antonio Maceo and Ernesto Che Guevara."
Known as the Titán de Bronce, Antonio Maceo Grajales was one of the great guerrilla leaders to
fight against Spain in the latter part of the nineteenth century. Havana.

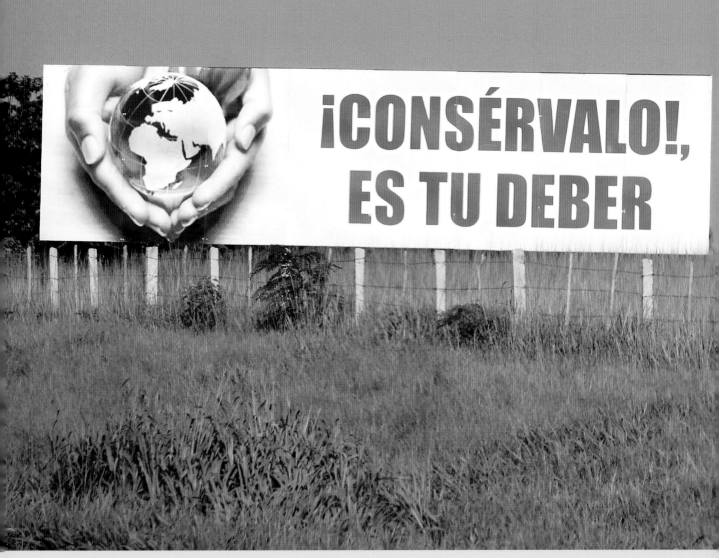

"Conserve it! It is your duty." Pinar del Río.

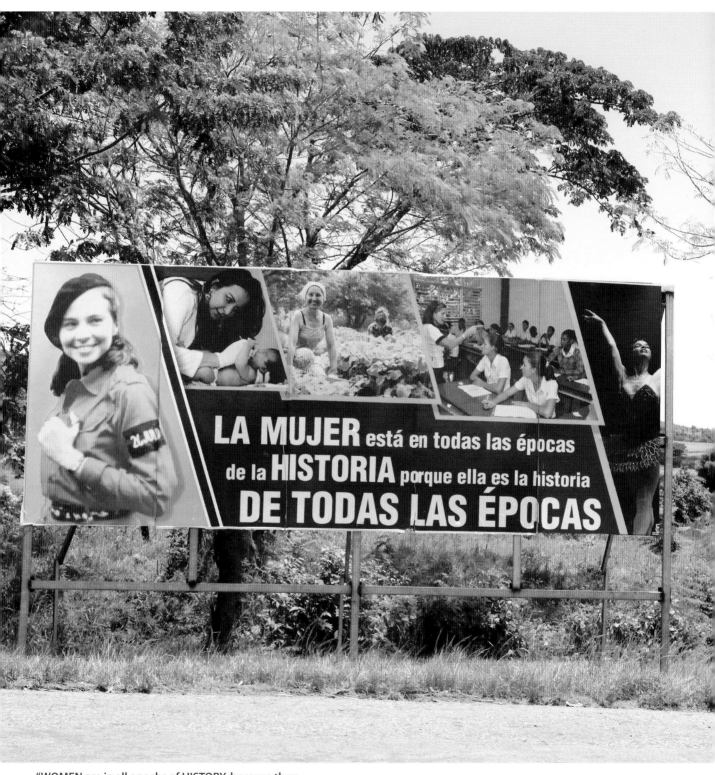

"WOMEN are in all epochs of HISTORY, because they
are the history OF ALL EPOCHS." Pinar del Río.

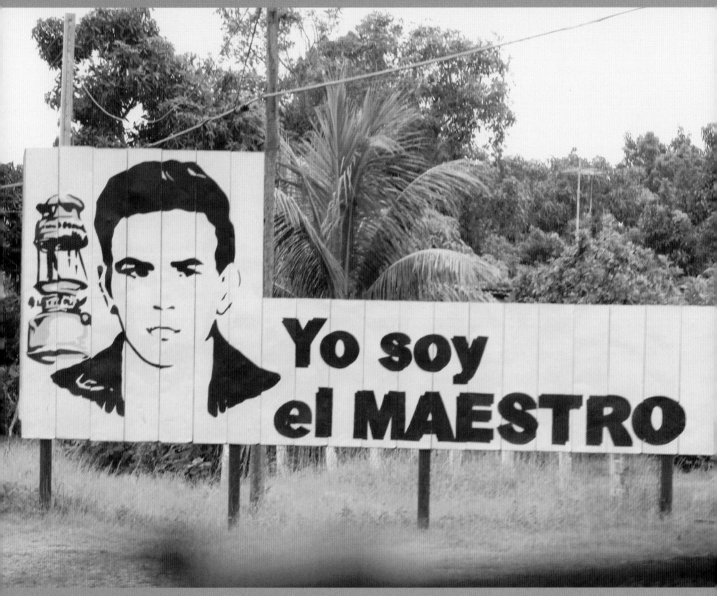

"I am the TEACHER." Santiago de Cuba.

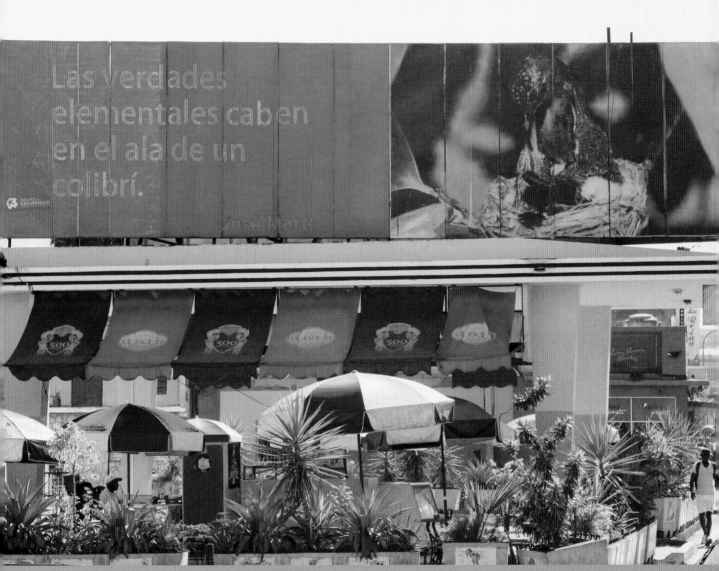

"The most elemental truths fit under a hummingbird's wing."
José Martí. Santiago de Cuba.

"This is a people OF IDEAS AND COMBAT." Matanzas.

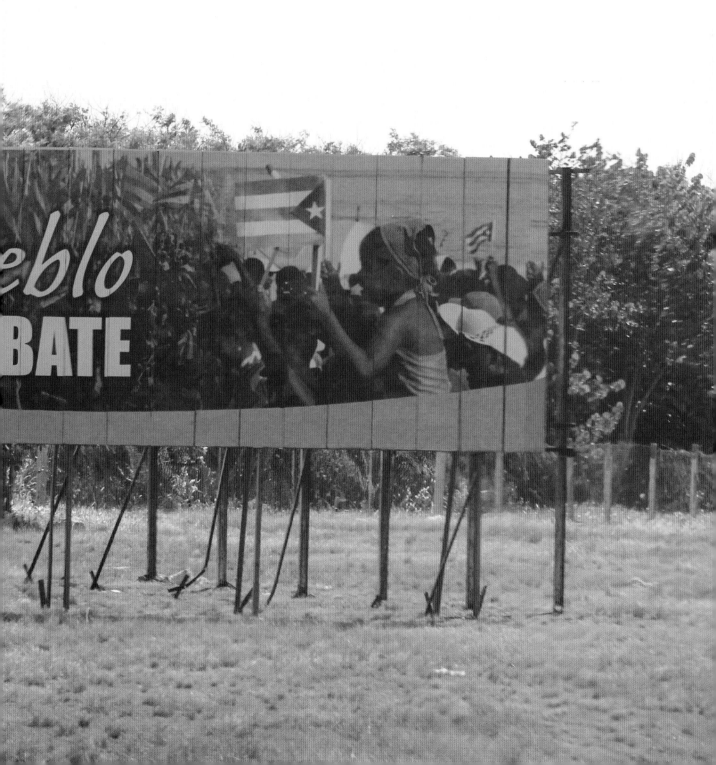

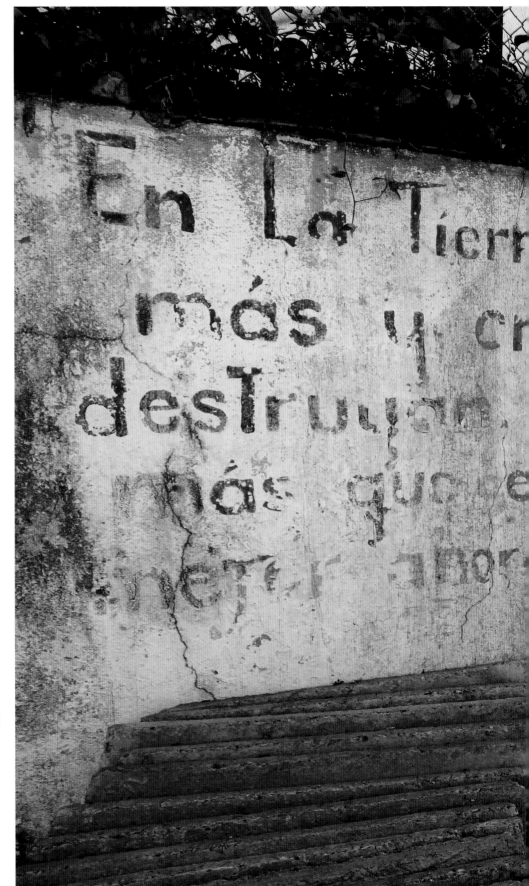

"On this earth, we need people who work more and criticize less, who build more and destroy less, who promise less and solve more, who expect to receive less and give more, who say better to-day than tomorrow." Che. Matanzas.

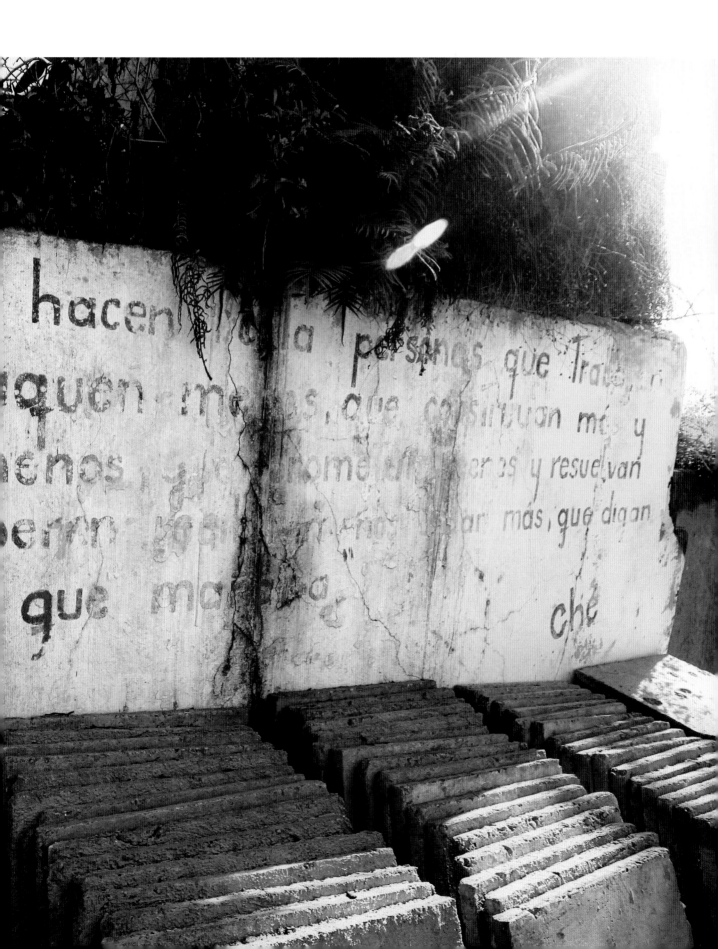

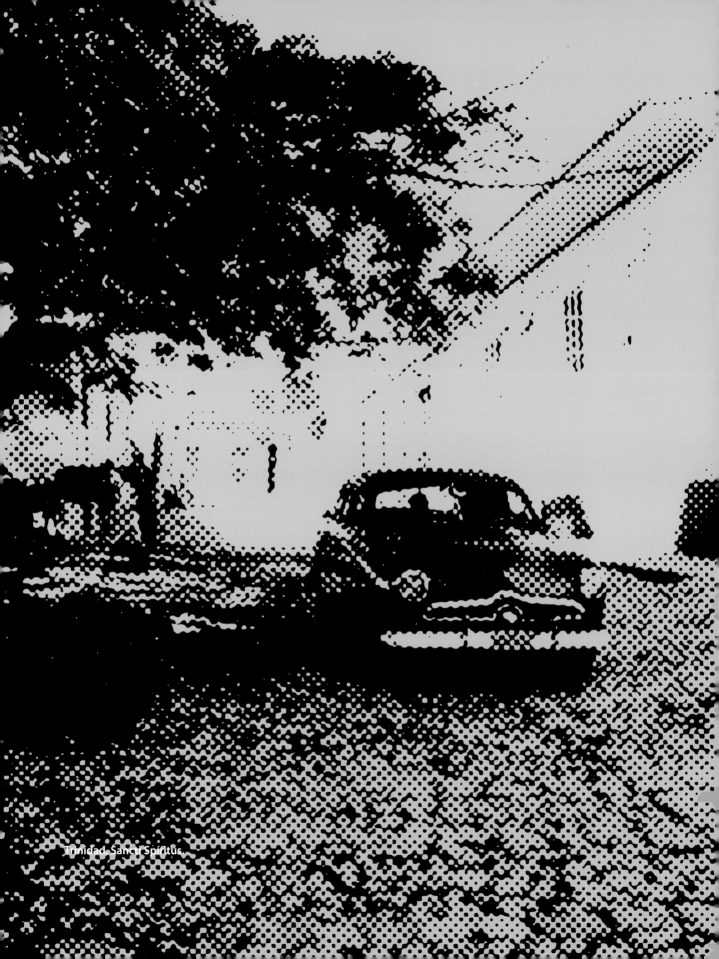

Trinidad. Sancti Spíritus.

Agriculture and the Land

One of the ideals of the revolution was to become self-sufficient in food production, but this idea was abandoned. We are a long and skinny island; all our rivers go north or south and run into the sea. In 1959 there were no dams; today we have many. However, despite tremendous efforts, the southern part of the island has become saline. We have had consecutive years of drought, and the rains have come with hurricanes. This makes agriculture very difficult. For small countries like Cuba, to be really independent and fair with its own population is almost unheard of. That is why I say that the revolution is a triumph over the impossible.

Anonymous female, 60

Since colonial times agriculture in Cuba has played an important role in defining the island's economy and society and even its relationships with other nations. Early on, Havana became a gathering point for the Spanish fleets traveling from the Americas back to Europe, and the provisioning of the ships with *casabe* (cassava), hides, and meat generated wealth for producers located around the island's capital. Opportunities expanded with the growth of the tobacco industry, and planters flourished. The island's social structures reflected its agricultural base, with merchants and large landowners at the top of the hierarchy.

In the mid-1700s, the Cuban countryside was transformed. The British occupation of Havana, despite lasting only 11 months, had profound consequences. It lifted the Spanish mercantilist restrictions on trade, opening the island to British, North American and Caribbean traders who were difficult to dislodge after the occupation ended. Food, horses and other goods from the British colonies saturated the island. In 1804 Haiti's war of independence devastated that nation's coffee and sugar plantations, further transforming the Cuban countryside. Wealthy French landowners left Haiti and brought their expertise in coffee and sugar production to Cuba, establishing an export-oriented plantation economy.

Demand for cheap labor grew and the importation of slaves increased significantly. By the time Cuba ended its participation in the Atlantic slave trade in 1867, the more than one million African slaves who had been brought to Cuba

"Outside of Havana, I think of Cuban roads, a lot of land that could be cultivated, many beautiful places, and magnificent beaches. I have gone diving in the most beautiful coral reefs. Along Cuban roads there are all sorts of people, the Cuban, the peasant, the people who walk, the people who are trying to subsist by selling their stuff to those who drive by."—Isabel Suárez Méndez, 23, actor

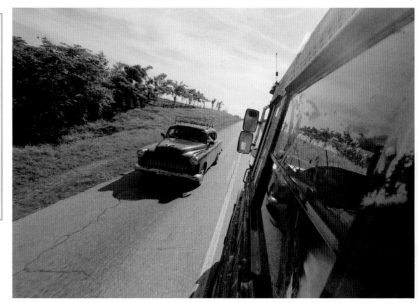

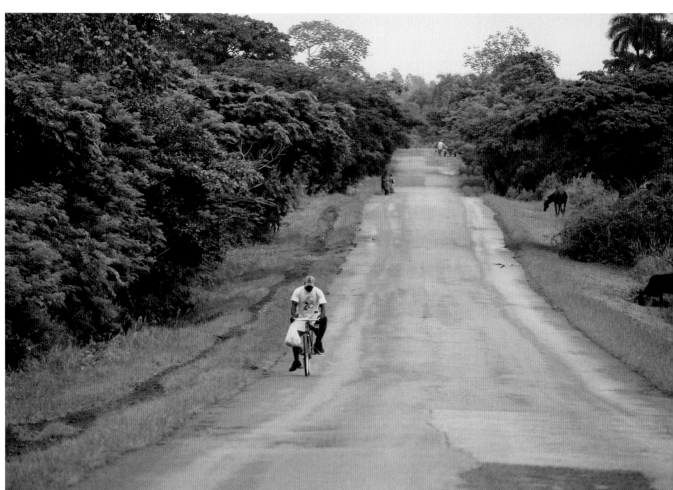

Pinar del Río.

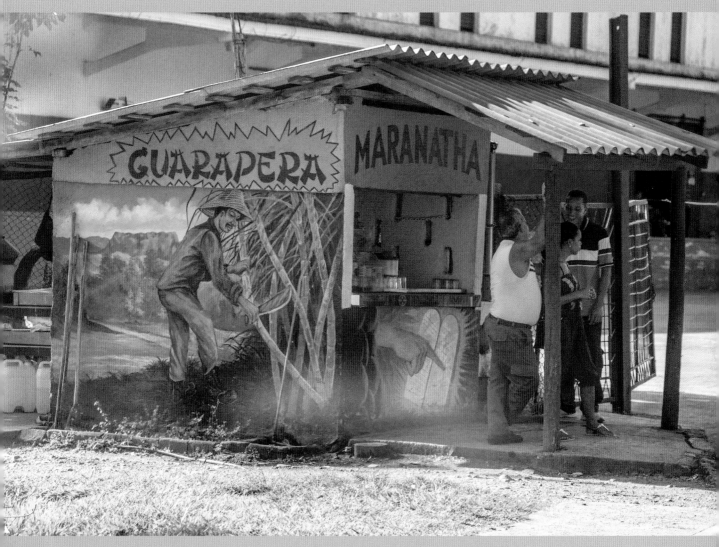

Baracoa, Guantánamo.

"I always have a liberated sensation when I leave Havana. When I go through the Bahía tunnel, which is a bit intimidating because even though it facilitates transportation it is a tunnel that goes under the sea, I feel freer, mainly from the city's smog. And to be in the countryside is to be in nature, more alive, more oxygen, and a rhythm that is slower, more constant, more noble than the one in the city."—Mayra María García, 50, record producer

outnumbered European Cubans. As the slave trade neared its end, slaves were substituted with Chinese indentured labor, whose living conditions were not much better than those of their African counterparts.

As the sugar industry took off, large cattle estates were initially subdivided into sugar plantations, and Cuba became the largest producer of sugar in the world. As sugar mills proliferated and the railroad connected plantations to mills to ports, sugar came to dominate the rural landscape. The wealth from its production simultaneously transformed urban landscapes as sugar magnates poured their profits into elaborate and luxurious homes in the cities. Today these cities and the mansions that embellish them are important tourist destinations—three of Cuba's nine UNESCO World Heritage Sites are centered on the landscapes shaped to a large extent by the production of key crops: tobacco in Viñales, coffee in the Southeast, and sugar in Trinidad and the Valle de los Ingenios.

An export-oriented agricultural economy continued to define Cuba after independence and the end of the U.S. occupation. Sugar constituted almost 80 percent of Cuba's exports, and the United States imported over half of this, making Cuba particularly vulnerable to cuts in U.S. sugar quotas. When the revolutionary government came to power in 1959, 75 percent of agricultural land in the island was owned by foreign (primarily U.S.) companies and individuals. The United Fruit Company (UFC) was only one of the many U.S. companies that had come to dominate land ownership and exert political control in Eastern Cuba. UFC, however, had a particular significance: its land was leased by Fidel Castro's father, Angel Castro. UFC holdings were among those expropriated by the new government in the first years of the revolution. Since sugar was the predominant crop, most of the agricultural labor force was occupied only during the harvest season or the *zafra,* which runs from January to May, leaving plantation workers scrambling to make a living during the rest of the year. An export-based agricultural economy also meant that the island was highly dependent on imported foodstuffs.

The agrarian reforms of 1959 and 1963 transferred over 70 percent of the land to the state, transforming plantations into state-owned farms and agricultural laborers into salaried employees. The United States cut its sugar quota to zero, and the Soviet Union and China agreed to take the bulk of Cuban exports. Despite Castro's desire to diversify the economy and trade, Cuba became dependent on the international socialist system. Sugar continued to make up the bulk of the country's exports and although there was a slight increase in the production of foodstuffs for domestic consumption, the country continued its dependence on massive food imports. In addition, reliance on a few export crops produced on large state-owned farms required continued dependence on industrial, capital-intensive, mechanized production, with the Soviet Union becoming the principal provider of critical inputs such as diesel and modern agricultural machinery, chemical

fertilizers, pesticides, and animal vaccines. Shortages of agricultural labor intensified after the revolution as young people migrated to the cities to take advantage of a new educational system that provided, for the first time, free access to higher education for all Cubans. Labor shortages were addressed by mass mobilizations of urban workers to state farms during zafra or, in the case of citrus, by establishing schools in the countryside that allowed students to participate in the harvest.

In the early 1990s, with the fall of the Soviet Union, subsidies disappeared and sugar production plummeted. Cuba lost access to its primary market and to critical Soviet imports. This had a devastating effect on agriculture. The Special Period destroyed what had been a modern, petrochemical-intensive agricultural system, forcing the Cuban government to reduce sugar production dramatically, closing sugar mills around the island and retraining workers. Food imports declined by more than 50 percent and Cuba experienced a period of widespread hunger.

The Cuban Agroecological Movement, a New Chapter

In 1993, the Cuban government undertook drastic agrarian reforms. State-owned farms were divided into agricultural cooperatives and farmers received land in usufruct—that is, they obtained rights on a profit-sharing basis to what they produced from the land, but the Cuban state retained ownership rights to the land itself. The state sector kept 33 percent of cultivated land, and 42 percent was transferred to the cooperative sector, which now produces 90 percent of the sugarcane and 60 percent of other crops, and negotiates production plans with the state farm enterprise.

To maintain agricultural production in the absence of imported chemicals and machine parts, the Cuban government, working with Cuban farmers and scientists, encouraged new directions in agriculture. Together, they promoted the recovery of traditional farming practices, which require as few petroleum-based inputs as possible. Instead they rely on oxen or manual labor to cultivate, organic fertilizers such as manure, compost and crop residues, and biological pest control, which is a method of keeping pests below damaging levels by using living organisms instead of chemicals to control them. This type of farming is also highly diversified in terms of crop production and has led to substantial scientific research in the use of ecological methods.

One of the scientists involved in this initiative is Miguel Angel Salcines López, founder of one of Cuba's most renowned organic farming cooperatives Organopónico Vivero Alamar. Alamar captures the spirit of shared community values and willingness to work together that has facilitated Cuba's profound agricultural transformation. As he told us, "I am an agronomist with peasant roots. When we started more than 15 years ago, we either produced food organically or

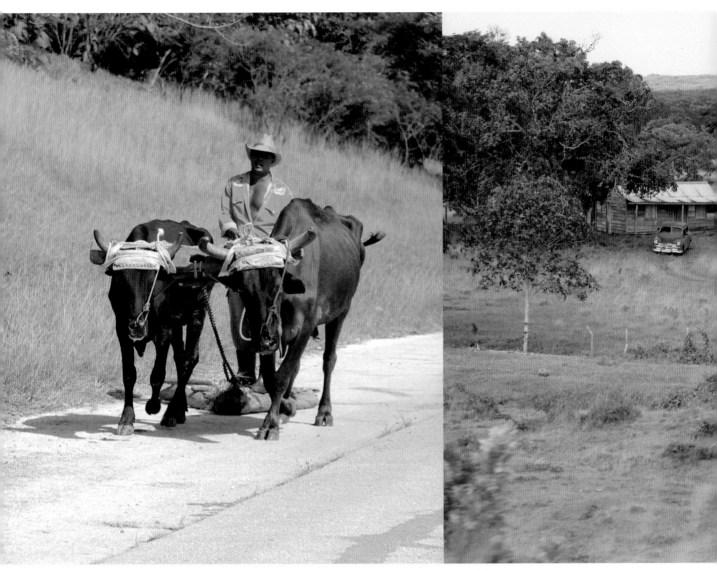

Countryside, Guantánamo.

Pinar del Río.

we starved to death. It was production for survival because we didn't have another alternative, and it turned out to be nothing like that. We have been learning that we could produce four times more organically than with chemicals."

Part of the agroecological movement included the development of urban agriculture, including private gardens, cooperatives, state-owned research gardens, and community gardens. These have been critical in providing food supplies to urban residents. Efforts to provide more opportunities for small farmers have led to the opening of agricultural markets throughout the country, where farmers can sell their surplus produce (that which is not included in agreements with state-owned enterprises) at market prices. Since 2008, government policies have encouraged private farmers and agricultural cooperatives to lease land from the

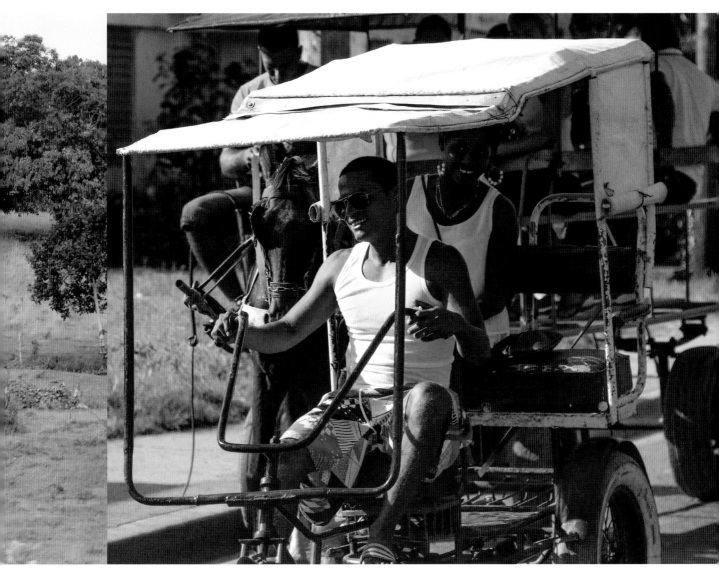

Baracoa, Guantánamo.

government for production and allowed farmers to sell directly to consumers. Farmers also are now permitted to sell a portion of their harvests directly to restaurants and hotels. With these reforms, the amount of uncultivated land in Cuba has declined by 62 percent. In order to make much of this land cultivable, many farmers had to clear it of the reviled *marabú* (sickle bush), a pervasive and highly aggressive invasive thorny shrub. This shrub, however, is now used to produce an "artisanal charcoal," which was approved as the first legal commercial import from Cuba into the United States since the beginning of el bloqueo.

Today, Cuba is recognized as one of the world's leaders in organic agriculture, urban gardens, and permaculture, which refers to the development of agriculture ecosystems that seek to be sustainable and self-sufficient. Although still relying on

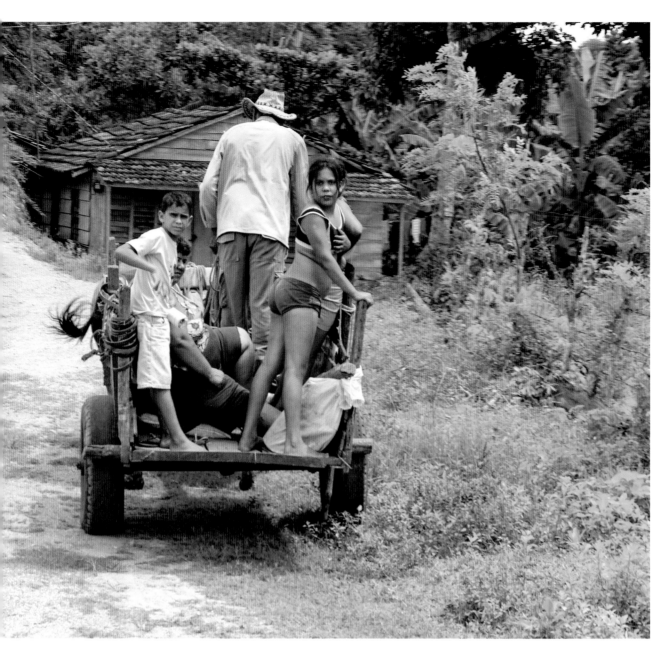

Pinar del Río.

imports for over 50 percent of its food consumption, the island has managed to increase production to local *agromercados,* domestic food-processing industries, and the tourism sector. The Organopónico Vivero Alamar is one of the earliest and most successful representatives of Cuba's agroecological movement. Depicted in multiple documentaries, Alamar regularly receives tourist groups and news crews, and its founders travel abroad to participate in international conferences and workshops.

The growth of tourism has also helped other farms to expand, as they are able to supplement the income they receive from the sales of their produce with the

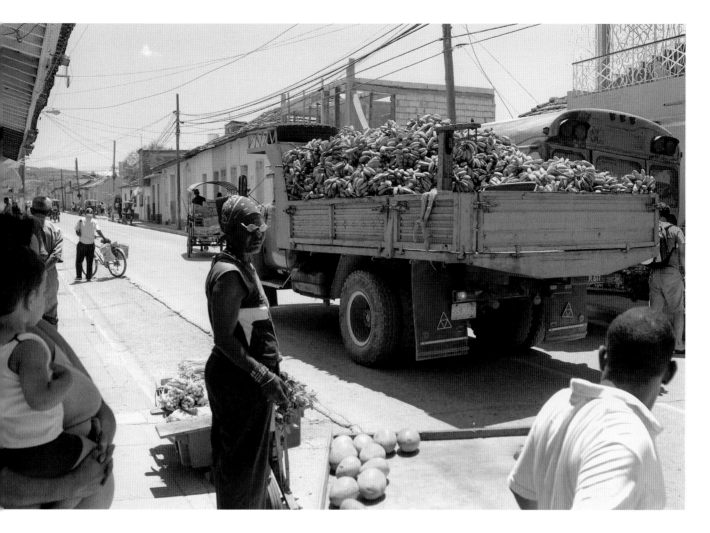

revenue generated by visits from tour groups, who often eat on site. Finca Agro-
ecológica El Paraíso, in Viñales, has expanded its dining facilities several times,
and regularly hosts busloads of visitors who dine on overly generous portions of
the vast array of vegetables produced on the farm. Following this example, farms
throughout the valley now have built facilities to serve tourists and host tours that
demonstrate the ins and outs of permaculture and organic production.

Finca Marta, in Artemisa, is perhaps the most ambitious agroecology project, hav-
ing cleared twenty acres of eroded, rocky, marabú-filled land and then regenerated
the soil to establish a diverse enterprise that combines fruit and vegetable produc-
tion (over 60 different products over the course of a year) with apiculture and the
raising of animals. Initiated by Fernando Funes, who holds a Ph.D. in production
ecology and resource conservation and who spent months digging through layers
of rock before finally striking the water that would supply its irrigation systems,
the farm is able to sell directly to top restaurants in Havana at the same time as

Trinidad, Sancti Spíritus.

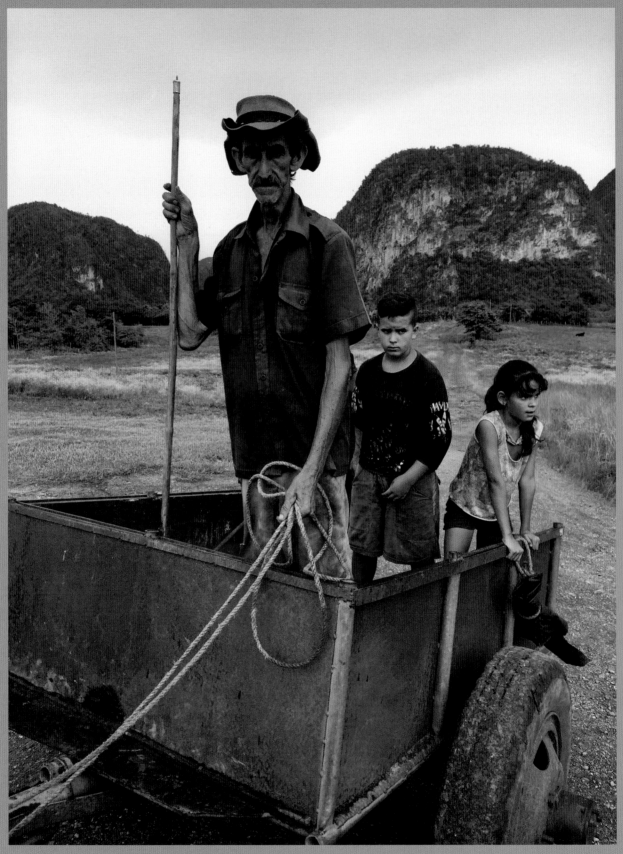

Viñales, Pinar del Río.

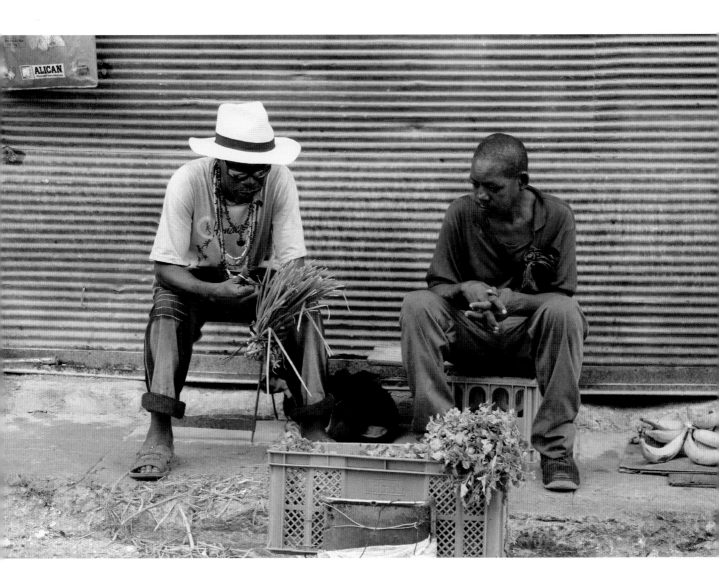

Trinidad, Sancti Spíritus.

it supplies local markets and donates produce to local schools and social institutions. A popular site for agrotourism, the farm uses the biogas it produces on site to cook meals for its workers and its visitors alike. Thinking beyond environmental protection and the production of food, Funes envisions a social and educational program that is able to continue to raise living standards by incorporating even more families into the project and to encourage other farmers to adopt agroecological practices that will allow them to enjoy higher incomes and stay on the land.

Traveling around the Island

Although many imagine Havana when they think of Cuba, over 80 percent of all Cubans live outside of Havana, in smaller cities or rural areas. These Cubans take great pride in the diversity of the island. For habaneros, the countryside is often

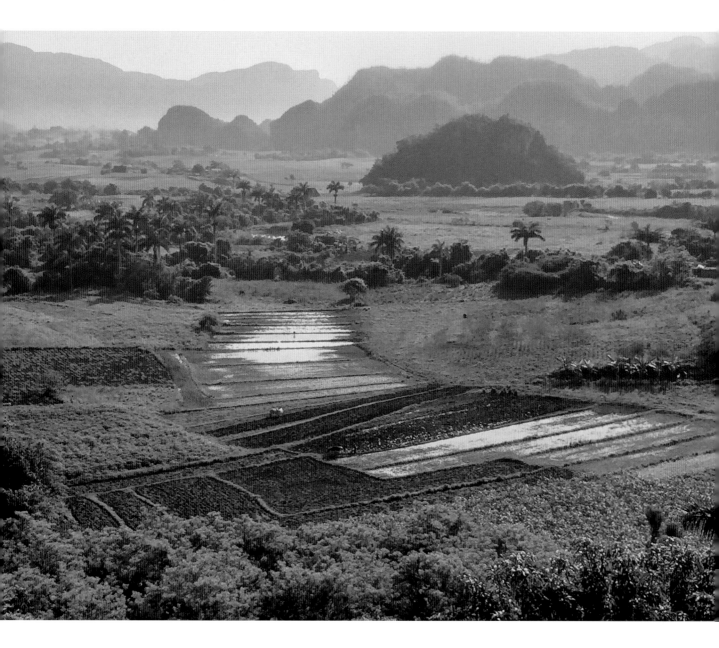

Viñales, Pinar del Río.

associated with the notion of an abundance of food unavailable to most in Havana. Food prices are generally lower than in Havana, and the 23 percent of the population that lives in rural areas enjoys greater access to a wider array of fresh fruits and vegetables and dairy products than do most urban residents.

The country is linked by the *carretera central* (the national highway), built between 1927 and 1931, and expanded in the 1970s to provide work and improve access to more remote areas. The two-lane highway winds its way through the countryside and through the centers of towns and cities as it unites the country from west to east. A more modern divided highway starts in the west and ends abruptly

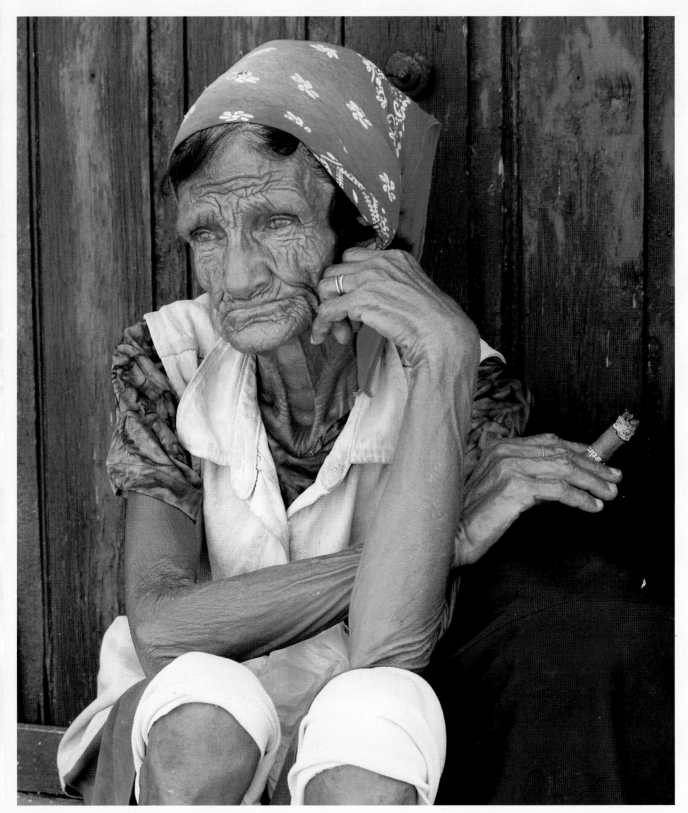

Trinidad, Sancti Spíritus.

in the center of the island, where construction was abandoned at the beginning of the Special Period economic crisis that began in the 1990s.

Found across the island are the ceibas and royal palms, an appetite for *lechón asado* (roasted pig) and a common cuisine, strongly influenced by tastes and ingredients that arrived with immigrants and the slave trade. Local character receives expression in subtle variations in regional foodstuffs. In the eastern reaches of Baracoa, where indigenous influences are strongest, coconut and cacao are more likely to appear in one form or another, and this is the region where dishes are the most likely to carry a trace of *picante* (spice). The countryside offers tourists the promise of new tastes: a glass of fresh-pressed *guarapo* (sugarcane juice) served at the edge of a field of cane, mangos offered straight from the tree by a *guajiro* (small farmer) on a country road, baked *casabe* (cassava bread) sold at a crossroads, a glass of the increasingly difficult-to-find guayabita del pinar (a typical liquor of Pinar del Río), and *cucurucho* (a fruit-and-coconut dessert from Baracoa) peddled in the valley of Yumurí. Fruits and vegetables are sold at small stands, signs advertise *pan con lechón* (bread with pork), and men stand at the side of the road peddling cheese and guayaba paste. Of course, in practice taking advantage of these offers may seem out of reach to both international tourists and Cubans alike, the former enclosed in air-conditioned Havanatur buses on a schedule and the latter challenged by the difficulties posed by the country's public transportation system and a paucity of private vehicles. A recent farm-to-table movement, sparked by agrarian policy reforms which began in 2008, allows travelers to stop for a meal at one of the picturesque farms serving a diversity of foods produced on location, or to dine at restaurants served by farms now permitted to sell directly to them.

New Challenges and Food Security

Despite the deep transformation of agriculture that came about in response to the Special Period, significant challenges remain. Although those involved in Cuba's agroecological movement see small farming as a way for Cuba to achieve food security, or at least to avoid the extreme shortages of the Special Period, tourism is bringing unexpected consequences. The 4.7 million tourists who visited Cuba in 2017 left farmers struggling to meet the rise in demand for food and locals experiencing soaring food prices and complained about the disappearance of such staples of Cuban cuisine as limes, tomatoes, garlic, and pork. While tourism certainly provides a new avenue for economic growth, the increase in visitors creates significant challenges to food security. This becomes evident when listening to a news broadcasts matter-of-factly reporting that the potato harvest will initially go to the tourism sector before arriving at outlets aimed at the public a month later, or when looking over menus at *paladares* catering to tourists, which, despite

routinely being unable to serve many items on any given day, regularly offer diners black-market lobster, shrimp, and other dishes to which most Cubans have no access. This problem is compounded by Cuba's challenging experience in developing wholesale markets to provide the necessary inputs, improve distribution channels, and supply local markets.

Climate change is a significant concern. Tropical storms, hurricanes, heavy rainfalls, and droughts pose a considerable threat to food security and export agriculture. In 2017 Hurricane Irma, the strongest storm to strike Cuba in more than 80 years, dealt a blow to the recovering sugar industry, affecting 338,000 hectares (835,200 acres) of sugarcane and damaging 40 percent of the mills. As a result, Cuba was forced to cancel some sugar exports and even to import sugar from France for its own consumption. Additionally, the hurricane damaged 466 poultry farms and 95,000 hectares (234,750 acres) of various crops. Some of the damaged areas had already been affected by a three-year drought, further impeding Cuba's ability to fulfill domestic food needs. According to the World Food Program, in the last eight years, climate hazards caused more than US$20 billion in losses, with a substantial impact on food availability and price increases.

Despite the setbacks, as stated by the World Food Program, Cuba's "comprehensive social protection programmes have largely focused on ensuring food security and nutrition as a key priority." The Ministry of Agriculture was quick to put in place a recovery action plan, and, as is regularly done after every hurricane, key agricultural centers prioritized short-cycle agricultural crops. While waiting for the first harvests three or four months later, Cubans got by with rations of rice, beans, and other basic foods at low and subsidized prices, some complaining that they had to stand in line for two hours to get a hold of a bunch of *burro* bananas and *macho* plantains at the state agricultural markets. Those lucky enough to live near urban agricultural sites that sold directly to the neighborhood had earlier access to a wider variety of vegetables and foodstuffs than could be found at the larger markets.

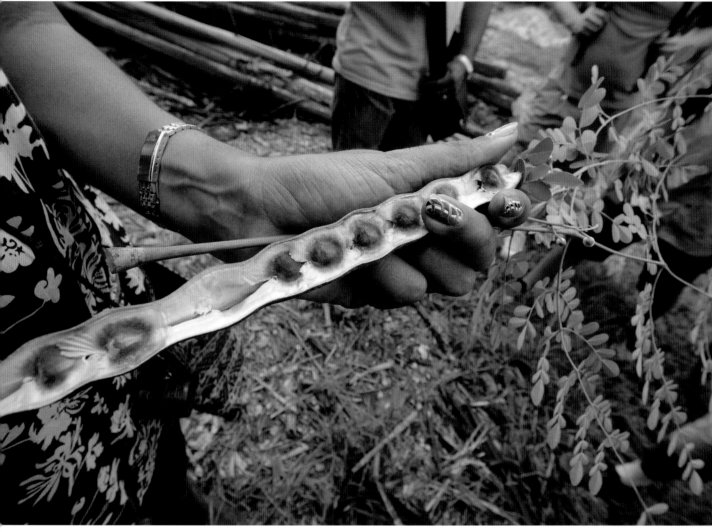

Alamar, Havana.

"This farm was created in 1997 during a very difficult time for Cuba when there was great need to produce foodstuffs. We started with 800 square meters and now we have 11.14 hectares. The majority of the land has been given by the state in usufruct. We are providing for around a thousand families per day: people who come to buy vegetables, medicinal plants, dry condiments, sugar cane juice. In Cuba, we import over 50 percent of our food. The rest is produced nationally, and 70 percent of that is organic. The other 30 percent consists of products that are difficult to produce in Cuba because of climatic conditions, like potatoes, and that thus require certain chemicals. The cooperative also gets revenues from specialized tourism. Every day we receive groups from different parts of the world, but mainly from the U.S., people interested in learning how we produce. There are around seventy-five farms like this one, and one of the policies of the Ministry of Agriculture is to replicate this type of farm all over the country."—Isis María Salcines, 28, Cooperative Organopónico Vivero Alamar

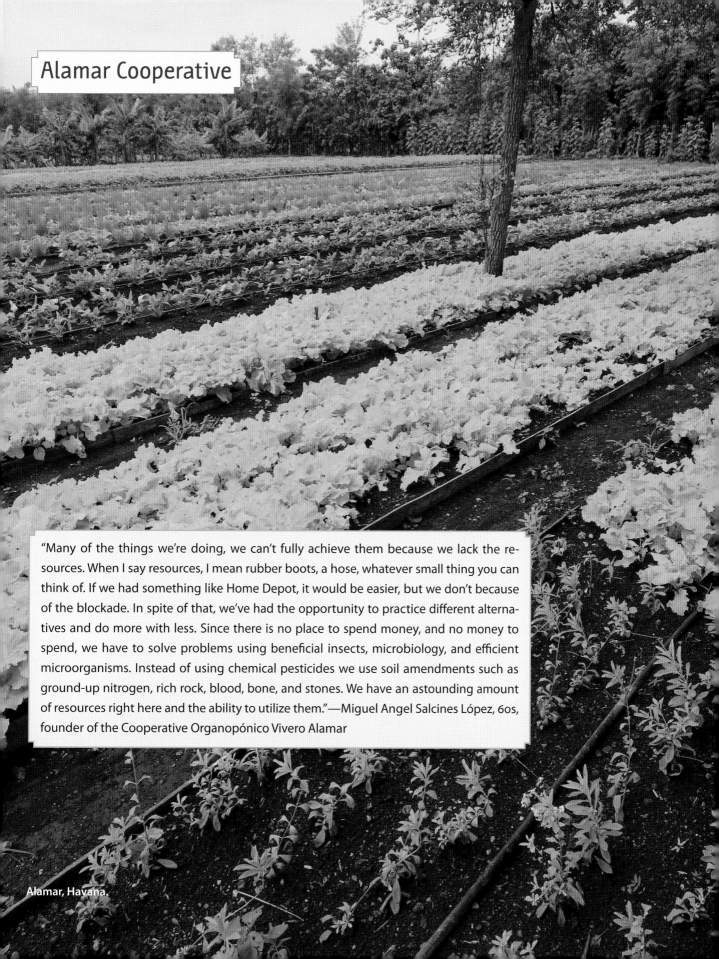

Alamar Cooperative

"Many of the things we're doing, we can't fully achieve them because we lack the resources. When I say resources, I mean rubber boots, a hose, whatever small thing you can think of. If we had something like Home Depot, it would be easier, but we don't because of the blockade. In spite of that, we've had the opportunity to practice different alternatives and do more with less. Since there is no place to spend money, and no money to spend, we have to solve problems using beneficial insects, microbiology, and efficient microorganisms. Instead of using chemical pesticides we use soil amendments such as ground-up nitrogen, rich rock, blood, bone, and stones. We have an astounding amount of resources right here and the ability to utilize them."—Miguel Angel Salcines López, 60s, founder of the Cooperative Organopónico Vivero Alamar

Alamar, Havana.

"This used to be a sugar-exporting country. We produced I don't know how many tons of sugar during the harvest. There came the time, however, when Cuba had to import sugar. A country full of productive lands that has to import rice, beans, and I don't know how many other things." —Jorge Martínez Álvarez, 56, musician and electronic engineer

Urban farming.

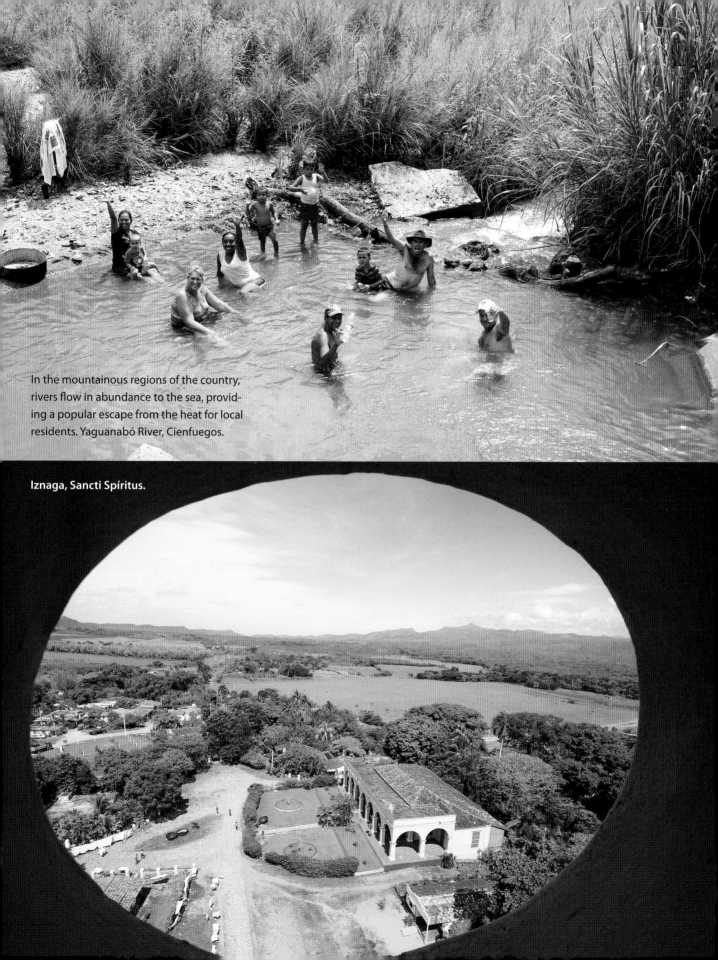

In the mountainous regions of the country, rivers flow in abundance to the sea, providing a popular escape from the heat for local residents. Yaguanabó River, Cienfuegos.

Iznaga, Sancti Spíritus.

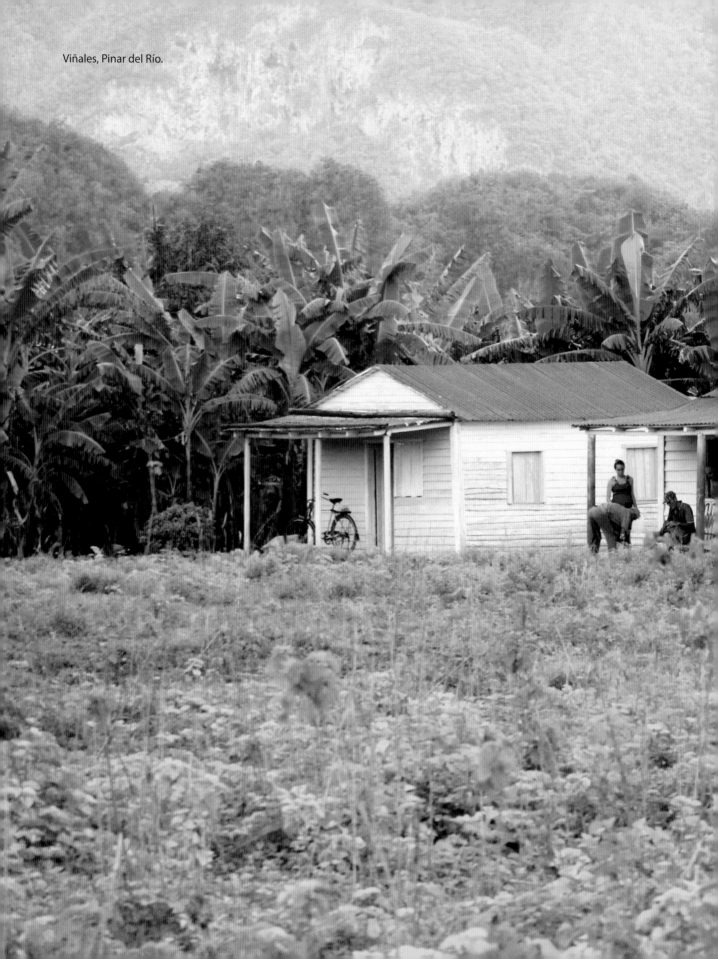

Viñales, Pinar del Río.

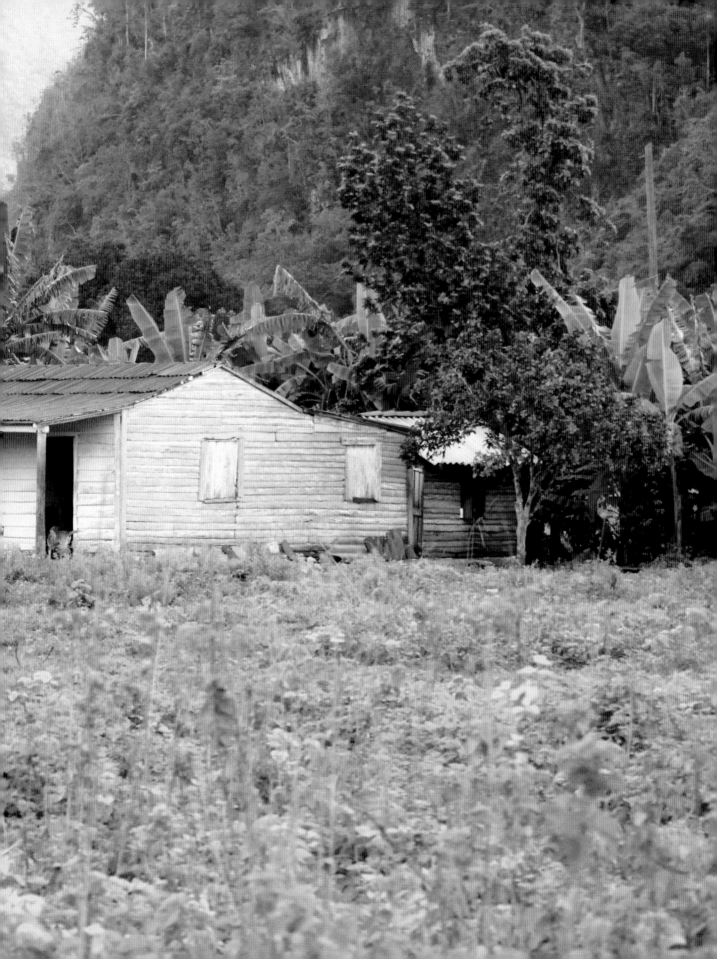

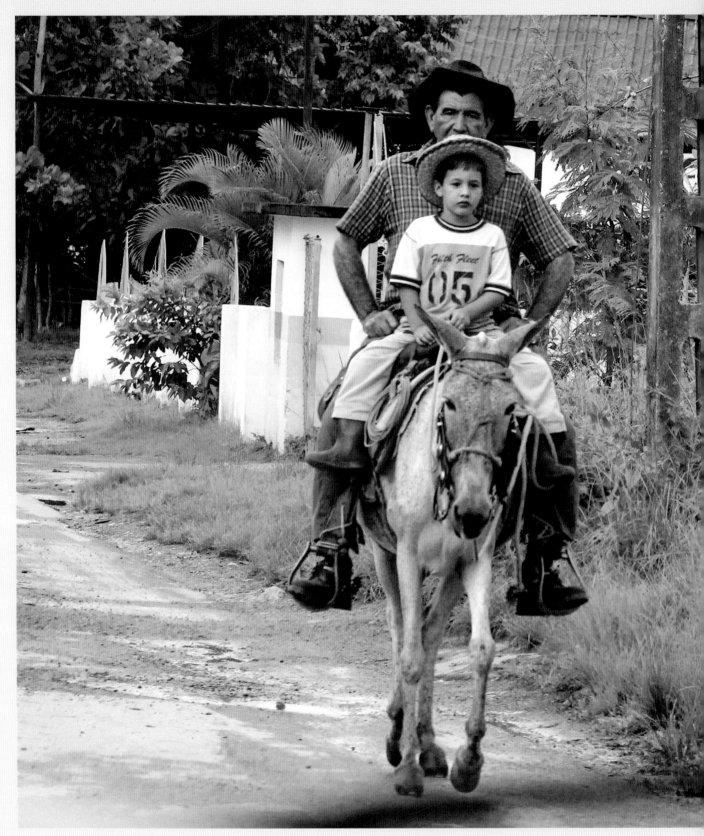

Viñales, Pinar del Río.

Playa Larga, Matanzas.

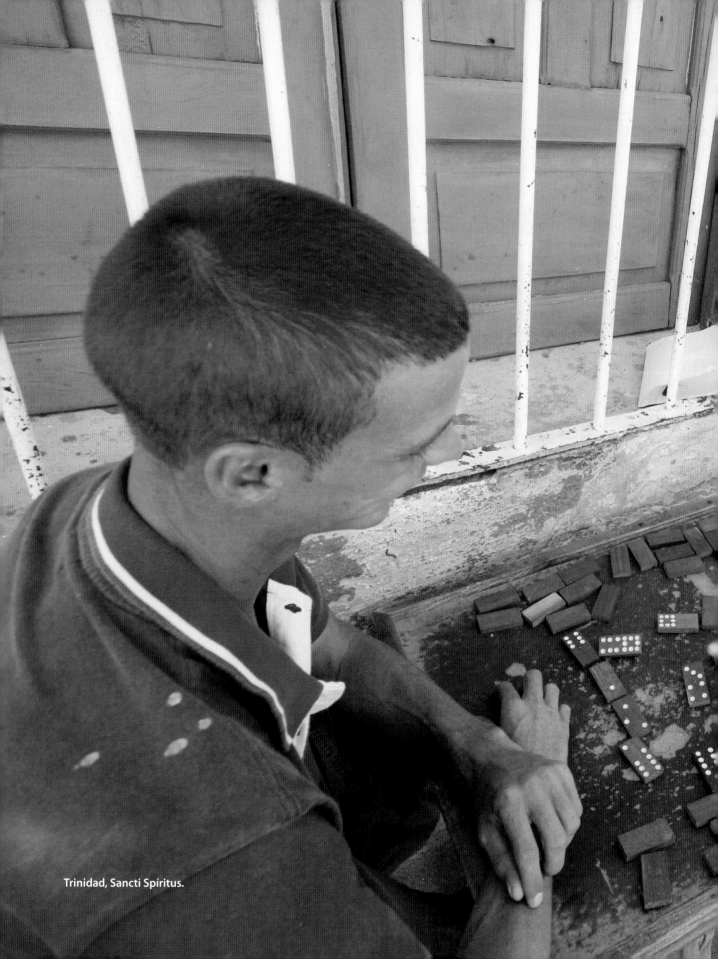

Trinidad, Sancti Spíritus.

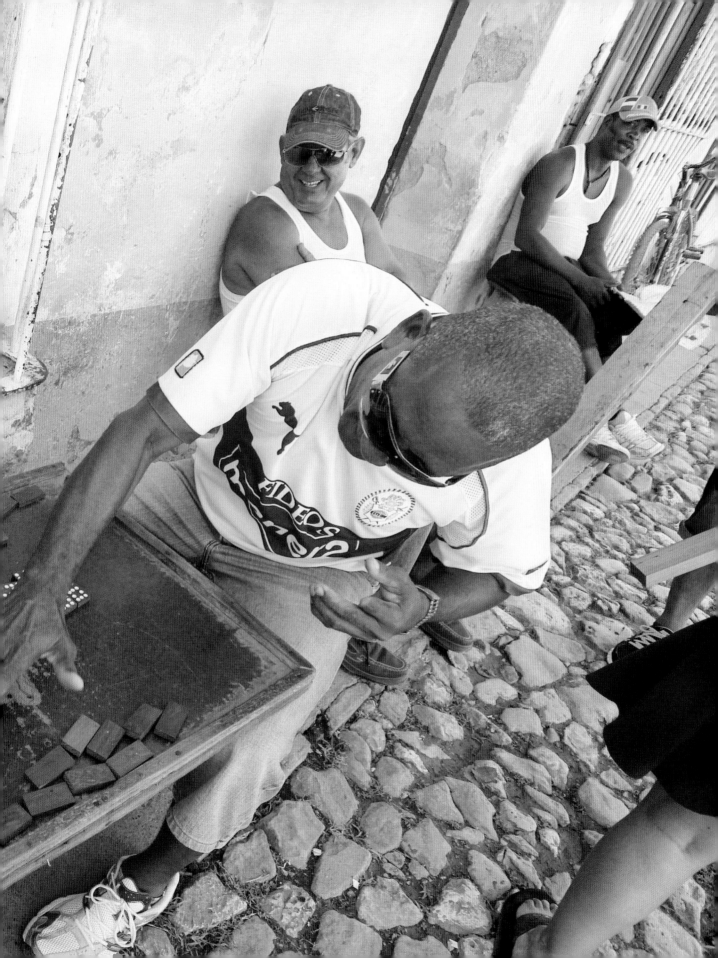

Sancti Spíritus.

"We would never trade our life here in the countryside for life in the city. Here we have food in our front yard and in the waters all around us. The land gives us what we need, and we take care of her."—Antonio Rosales, 30s, fisherman and farmer

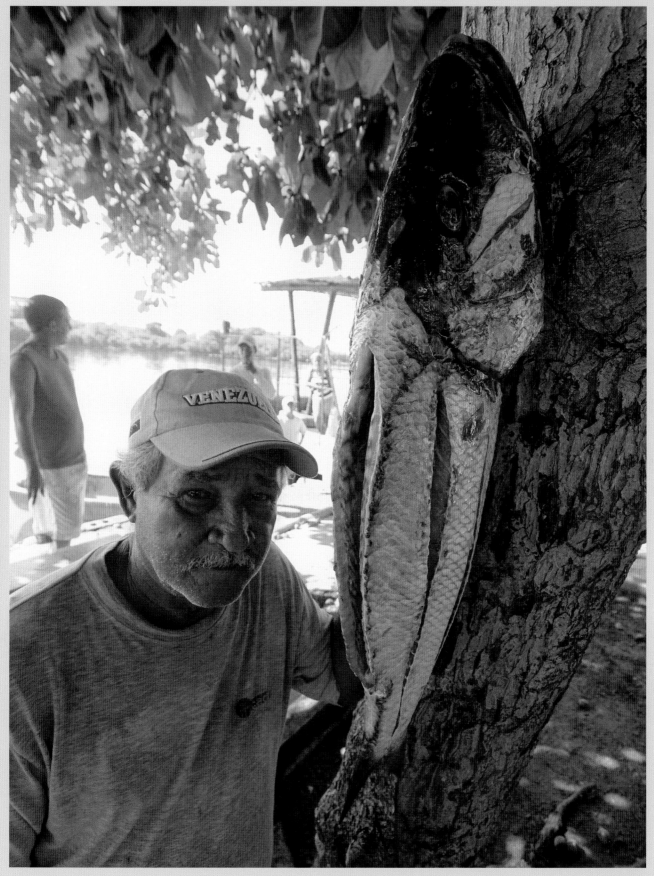

Jagua, Cienfuegos.

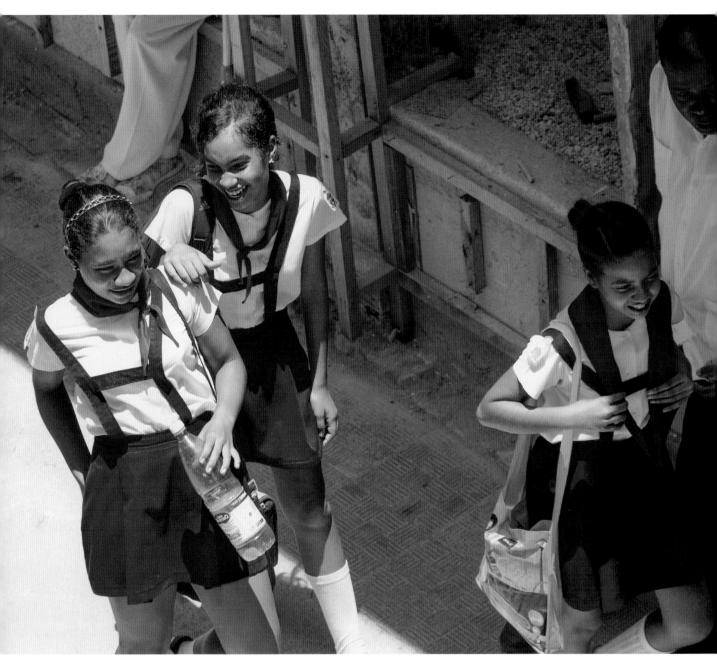

Schoolchildren in Cuba wear identical uniforms throughout the country. The color corresponds to their level of study—red for primary school, mustard for middle school, dark brown for tech school, and navy for pre-university high school. The handkerchiefs around these students' necks signify that they are members of the *pioneros,* the Cuban youth organization.

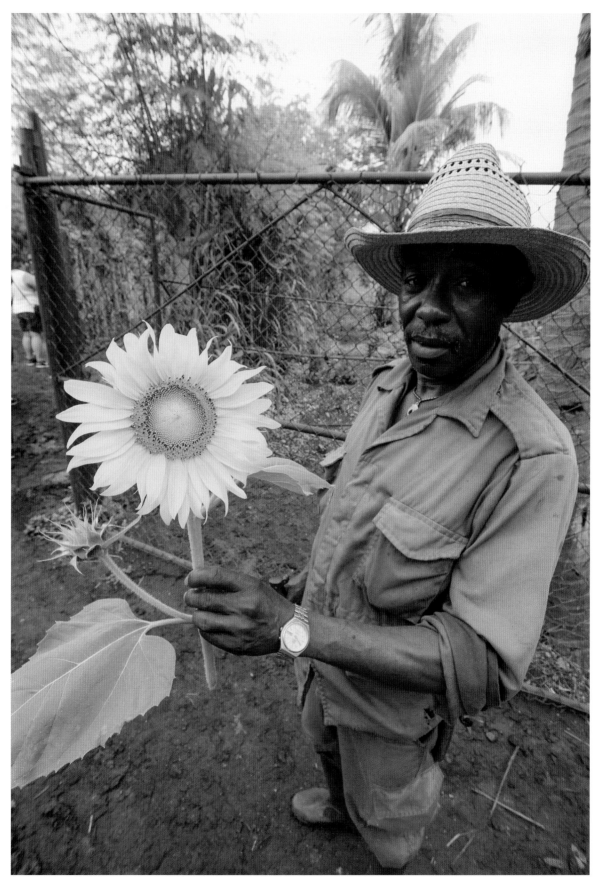

Alamar, Havana.

Traveling around the Island

Occasionally seen in Havana itself, horses become an increasingly important form of transportation as one leaves the capital for the provinces. Central Cuba.

Amarillos (yellow ones) are local officials dressed in mustard yellow. They match hitchhikers traveling from town to town with passing vehicles that have empty seats. This well-established system, instituted by the state, was designed to increase transportation efficiency. Amarillos are seen at major intersections in towns and cities all along the highways. Villa Clara.

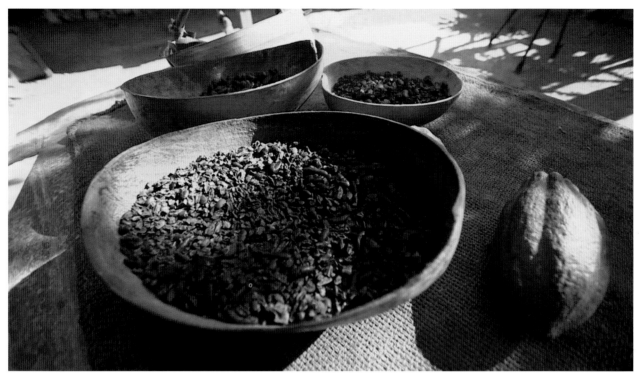

One hundred percent pure cocoa from Baracoa. Baracoa, Guantánamo.

A cucurucho is a delicacy typical of Baracoa. It is shredded coconut, sweetened with sugar or with honey, and people add fruit to the mix like oranges, pineapple, or guava. Guantánamo.

Caridad del Cobre, Santiago de Cuba.

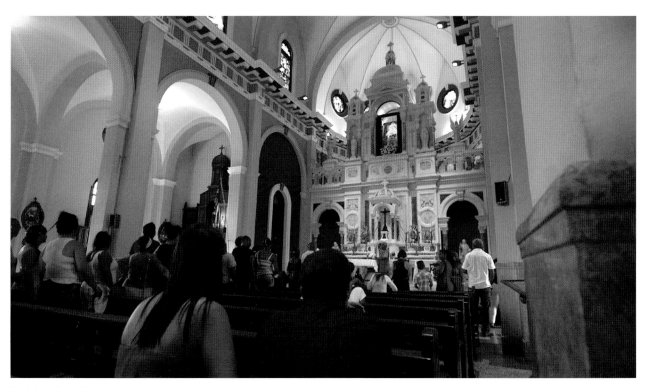

Caridad del Cobre, Santiago de Cuba.

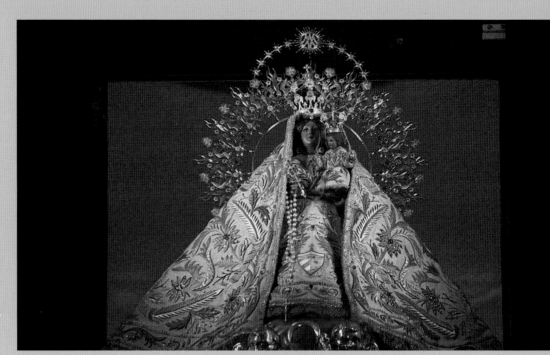

Caridad del Cobre,
Santiago de Cuba.

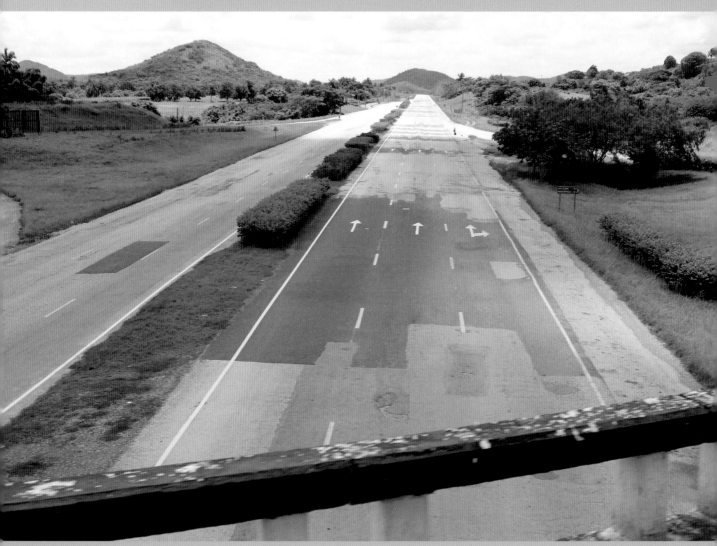

Villa Clara.

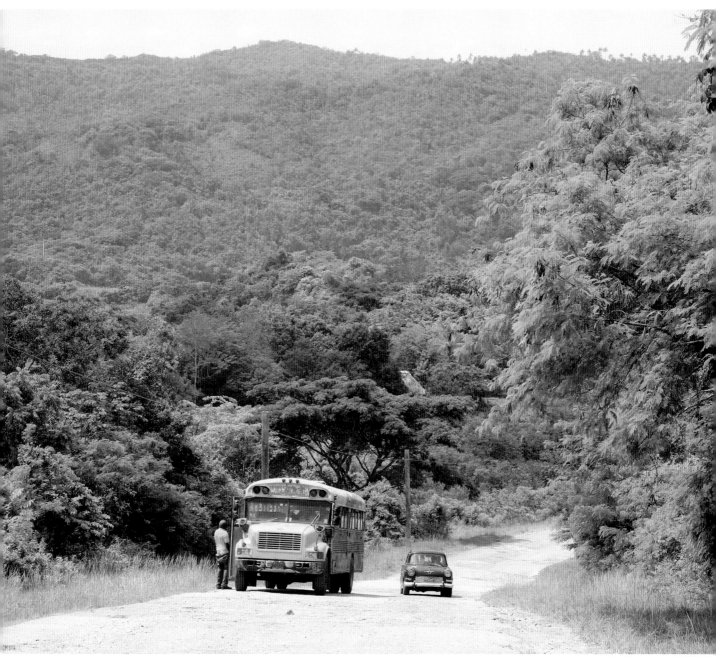

Sancti Spíritus.

"In the 1920s, the United States built a central highway that crossed the length of the island, making it easier to take to port goods produced by U.S. businesses, particularly sugar."—Fernando Martínez Heredia

"A proclamation from the Vatican was issued when a group of officers and veterans of the war of independence who were devoted to the Virgin asked Pope Benedict XV to proclaim Our Lady of Charity of El Cobre as the Patron Saint of Cuba. May 10 we celebrated the centennial of this proclamation."—Rafael Duarte Jiménez, 50s, historian of Santiago de Cuba

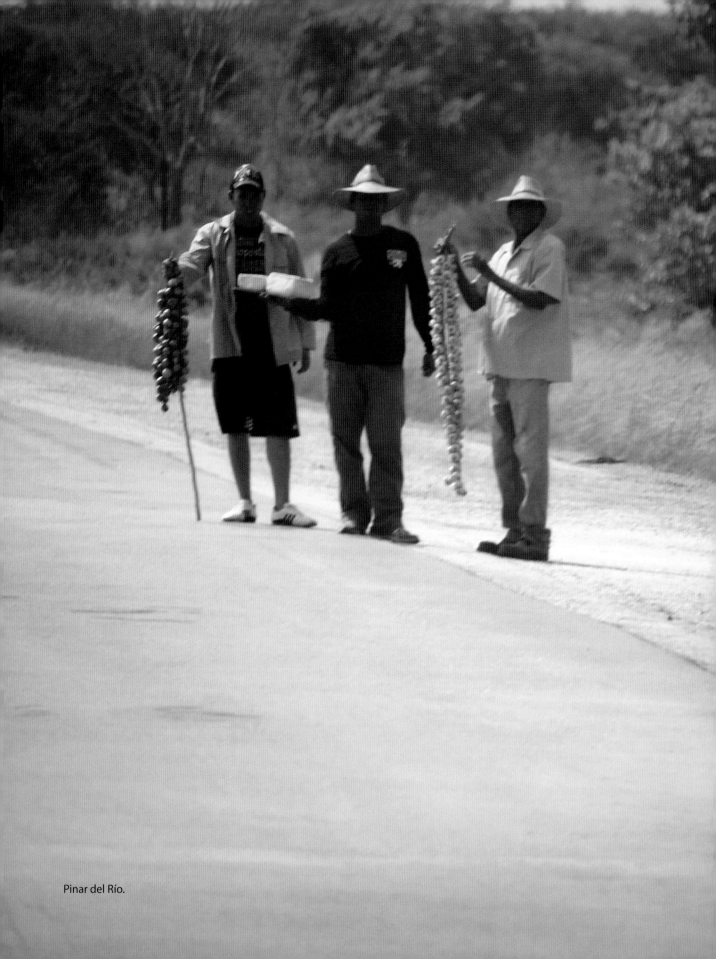

Pinar del Río.

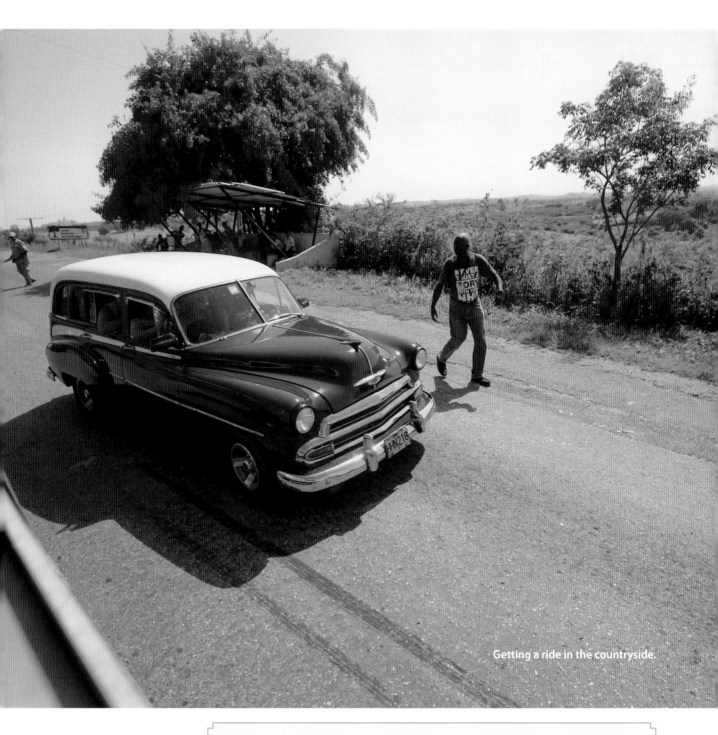

Getting a ride in the countryside.

"I love to travel along the highways. I have traveled a lot, and you see people selling, people helping each other all along the way, people asking for rides all over the place, getting rides on trucks. I, myself, sometimes we would be traveling to the provinces in an empty truck and we would give rides to people without ever charging them, because it is like that, helping, those are the roads in Cuba."—Abel Pérez Álvarez, 33, medical technician

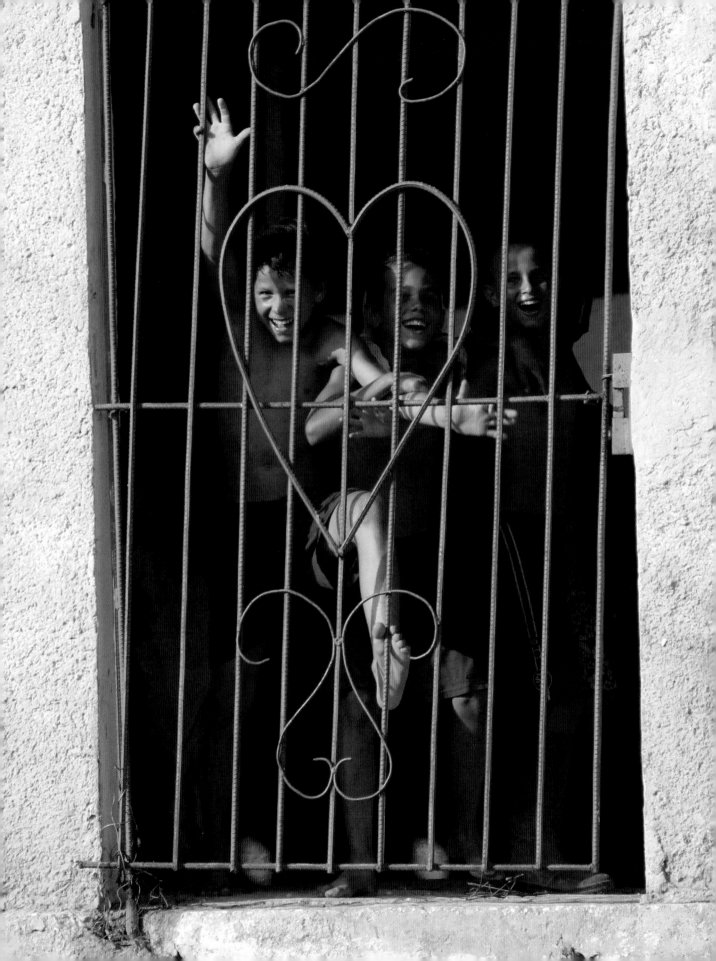

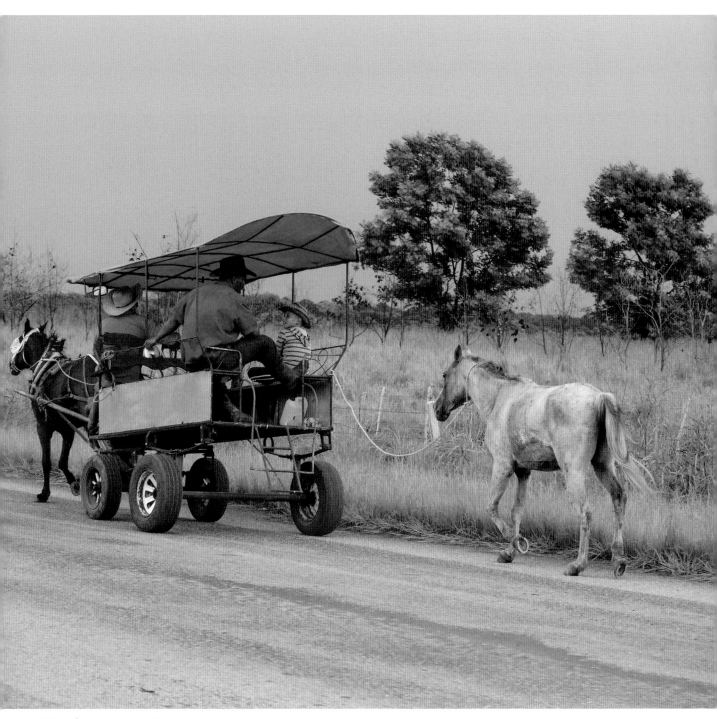

Training the next generation.

Kids looking out.

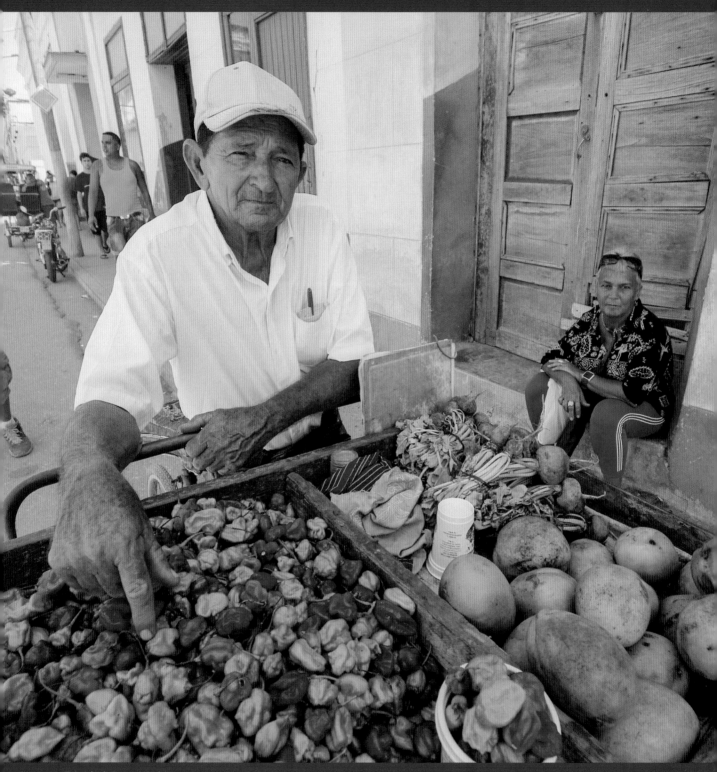

Trinidad, Sancti Spíritus.

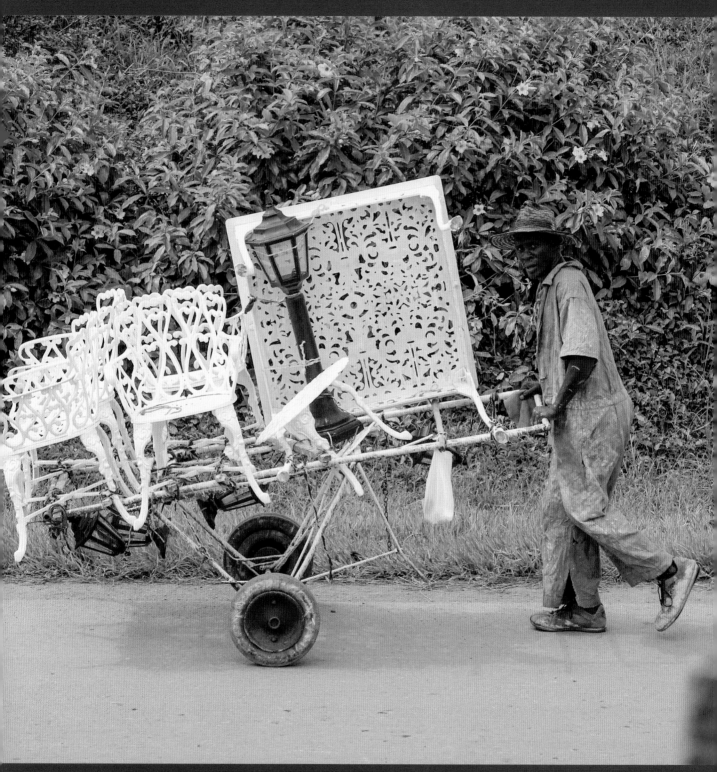

Santiago de Cuba.

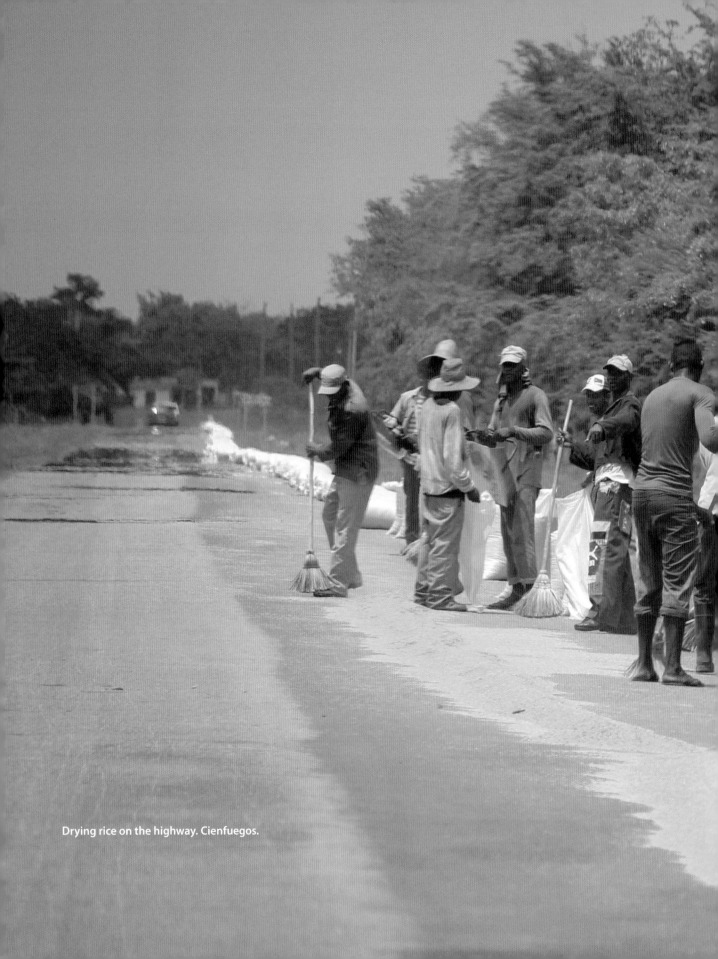

Drying rice on the highway. Cienfuegos.

Playa Larga, Matanzas.

Economy in Flux

The economic battle is today, more than ever, our primary task . . . on it rests the sustainability and the preservation of our social system.

Raúl Castro

Anyone who spends much time at all in Cuba quickly begins to share a sense of being *en la lucha* (the struggle), of searching for ways to *resolver* (resolve) the needs of daily life and manage the vagaries of an ever-changing economic system. Walk down the street carrying eggs or an apple, items that are desirable but difficult to get, and you are likely to feel like a local as passersby ask where you managed to obtain the items. Neighbors quickly share news of deliveries at the corner store or agromercado, alert each other that the water did not arrive that morning to fill the cisterns, or share Oscar-nominated movies from one flash drive to another. Even the system of waiting in lines depends upon collaboration and trust that can make a newcomer momentarily feel like an insider. The latest arrival asks who is *el último* (the last one in line) and then waits for the next arrival. At that point, he or she may decide to mark the place in line before going to sit in the shade across the street.

Everyone understands that their well-being depends upon the economy's success. The nightly national news often leads with stories of cabinet ministers visiting factories, updates on the progress of major harvests and tourist arrivals, reports of international solidarity projects, or the restoration of public spaces. While closely attuned to the changes that the government says are for "*más socialismo*" (more socialism), Cubans are also keenly aware that there is much beyond its control. The U.S. embargo remains in place, and the ways in which it constrains foreign investment and trade with non-U.S. partners receives prominent coverage.

The Special Period

When the Soviet Union dissolved in 1991, the Cuban economy experienced a sharp contraction. The Special Period brought hardship to all aspects of the economy, not just the agricultural sector, as food, transportation, and electricity all became scarce. Although many observers outside the island predicted the collapse

of the Cuban economy, the country adjusted by reaffirming its commitment to education, public health, and international solidarity. Besides deep transformations to the agricultural sector, the country opened the economy to limited foreign investment and a growing tourism sector. The government ran "dollar stores" to capture hard currency from 1993 until 2004, when it closed the stores but imposed a 10 percent tax on U.S. dollars exchanged for Cuban currency. Cubans adapted to the dual currency economy, which is being phased out. For individuals, the peso—called *moneda nacional* or national currency—trades at 24 to 1 CUC, the convertible peso, which is pegged at US$1. Cubans also adapted to the reintroduction of an "apartheid tourism," in which Cubans were banned from hotels catering to foreigners. Along with growing remittances and the expansion of limited small-scale self-employment, this increased tourism reenergized the economy while simultaneously contributing to growing inequalities on the island. As the economy recovered throughout the 1990s, the pace of reform slowed. This pause was soon reinforced by new limits on travel and remittances that were put in place in the early 2000s, during the George W. Bush administration.

In 2006, Fidel Castro faced severe health problems that caused him to take a leave from the presidency; his brother Raúl Castro stepped into his place as acting president. Two years later, Raúl officially assumed the post of president. Initial reforms that year permitted Cubans to enter hotels previously reserved for foreigners, expanded the range of imported goods available for local consumption, and made cell phone service, although expensive, generally available.

In an effort to reduce dependence on the state, new avenues for self-employment opened, and small businesses were able to hire employees outside of their immediate families and expand their operations. The government expanded the list of permitted activities for small businesses and the self-employed. Urban landscapes changed dramatically as many Cubans took advantage of porches, driveways, and front rooms to establish cafeterias, CD stores, and barbershops, and to offer services repairing shoes, fixing cell phones, refilling lighters, or cleaning spark plugs. A network of storefronts offering to fill memory sticks with that week's latest films, documentaries, TV, literature and news from around the world sprang up, delivering the latest Netflix series before even the most addicted U.S. viewer could have made it through the season's episodes. Small government loans, construction cooperatives and brigades, and new markets permitted Cubans to repair and expand their homes, and their newly painted facades brightened streets in some neighborhoods. Together with the increased remittances, disposable income from these businesses and new consumption opportunities allowed Cubans to express their sense of fashion more freely, further changing streetscapes in towns across the island.

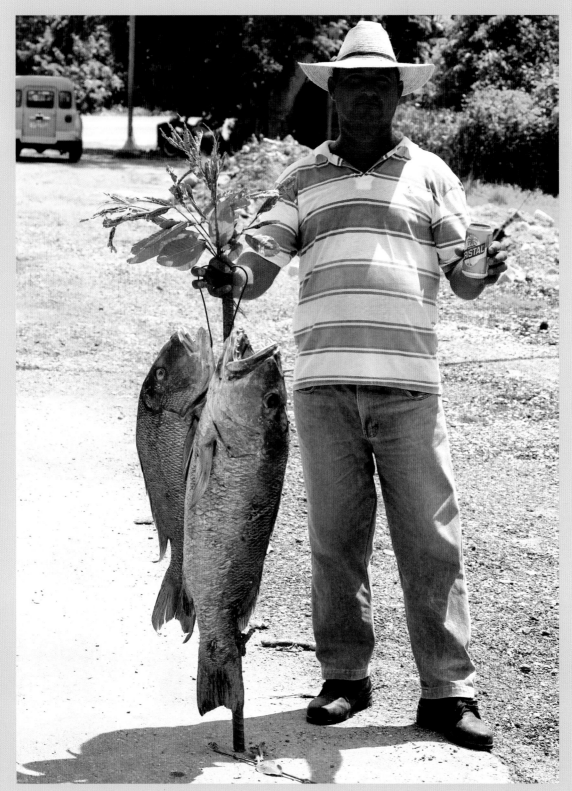

Playa Larga, Matanzas.

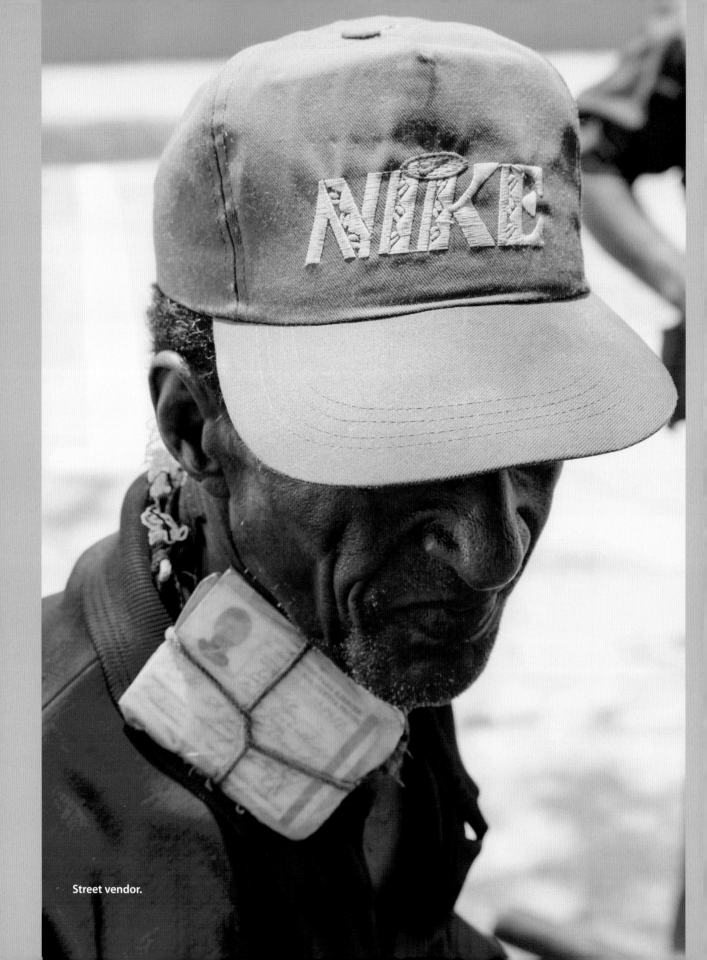

Street vendor.

The reforms continue to transform the economy. After a year of open discussion in workplaces and mass organizations around the country, the government announced the new *lineamientos* (guidelines) which were to shape the economic changes over the coming decades. The guidelines aimed to raise living standards while strengthening the socialist economy. In the midst of the changes, individuals considered the future of the economy. As one state worker confirmed, "Today we discuss culturally what socialism should be, but what we are discussing, really, is if we continue to be socialist or if we go back to capitalism. As you can probably tell, I belong to that enormous part of the Cuban people who know that we would not have much to gain, but a lot to lose, if we went back to capitalism; we would lose our national sovereignty."

Tourism

During Prohibition in the United State, Cuba became a favorite destination of U.S. visitors, bartenders, and investors. During the 1950s, the tourism industry in Cuba was closely associated with gambling, drugs, prostitution, and the U.S. mafia, which owned large hotel casinos in Havana. Taking on these symbols of decadence and corruption, the revolutionary government quickly closed the casinos and many of the bars. By 1960 the revolutionary government had nationalized the largest hotels. U.S. tourism and, for a long time, the Cuban state remained ambivalent about the international tourism sector. It was not until the crisis of the Special Period and the collapse of the sugar industry that Cuba turned to tourism to reinvigorate its economy, excluding Cubans from hotels catering to foreigners. Tourism is now one of the top sources of revenue and foreign exchange, and an important source of employment; visitors and revenues are expected to more than triple between 2015 and 2030.

As Cuba became a "trophy destination," the number of tourists visiting the country broke records in consecutive years. Tourism has become increasingly critical as a source of foreign exchange, particularly for the growing private sector dominated by restaurants, beds-and-breakfasts, and transportation services aimed at tourists. Since the revolution, Canadians have made up the largest percentage of tourists to Cuba, with visitors from Western Europe ranked second. Travel from the United States has increased, but Cuban-Americans born in Cuba are not counted in official tourism figures and are generally required to travel on Cuban passports.

Many tourists are isolated in the all-inclusive resorts located along the powder-soft beaches of the Varadero peninsula and the chains of islands along the northern coast. While beaches are public in Cuba and a "social" domestic tourism industry existed, Cubans were unable to access these luxury hotels until 2008, when

Raúl Castro eliminated the prohibition on Cubans staying in hotels that catered to foreigners. This was initially more of a symbolic gesture, as most local Cubans could not afford the high price of these hotels. However, Cubans are increasingly frequenting these resorts as visits from relatives outside the country have grown and some Cubans have benefitted from the economic reforms. A more common avenue for locals is through day trips on buses or trucks adapted to carry passengers, which gather a short distance down the beach from the resort amenities.

Increasingly, travelers venture beyond the renowned beaches of the island as the state tries to attract tourists to less-visited areas. The state has invested heavily in the restoration of urban centers outside of Havana, repairing the historic cores of the 500-year old cities of Camagüey, Santiago de Cuba, Trinidad, Sancti Spíritus, Baracoa, and Bayamo. Tourists have also been drawn to the natural landscapes of Viñales and Baracoa, and many foreigners are exploring "people-to-people" tourism, in part due to the group travel encouraged by the U.S. restrictions. Three key tourism areas promoted by the government are medical/health tourism, ecotourism, and cruises. The health sector is a growing source of revenue, as travelers take advantage of the health care infrastructure and treatments developed in Cuba in facilities designed to serve the foreign market. The natural wonders of Cuba are a prime attraction as well, and Ecotour offers trips that include kayaking, birdwatching and horseback riding in protected natural areas. In Varadero and elsewhere the newer hotels are set back from the coast to protect the shoreline and encourage sustainable development. With 20 percent of its surface area set aside in protected areas, Cuba has some of the most pristine coral reefs in the Caribbean, with hundreds of endemic species that attract divers throughout the year.

The increase in tourism has had unintended consequences, however. New businesses have crowded into the tourism sector. For example, privately owned restaurants, or *paladares,* and cafeterias have been an important part of the growing tourism industry, and one of the fastest-growing niches in the private sector. Habaneros complain about increased food prices and food shortages, as the economy struggles to meet demand. Without a wholesale market to turn to for their supplies, *cuentapropistas* clear the shelves. Goods have become harder to find for the average shopper, as restaurants hire "buyers" to make the rounds of stores to secure needed items. An expanded tourism sector has also exacerbated income inequalities that had already been growing along with remittances. In 2017 the government closed some restaurants and put a temporary freeze on new licenses for *casas particulares* and paladares, among other businesses, as it worked to "perfect" the regulatory framework. While Cubans talk about the importance of tourism in casual conversation, the broader impact of tourism should not be overestimated. Visitors increasingly mingle with Cubans across the island, but change comes in starts and stops and is unevenly distributed.

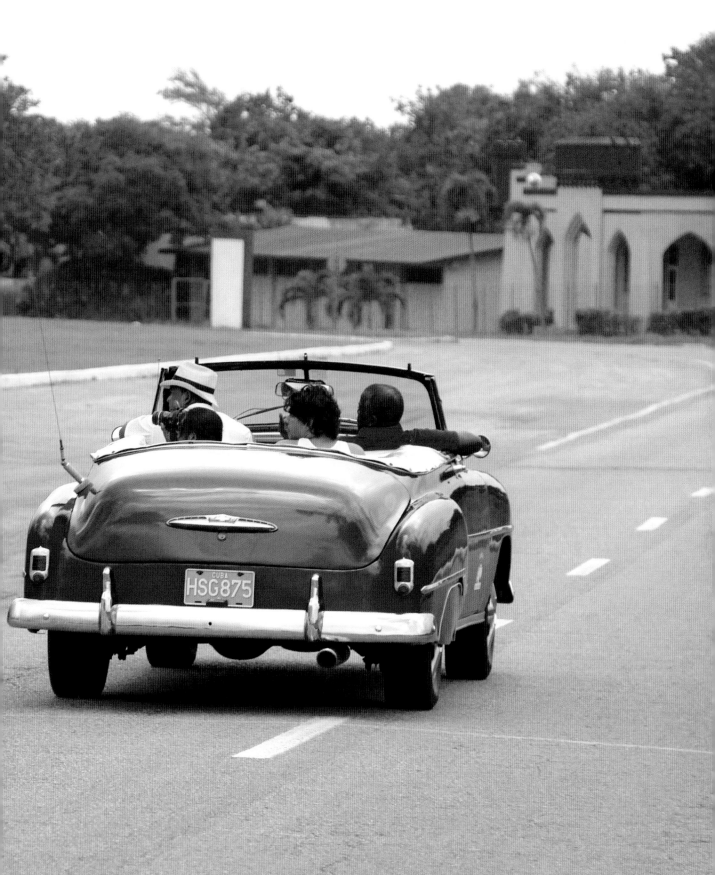
La Cabaña, Havana.

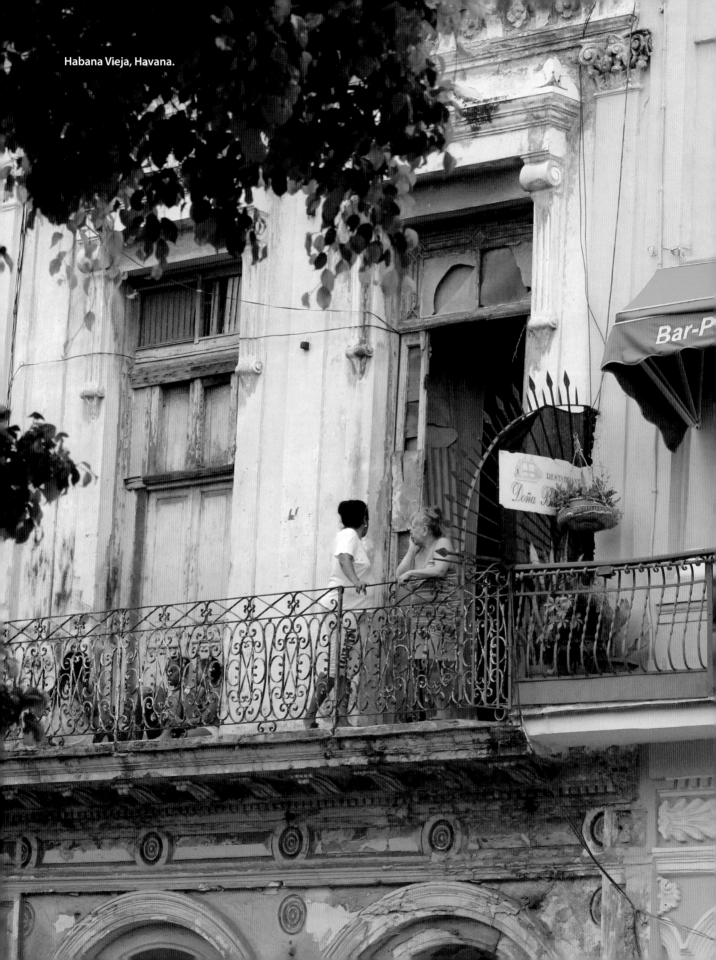

Habana Vieja, Havana.

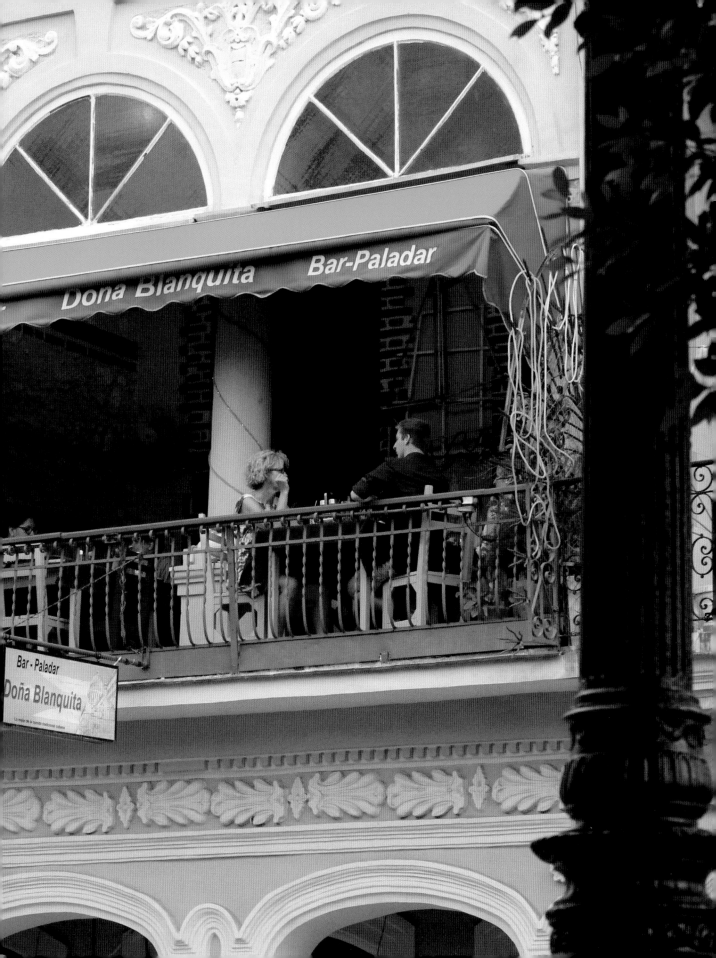

Santiago de Cuba, Santiago de Cuba.

Ernest Hemingway's relationship with Fidel Castro
and the revolution is often a subject of speculation,
but the Hemingway circuit is a popular one with
tourists of diverse nationalities.

Mojitos.

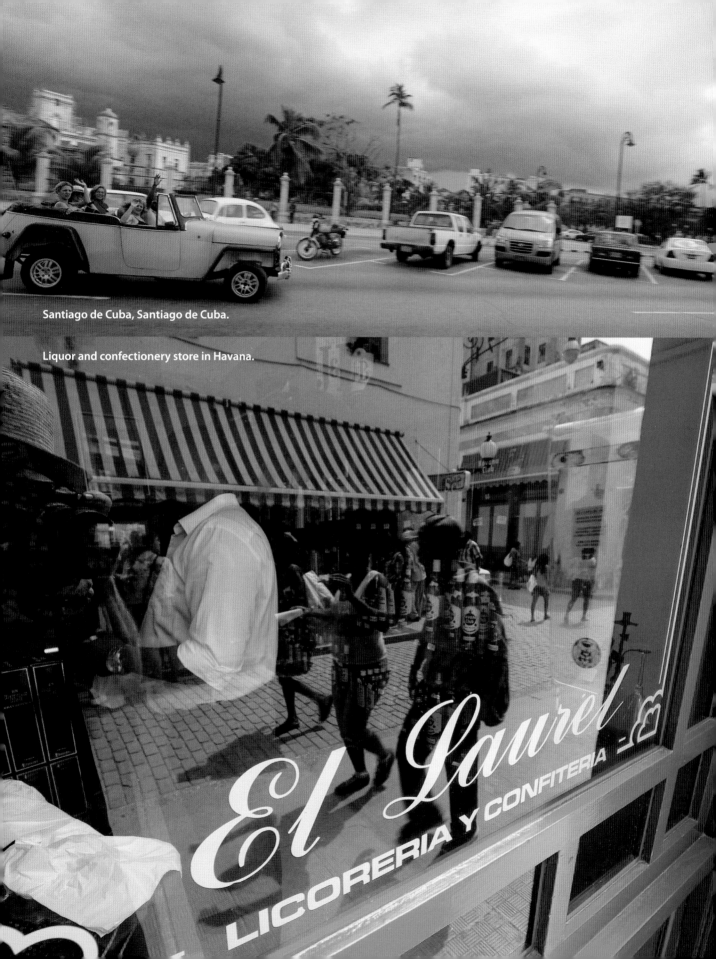

Santiago de Cuba, Santiago de Cuba.

Liquor and confectionery store in Havana.

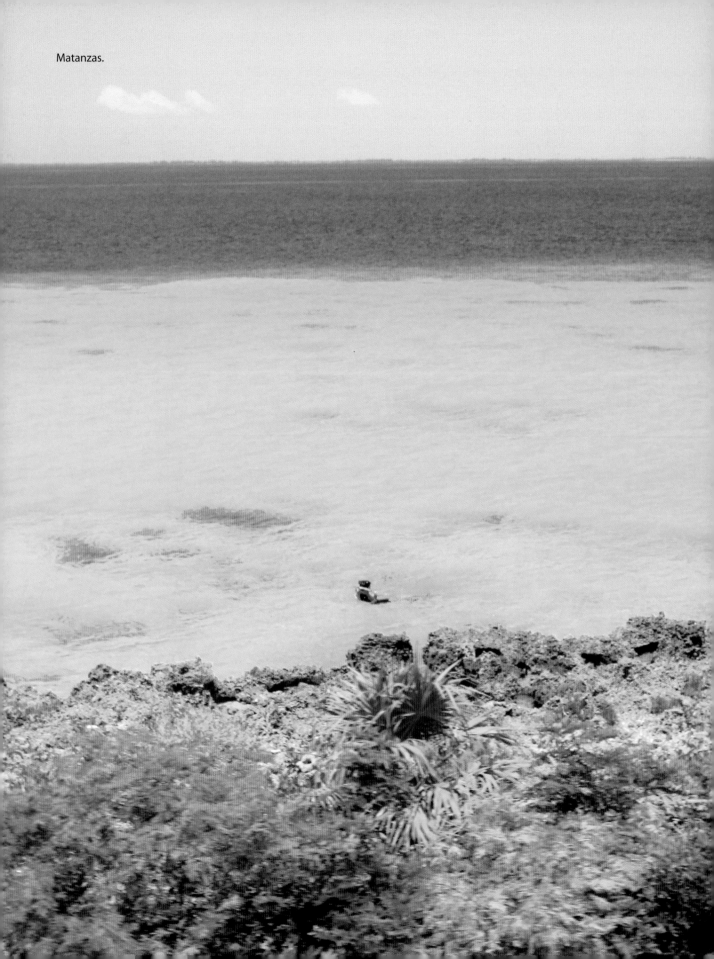

Matanzas.

Near Varadero, Matanzas.

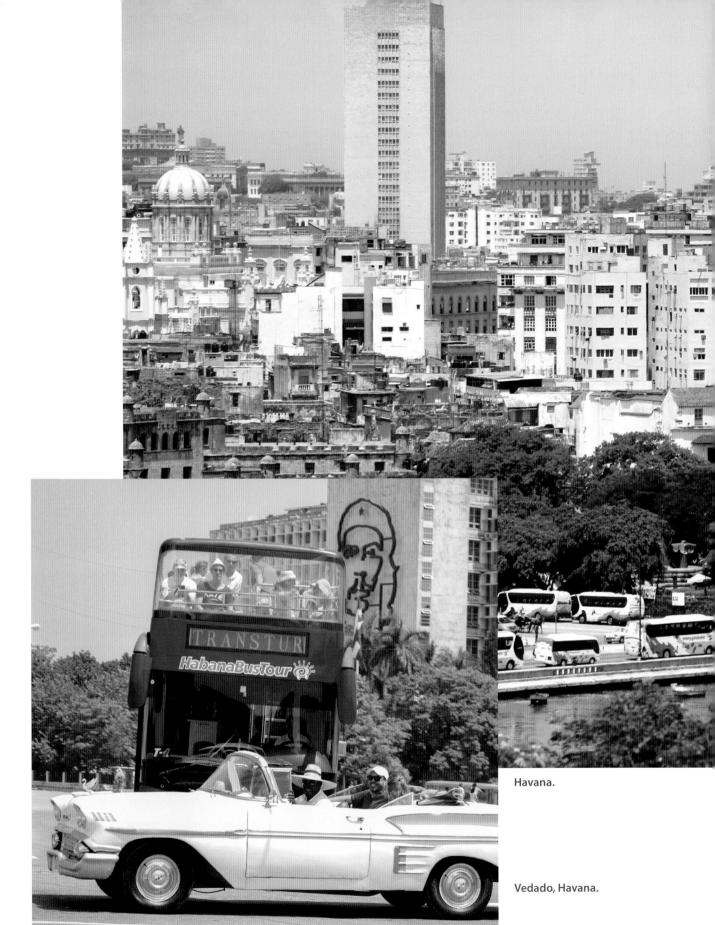

Havana.

Vedado, Havana.

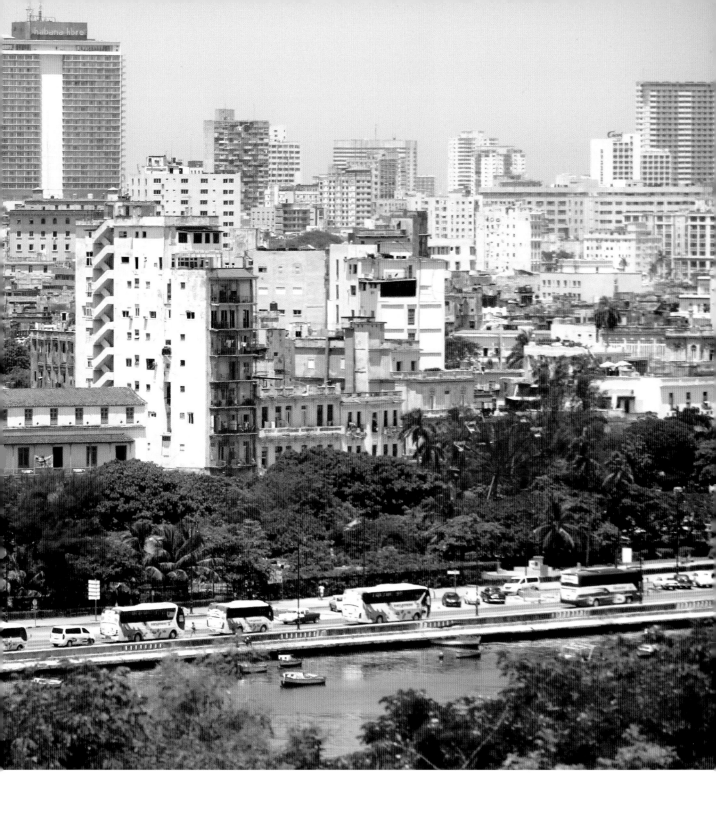

Habana Vieja, Havana.

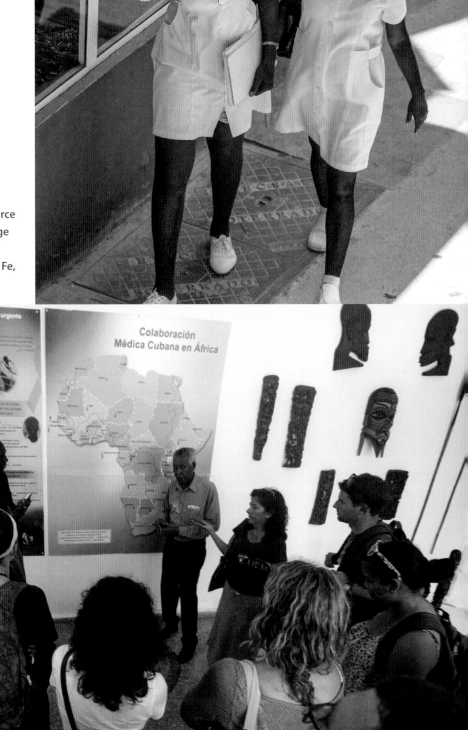

Medical tourism is also a growing source of revenue, as travelers take advantage of the health care infrastructure and treatments developed in Cuba. Santa Fe, Havana.

Trinidad, Sancti Spíritus.

"We are living a period of change in Cuba, a new opening to private businesses, and certainly, the cuentapro-pistas have proliferated. It's an alternative that is not bad because, really, the state cannot shoulder that aspect of life completely. It also helps to maintain creativity and the constant Cuban inventiveness, right? Because to be able to maintain those businesses, you have to be really creative, because in Cuba we don't have a sustain-able material base for that type of businesses. So you have to look for hundreds of variants in order to create a business that is profitable and lasting."—Mayra María García, 50, record producer

"Small businesses are not going to save the economy of this country. They will save the individual economy of households, but not the country's economy."—Anonymous, 52, high school teacher

Caffeine fix.

A day's wages.

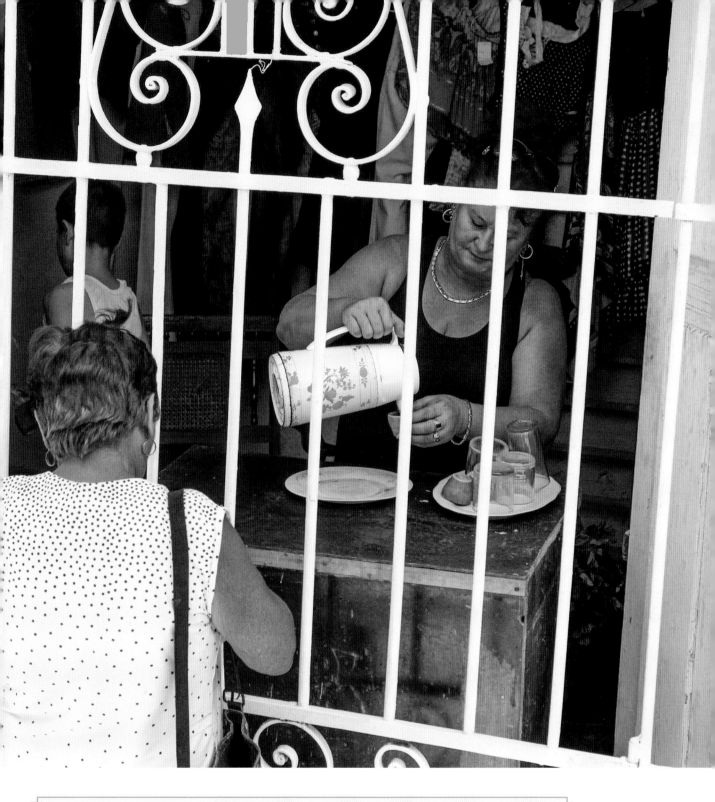

"Cuentapropistas? I can tell you that opening up is a good thing. I can also tell you that that is not the way out of the problems. That is just starting, and I can't tell you what will happen because that is not history yet, it is just starting."—Camilo Miranda Álvarez, 23, philosophy student

"Capitalism doesn't really tell me anything. I believe in a hybrid regime. I think that socialism has a lot of great things, and there are parts of socialism that I defend and that I consider non-negotiable. For example, education and health care are universal rights. One of the principles of socialism that I admire is that no one should profit from medicine; that is just horrible. I believe doctors, nurses, researchers should earn well, but I don't agree with the profits made by the great pharmaceutical companies. But capitalism also has it good side, and we need to apply what is positive about it and become a hybrid nation." —Frank Delgado, 53, musician

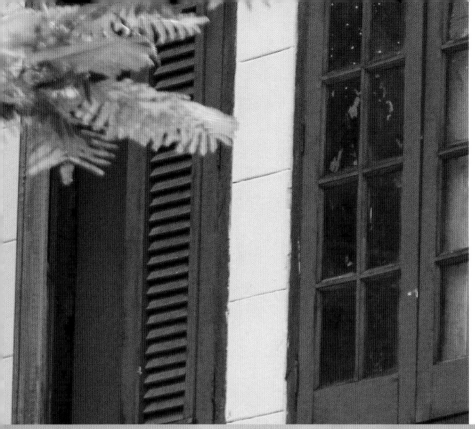

One of the largest supermarkets in Havana. In the 1990s it was a *diplotienda,* or "diplomatic store," open only to foreigners with dollars. The Russian Embassy is in the background. Playa, Havana.

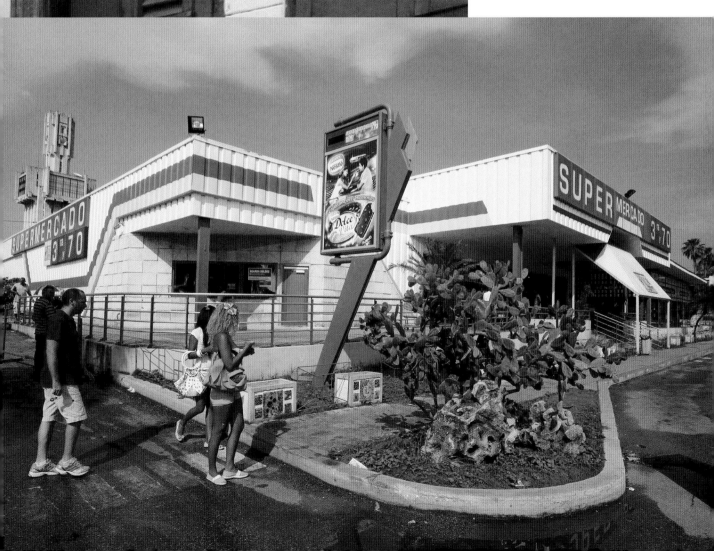

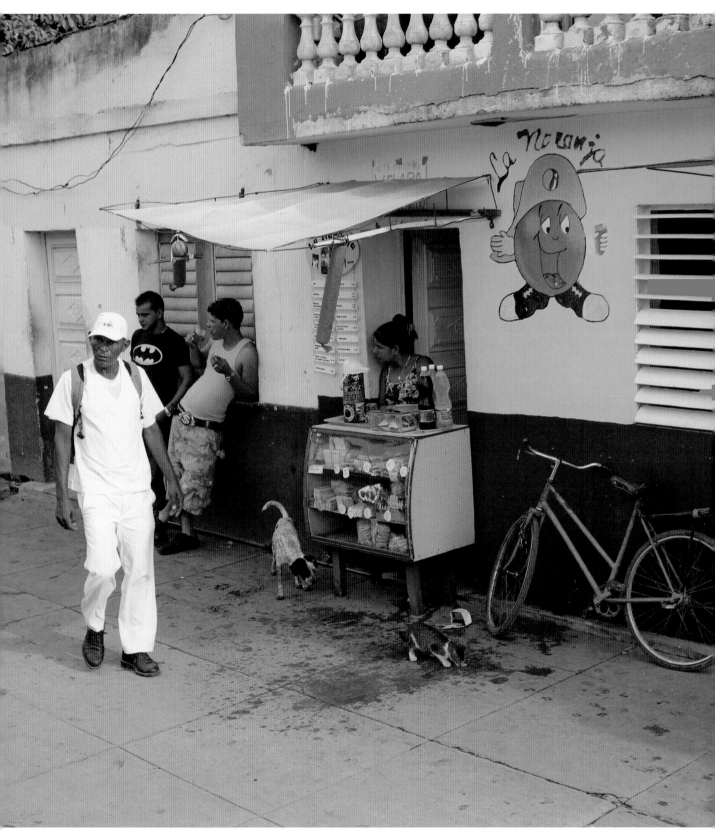

Santa Clara, Villa Clara.

"There are a lot of people now who don't want to work for the state because you can't live on a state salary, so people have to look for alternatives. A lot of professionals are leaving the state and moving into the private sector, sometimes to do things that have nothing to do with their training, and that is not the way . . . the pyramid is inverted. A person with a high level of education working for the state earns one-third of what a person who has a private business earns. That doesn't correspond to the contribution of the person in the state sector."—Estrella Álvarez Varela, 52, computer mathematician

DVDs for sale.

Heading home.

The Revolution Is Not Over

To those who do not live in Cuba, about Cuba I would like to tell them first of all, that they must let us find our own our path. To look at us, not in the mysterious and questioning way that they always look at us, but to let us find our own path, to let us greet them, show them how we live, who we are, let us communicate in our own terms. That's all.

MAYRA MARÍA GARCÍA, 50, RECORD PRODUCER

The Revolution across the Generations

There are important generational differences in how the revolution is understood and lived. Many who fought in the revolution continue to speak with pride and have a profound sense of accomplishment. Such is the case of Adolfo, a barber in Habana Vieja in his 70s. He remembers with a sense of nostalgia the days of the revolution: "I was a teenager and before 1959 we were living in a dreadful tyranny, a lot of young people were assassinated everywhere. Every day twenty to thirty corpses were found, shot to death, and that made us reject the [Batista] regime. Our conversations always had to do with the same [thing]: today they murdered and tortured so-and-so. And the jails were full of young prisoners. I was at Lomas de Escambray when Fidel sent Che and Camilo to support the insurrection at the center of the island in Villa Clara. My mom used to cry and would ask us to be careful, but she never told us not to fight. In December 1958, the city was taken and the tyrant ran away on January 1, 1959. My life took a 180-degree turn. Up until then, the poor, who were the majority, were born poor and died poor. The first thing that happened after the triumph of the revolution were the literacy campaigns, and the whole country became literate. My level of education was really low, so I became literate then. My kids have it easy now that they have been able to study. But they are not satisfied with having guaranteed education. They want more."

For many who were born after the revolution but grew up during the revolutionary reforms, there is a deeply ingrained sense of ownership of the revolutionary process, as well as some skepticism. As Boris Martin, a historian in his 30s, said: "The revolution continues to exist today as part of our habitus in perhaps a

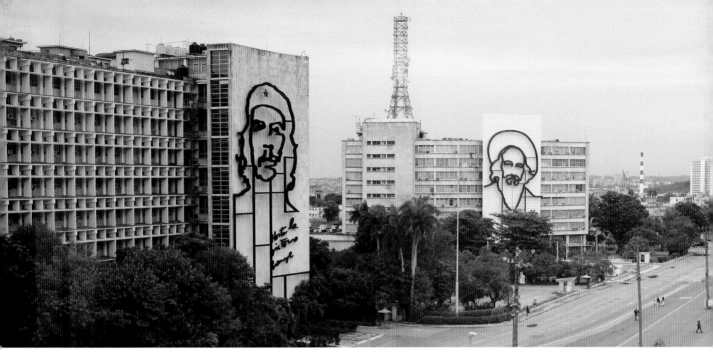

Fervor for the revolution varies not just by generation, but by geography; the farther east on the island one goes, the stronger the support for the revolution. Regardless of generation or region, however, the revolution is very much alive, as evidenced by Cubans' frequent references to it in thanks for housing, jobs, education, health, and many other benefits. Vedado, Havana.

strange and complex way. The fact is that we still have a revolutionary mentality, and by that I mean that we think to the left. We value being human, being ethical, helping others more than economic principles such as capital gains, or business, or consumerism. That is the way that the revolution is still lived, fortunately. We also know that it is in our common interest to move in the same direction so the revolution can continue to teach us. It could take a turn toward a left that is softer, more mature, and more democratic. I think that the moment that we Cubans feel part of this revolution, as participants and not as simple spectators, [will be the moment when] the revolution will teach us even more. The future is almost always uncertain [laughs]. Our future will depend on the decisions that we make today, and I won't try to guess."

Others have grown tired of the revolutionary rhetoric, like Mariana, a nurse in her late 40s who lives in Havana: "It's been a while since the revolution stopped having any significance for the majority of the people. Revolution implies changes and renewal, and we are at a standstill. Maybe now we can start talking about revolution again, if structural changes are really made, changes that the country needs in order not to continue dying slowly, which is what has happened up to now."

For many millennials, the revolution at times seems old. They want to move on, go beyond it and create a new paradigm. Their vision is different in a way that perhaps takes for granted the social gains of the revolution. Most of these millennials would say that they do not want capitalism, but they know that they want something more than the possibilities that they see in front of them. Indeed, among those who have left in recent times, those unachieved goals and what has remained beyond the reach of the revolution were often the impetus for their departure. As

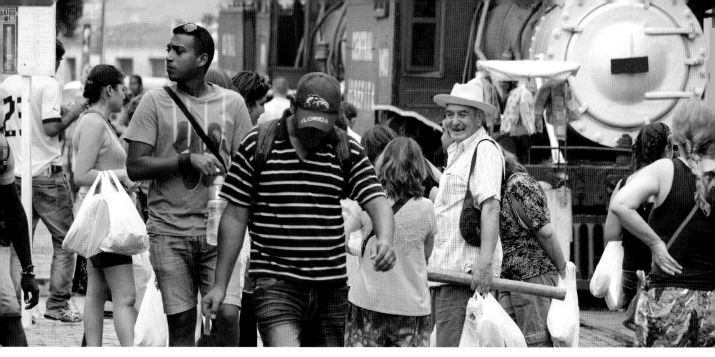

one habanero said as he was selling his belongings to prepare for the move, "If this were socialism, it would be a paradise."

Jorge Luis Baños Hernández, a 40-year-old photojournalist, broadly summarizes generational differences: "Our grandparents' and our parents' generations continue to have a political and moral commitment to the system and the idea of the revolution. For people in my generation, some of us still have the hope and the naiveté, perhaps, that things will start moving in the direction that we want. But unfortunately, for the younger generation, maybe those younger than twenty, they have a feeling of disappointment and want something different. Many prefer to migrate."

Regardless of generational differences, over and over again, Cubans have shown their remarkable resilience in confronting challenges, such as the prolonged attempt by the United States to destabilize the regime through the bloqueo, or the severe economic collapse triggered by the disintegration of the Soviet Union. When asked about the impact of the bloqueo on the revolutionary process, Cubans have strong and diverse opinions. However, for younger Cubans, the scarcity produced by the bloqueo remains particularly difficult to understand.

Embracing Challenges

The revolution brought fundamental changes to the way the country operated. It attempted to restructure society in an effort to transform perceptions of class, gender, race, power and hierarchy as well as political participation. While the revolution made deep social and ideological transformations, challenges remain. In

Habana Vieja, Havana.

Taking El Che to heart.

reference to racism, for example, Ana Pedreira, a historian in her 60s, talks about how "the revolution has been antiracist from the beginning, it has given people of African origin the rights and possibilities that Cuban society never gave them. In Cuba, we had legal discrimination until 1959.That doesn't mean that fifty years later the quality of life and development possibilities of people of African origin and European origin are exactly the same. However, the revolution has done a lot to improve conditions for people of African origin, and we must, from that point on, talk about improvement." Today the younger generation finds itself in a difficult dilemma. The high level of education achieved by the ever-growing number of university graduates clashes with an economy of scarcity. The recent transformations

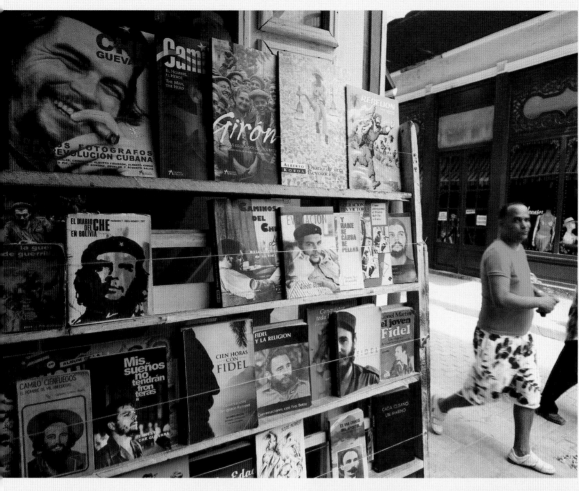

Tales of the
revolution.

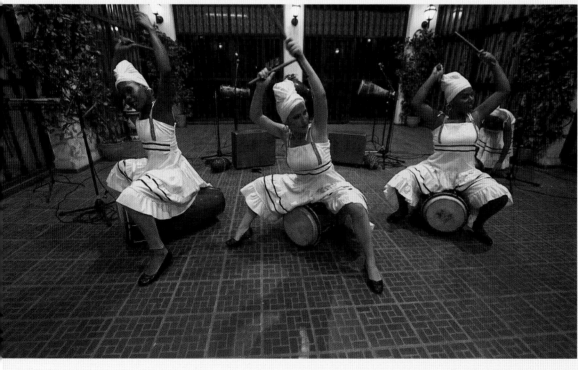

Obini Batá
Drummers in
Havana.

On the way to school.

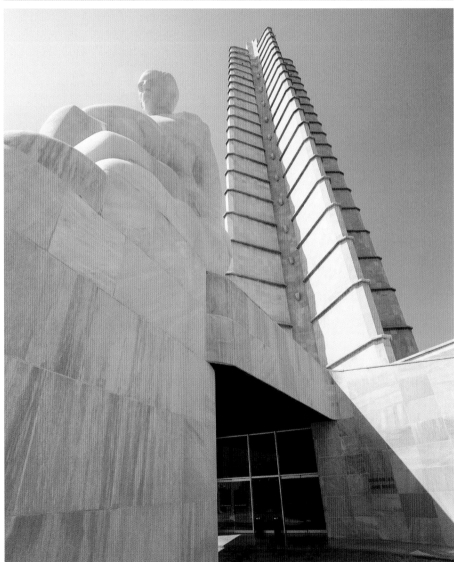

"Love . . . of the homeland / is not the ridiculous love of the earth, / nor of the grass that we tread; / It is invincible hatred toward those who repress it, / It is eternal rancor against those who attack it." José Martí.

Libretas (ration books) are taken to the bodega to obtain a wide range of basic necessities (from rice and beans to school uniforms) at subsidized prices. Since President Raúl Castro took office, items such as the cigarettes previously given to those over sixty, soap, and toothpaste have progressively been removed from the ration books. These items are generally available in the marketplace, but people must generally pay a higher, unsubsidized price for them.

in the service area do not challenge the generations of well-educated Cubans. The situation is further complicated by growing differences in salaries between the state and private sectors and by the new opportunities for conspicuous consumption that are the result of recent economic reforms. Some of these young people express their sentiments through blogs and websites such as *www.havanatimes.org*, which provides a window into Cuban life as written by Cubans on the island. While their parents and grandparents lived the revolution with enthusiasm as they fought for and lived through profound transformation, it is not surprising that enthusiasm for the revolution from Cuba's well-educated young adults has waned. As they move beyond ideology, they want concrete results and a better quality of life. As renowned Cuban historian Fernando Martínez Heredia eloquently said in an

interview, today's struggle in Cuba "consists in not going back to capitalism, but instead, in finding the way . . . to come out ahead without losing the only thing that cannot be lost: the socialist society that we created."

Even though some young people are looking for job opportunities outside of Cuba, it is undeniable that the new generation also understands the importance of national independence. During the memorial service honoring the late Fidel Castro in the Plaza de la Revolución on November 28, 2016, thousands of young adults cried *"Yo soy Fidel"* (I am Fidel—now a hashtag). This refrain has echoed at countless events since. What continues to be revolutionary is Cuba's refusal, as a country and a society, to give in to the demands of its neighbor to the north, and its resolve to continue to change on its own terms and according to its own rules.

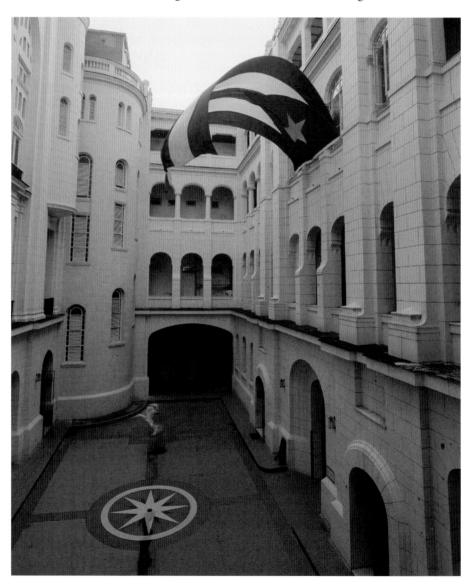

At the Museo de la Revolución, Havana.

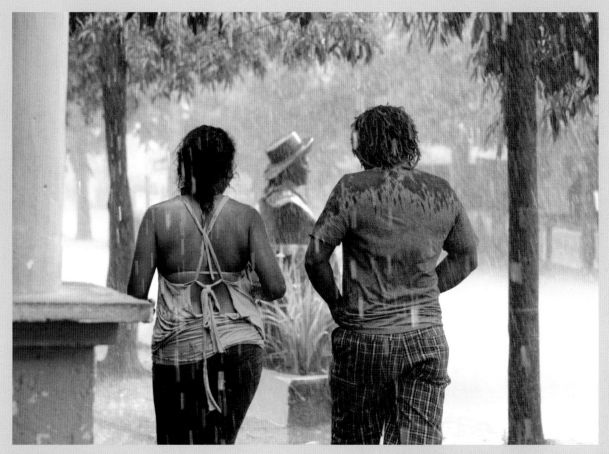
Summer rains.

"The bloqueo became much more visible when the Socialist bloc crumbled. Before that we had everything. Perhaps what we had was not so expensive or of top quality, but everyone had their Russian boots, khaki pants, olive-green shirt, and people were happy, we didn't think it important to have expensive, sophisticated things. You would dye your green shirt black, put your Russian boots on, and off you go to the party, you danced, and you had as much fun as everyone else. When the Cuban-American community started entering the country in the 1980s, differences started to matter. They would come with their super jeans, fancy shoes, and personal music boxes. We started to realize that there was another world apart from ours. And with the end of the Socialist bloc, the impact of the blockade became painfully clear."—Jorge Martínez Álvarez, a musician and electronic engineer in his 50s

"The bloqueo impacts in every sense. It limits the infrastructure or industrial development in our country that could guarantee our sustenance in the future. Given that we are so dependent on the outside, the blockade is really a dirty play against us. It's not only that we cannot import from the U.S., we cannot import from third parties and that makes everything difficult."—Estrella Álvarez Varela, 52, computer mathematician

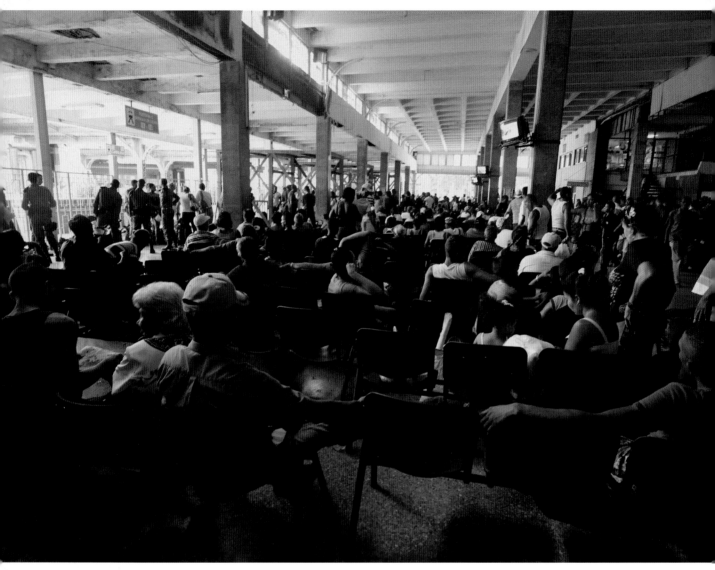

Train depot in Havana.

"During the Special Period, when tires were really worn out, we would paint the lines on the tires with a tin soldering gun so that they would pass inspection. We would also make all sorts of innovations to the engines, the body of the car. There were homemade windshield wipers. That shows that we will never give up. We are not afraid to fight and are always going forward."—Julio Acosta Manso, 62, driver and tourism guide

Gisela, an architecture student in her 20s, believes that "scarcity is not something just imposed by the blockade because, as has been said quite often, we have Coca-Cola here. I don't know where it comes from, but many products like that come in. So I really have never understood that."

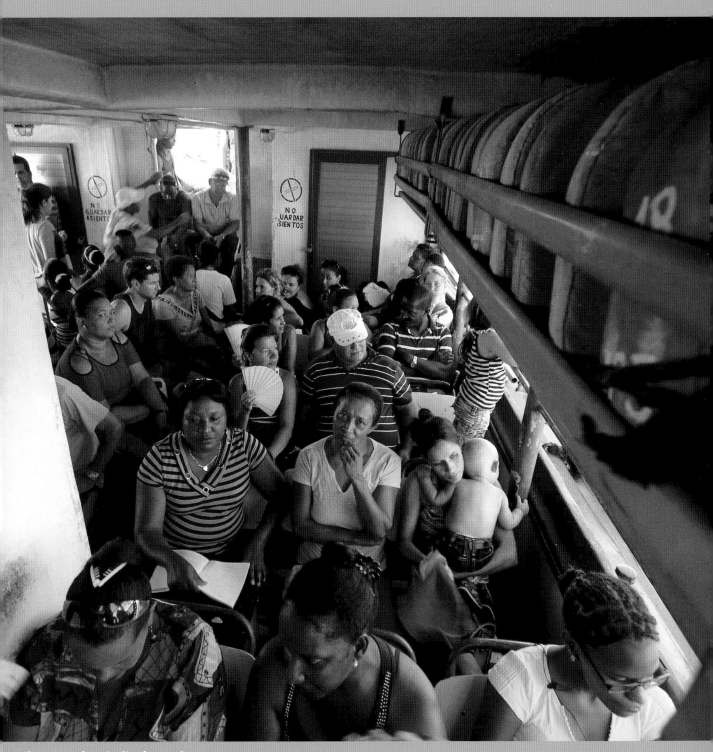

Passenger ferry in Cienfuegos Bay.

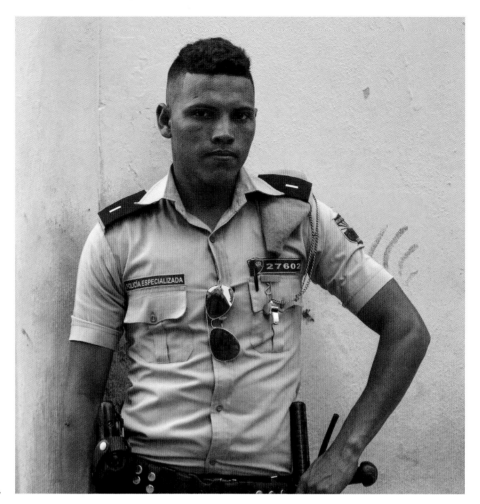

Police on duty.

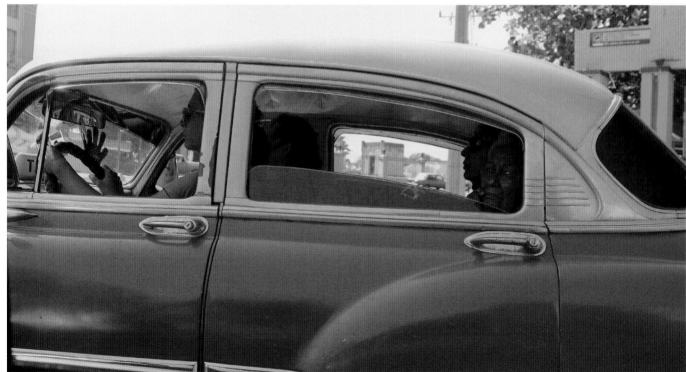

Sharing a ride in a *colectivo*.

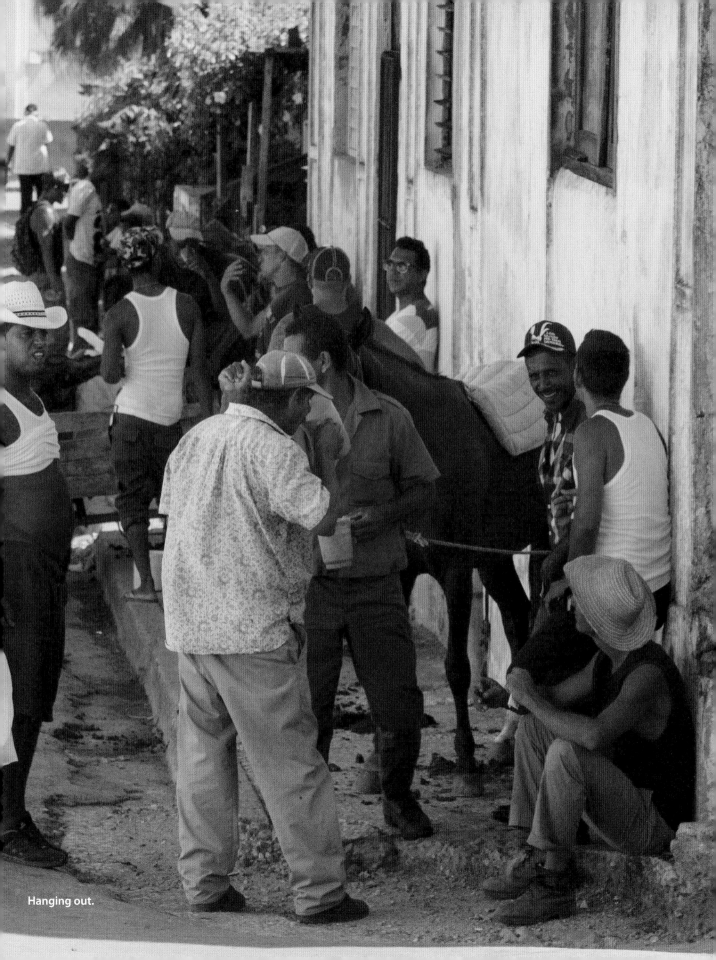

Hanging out.

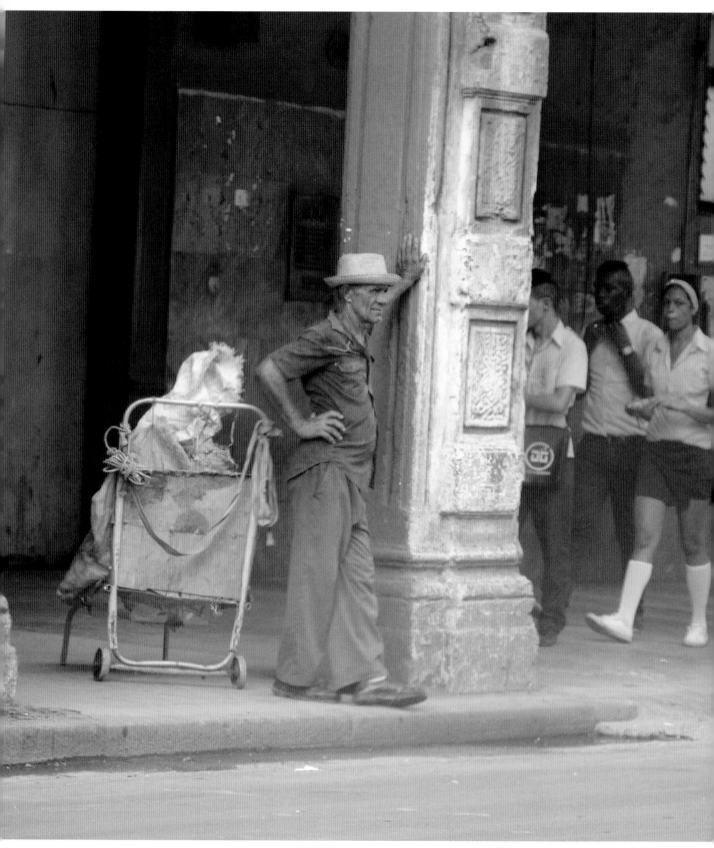

Generations in blue.

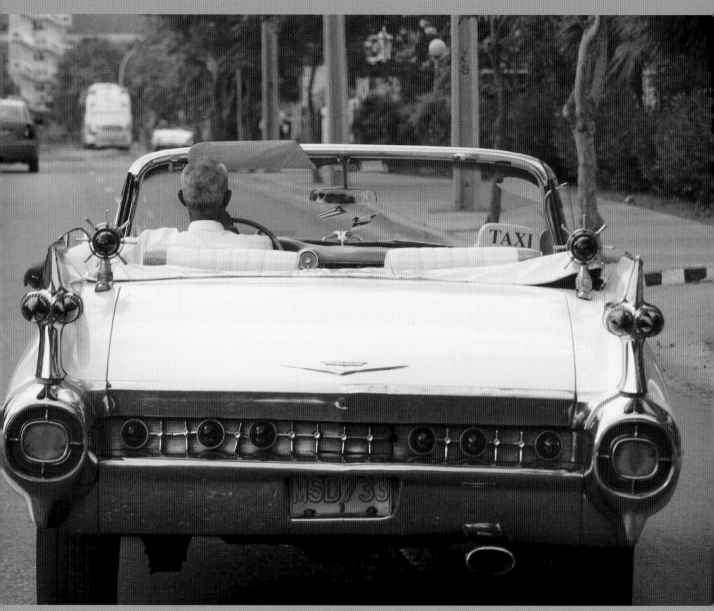

Matanzas taxi.

"It is necessary to walk toward the future with a firm and determined step."—Raúl Castro

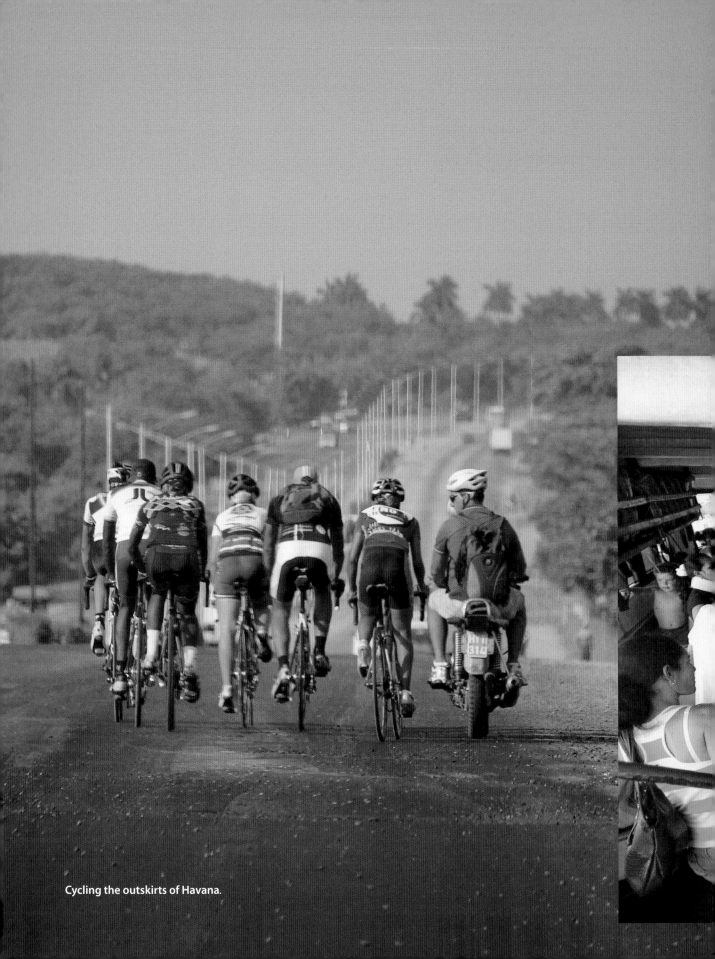

Cycling the outskirts of Havana.

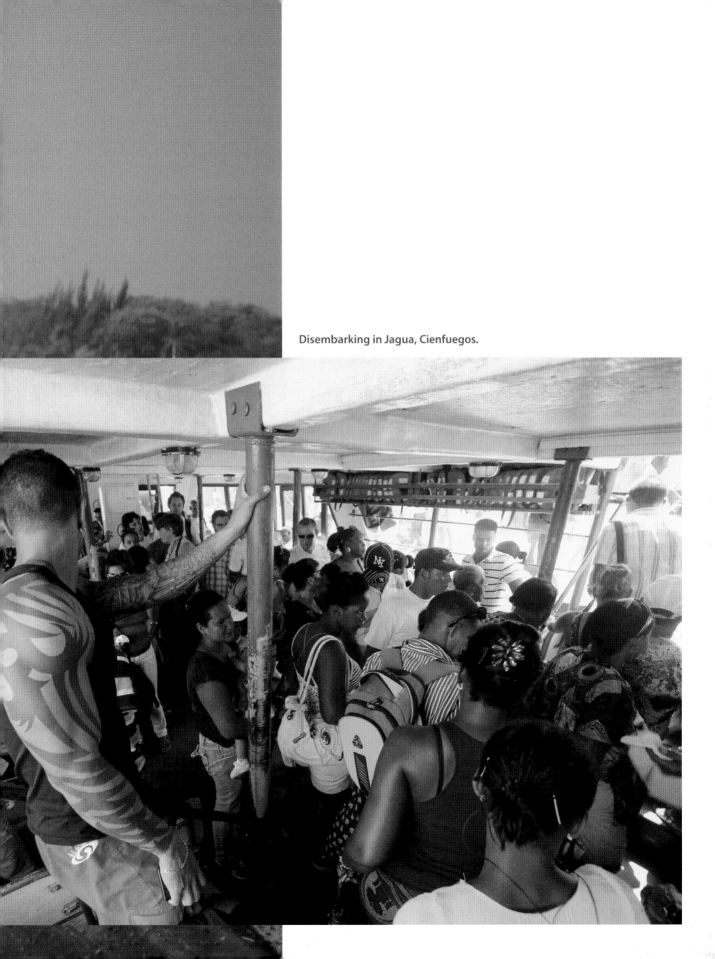

Disembarking in Jagua, Cienfuegos.

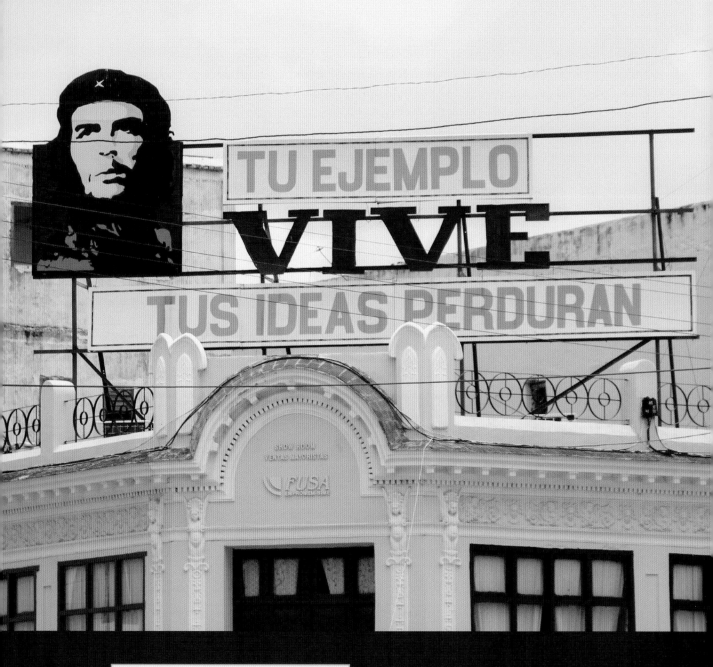

"Your example lives on. Your ideas endure."

Conclusion

Unlike other Latin American social revolutionary movements of the 1960s, 1970s, and 1980s, in Cuba the revolution has endured. As many Cubans argue, the revolution is not just a moment in history, but a dynamic process that has guided the people as they adjust to both internal and external challenges.

The words of Humberto Miranda Lorenzo, a university researcher in his 50s, provide an eloquent conclusion as he summarizes the sentiments and the convictions that we have heard from many Cubans through the years and of the dozens of women and men of different ages and opinions whom we interviewed for this book: "Revolution is a process. For Cubans—both young and old—the sentiments of patriotism and independence persist. Most people in Cuba like U.S. music and movies. We love U.S. TV series, but we don't want the United States leading our country. The United States is an ailment from which we have already freed ourselves. I think that this country reached very high levels of dignity. Some people say, 'But you cannot eat dignity,' and I say that without dignity, you cannot live. Today Cubans don't have a subservient attitude, and will look you straight in the eye."

That sense of dignity also has to do with critical achievements related to universal and free access to education and health care, basic rights that are nevertheless absent in many parts of the world. Those are gains brought by the revolution that Cubans feel must be preserved.

At the same time, Cubans must also deal with basic economic problems, a material scarcity that complicates daily living, and a bureaucracy that mystifies. The importance of solidarity as a fundamental part of the Cuban social matrix has allowed Cubans to adapt to one of the longest and harshest embargoes imposed by one nation on another in modern history, even during the Special Period, which marked the worst stage of crisis. Humberto, again, echoes the sentiment of many: "Cuban men and women survived the Special Period because we shared sugar, a cup of coffee, an old piece of bread. We shared bicycles. We shared everything instead of killing each other." For many Cubans, this solidarity also means that people must take part in Cuba's strategic decisions. Humberto continues, "The future of the revolution as an emancipating process must include the participation of all of us in all decisions and a real improvement in our daily lives."

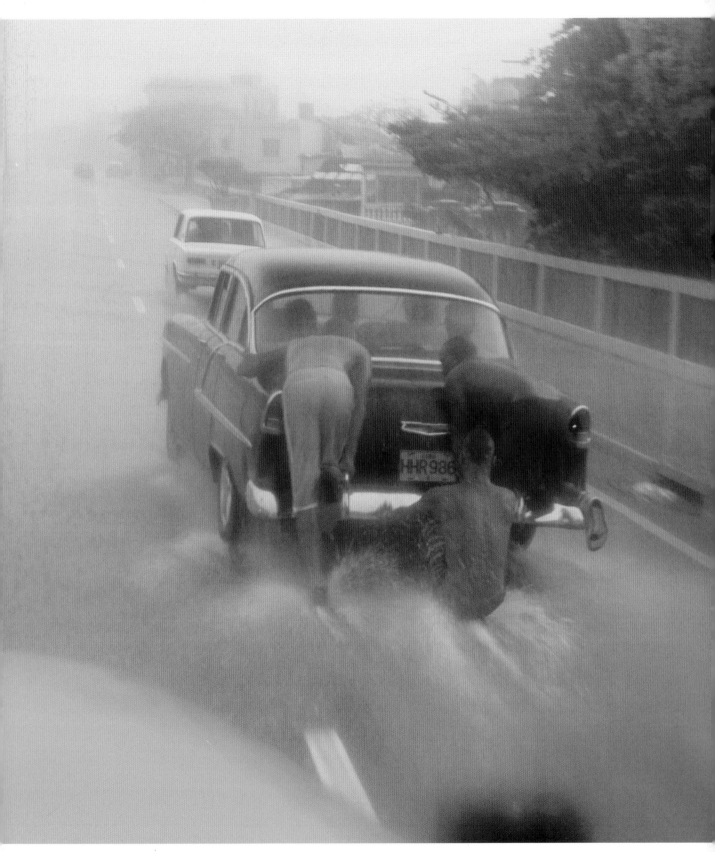

Playing in the rain, Marianao, Havana.

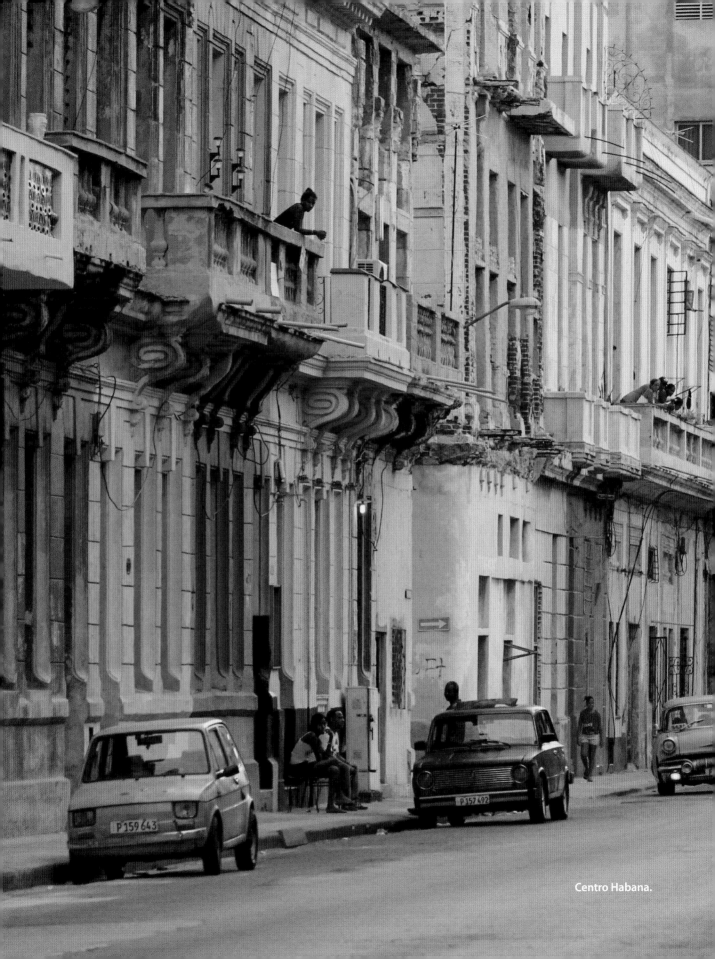

Centro Habana.

Notes

Introduction: The Revolution and El Bloqueo

This has been the longest and most restrictive trade embargo . . . : United Nations General Assembly Plenary, "'Archaic, Punitive' Embargo Must Be Consigned to History Books, Say Speakers, as General Assembly, for Twenty-First Year, Demands End to Cuba Blockade," news release, November 13, 2012, https://www.un.org/press/en/2012/ga11311.doc.htm. Accessed January 2018.

Today, the embargo seems . . . : Guillermo Grenier and Hugh G. Gladwin, "2014 FIU Cuba Poll: How Cuban Americans in Miami view U.S. Policies Toward Cuba" (Florida International University: Cuban Research Institute, 2014). Generational differences persist in this group.

The small island economy also has . . . : Isolina Boto and Ronalee Biasca, "Small Island Economies: Vulnerabilities and Opportunities" (CTA Brussels Office, 2012), https://brusselsbriefings.files.wordpress.com/2012/10/reader-br-27-small-island-economies-vulnerabilities-and-opportunities-eng.pdf.

He called for change . . . : Collin Laverty, "Economic Reform and Its Implications for U.S. Policy" (Washington, D.C.: Center for Democracy in the Americas, 2011). See also Feinberg 2012.

Since the revolution . . . : Richard E. Feinberg, "The New Cuban Economy: What Roles for Foreign Investment?" (Washington, D.C.: Brookings Institution, 2012).

This socioeconomic infrastructure ensures . . . : Jonathan Keyser and Wayne Smith, "Disaster Relief Management in Cuba: Why Cuba's Disaster Relief Model is Worth Careful Study" (Washington, D.C.: Center for International Policy, 2009).

Cuba has created a booming tourism industry . . . : Richard E. Feinberg. *Open for Business: Building the New Cuban Economy* (Washington D.C.: Brookings Institution Press, 2016).

The Platt Amendment of 1901 . . . : For insightful discussion, we refer readers to the works of Cuban historians Fernando Martínez Heredia and Ernesto Limia Diaz and U.S. historians Louis A. Pérez, Dick Cluster, and Richard Gott.

Cosmopolitan Havana boasted the world's largest . . . : Dick Cluster and Rafael Hernández, *The History of Havana* (New York: Palgrave Macmillan, 2006).

This stood in stark contrast with the abject poverty . . . : Jean Hostetler Diaz, "Introduction to Cuba in Transition," *Latin American Perspectives* 197, no. 41 (2014): 3–12.

In practice, this meant that the government took . . . : Cluster and Hernández, *The History of Havana*, 271.

Likewise, international human rights groups . . . : Amnesty International, "The US Embargo Against Cuba : Its Impact on Economic and Social Rights" (Amnesty International Publications: London, 2009).

Cuba has emerged as a leader in sustainable agriculture . . . : Efe Can Gurcan, "Cuban Agriculture and Food Sovereignty: Beyond Civil-Society-Centric and Globalist Paradigms," *Latin American Perspectives* 197, no. 41 (2014): 129–146; Gladys Hernández, "The Evolution of Cuban Agrarian Relations," *Agrarian South: Journal of Political Economy* 3, no. 2 (2014): 303–312.

Cuban scientists have become leaders in medical research . . . : Halla Thorsteinsdottir, T. W. Sáenz, U. Quach, A. S. Daar and P. A. Singer, "Cuba: Innovation Through Synergy," *Nature Biotechnology* 22, 2004, DC19-DC24.

Among countless medical breakthroughs . . . : Frances Shepherd, J. Y. Douillard, and G. R. Blumenschein, "Immunotherapy for Non-small Cell Clung Cancer: Novel Approaches to Improve Patient Outcome," *Journal of Thoracic Oncology* 6, no. 10 (2011): 1763–1773.

. . . in the international battle against Ebola. : Enrique Beldarraín Caple and Mary A. Mercer, "The Cuban Response to the Ebola Epidemic in West Africa: Lessons in Solidarity," *International Journal of Health Services* 4, no. 1 (2016): 134–149; Robert Huish, "Why Cuban Solidarity was Ebola's Antidote: How Cuban Medical Internationalism is Radically Changing Health Geographies in the Global South," *Human Geography* 10, no. 3 (2017): 54–70; see John Kirk, *Healthcare Without Borders: Understanding Cuban Medical Internationalism* (Gainesville: University Press of Florida, 2015) for an excellent discussion of Cuban medical internationalism.

In addition, its contribution to global education . . . : Kepa Artaraz, "Cuba's Internationalism Revisited: Exporting Literacy, ALBA, and a New Paradigm for South-South Collaboration," *Bulletin of Latin American Research* 31, no. 1 (2012): 22–37.

In fact, it is often praised by Washington . . . : "Cuba," in International Narcotics Control Strategy Report (INSR) (Washington, D.C.: Bureau of International Narcotics and Law Enforcement Affairs, 2015), https://www.state.gov/j/inl/rls/nrcrpt/2015/vol1/238961.htm.

Havana

Nevertheless, outside the restored areas . . . : Mario Coyula and Jill Hamburg, *Understanding Slums: The Case of Havana, Cuba* (The David Rockefeller Center for Latin American Studies, Working Paper Series, 2003). https://drclas.harvard.edu/files/drclas/files/slumshavana.pdf.

The hurricane season runs from . . . : Anke Birkenmaier and Esther Whitfield, eds., *Havana beyond the Ruins: Cultural Mappings after 1989* (Durham: Duke University Press, 2009).

Despite recent reforms . . . : Joseph L. Scarpaci and Armando H. Portela, *Cuban Landscapes: Heritage, Memory, and Place* (New York: The Guilford Press, 2009).

Culture, Religion, and the Revolution

Cuba's commercial entertainment industry . . . : Ned Sublette, *Cuba and its Music: From the First Drums to the Mambo* (Chicago Review Press, 2004); Rebecca Gordon-Nesbitt,

To Defend the Revolution is to Defend Culture: The Cultural Policy of the Cuban Revolution (Oakland: PM Press, 2015).

The revolutionary state vowed . . . : Aviva Chomsky, Barry Carr, and Pamela M. Smorkaloff, eds., *The Cuba Reader: History, Culture, Politics* (Durham: Duke University Press, 2003): 448–513.

They also signified commitment to revolutionary values . . . : Fidel Castro Ruz, "Discurso Pronunciado por el Comandante Fidel Castro Ruz, Primer Minístro del Gobierno Revolucionario y Secretario del PURSC, como Conclusión de las Reuniones con Los Intelectuales Cubanos, Efectuadas en la Biblioteca Nacional el 16, 23, y 30 de junio de 1961" (Departamento de Versiones Taquigráficas del Gobierno Revolucionario, 1961). http://www.cuba.cu/gobierno/discursos/1961/esp/f300661e.html. Accessed July 25, 2017.

The 1970s were known as the Quinquenio Gris . . . : Gordon-Nesbitt 2015.

The Nueva Trova, a genre of singer-songwriters . . . : Margaret Randall, "Book Review," *Policy Futures in Education* 14, no. 6 (2016): 864–866.

By the mid-1970s the Nueva Trova received . . . : Ilan Stavans and Joshua Stavans, *Latin Music: Musicians, Genres, and Themes,* vol. 1 (Santa Barbara, CA: Greenwood, 2014).

Throughout Cuba, Casas de la Música offer . . . : John Finn and C. Lukinbeal, "Musical Cartographies: Los Ritmos de los Barrios de la Habana," in *Sound, Society and the Geography of Popular Music,* ed. O. Johansson and T. Bell (New York: Routledge, 2016), 127–144.

This meant that all leagues and teams were seen . . . : Peter C. Bjarkman, *A History of Cuban Baseball, 1864–2006* (Jefferson, NC: McFarland & Company, 2007).

Billboards and Murals

started as "un grito en la pared" *(a scream on the wall)* . . . : Reinaldo Morales Campos, "El Cartel en Cuba: República y Revolución," Monographias.com, n.d. http://www.monografias.com/trabajos88/cartel-cuba-republica-y-revolucion/cartel-cuba-republica-y-revolucion.shtml. Accessed December 20, 2016.

Because these billboards represent state policy . . . : Julio Larramendi Joa and Jose A. Martínez Colonel, *Vallas y Carteles de Cuba* (Ediciones Polymitas, S.A., 2013).

Prior to the 1959 revolution, the official literacy rate . . . : Hostetler Diaz 2014.

As narrated in Catherine Murphy's 2012 documentary "Maestra" . . . : Catherine Murphy, *Maestra* (Women Make Movies, 2012), DVD.

In the words of historians, vallas and murals in Cuba . . . : Joseph L. Scarpaci and Armando H. Portela, *Cuban Landscapes: Heritage, Memory, and Place* (New York: The Guilford Press, 2009), 152.

Agriculture and the Land

An export-based agricultural economy . . . : Hernández 2014.

The state sector kept 33 percent of cultivated land . . . : Hernández 2014.

With these reforms, the amount of uncultivated land . . . : Carmelo Mesa-Lago, "Institutional Changes of Cuba's Economic Social Reforms" (working paper, Foreign Policy Latin America Initiative at the Brookings Institution, Chicago, IL, May 24, 2014). https://www.brookings.edu/wp-content/uploads/2016/06/cubaeconomicsocialreformsmesalago.pdf.

This shrub, however, is now used . . . : "The miracle of marabú, Cuba's wonderful weed," *The Economist,* June 1st, 2017, https://www.economist.com/the-americas/2017/06/01/the-miracle-of-marabu-cubas-wonderful-weed.

Some of the damaged areas . . . : "Cuba Issues Detailed Report on Damages from Hurricane Irma," *Havana Times,* September 30, 2017, https://havanatimes.org/?p=127591.

According to the World Food Program . . . : "Cuba Country Brief," Where We Work, World Food Programme, http://www1.wfp.org/countries/cuba. Accessed September 2018.

Despite the setbacks . . . : "6 Facts About Food Security in Cuba," World Food Programme, 2016, https://www.wfp.org/stories/6-facts-about-food-security-in-cuba. Accessed September 2018.

Economy in Flux

"The economic battle is today . . .": Raúl Castro, speech on the 10th anniversary of the Comprehensive Cooperation Agreement between Cuba and Venezuela, November 8, 2010, Palacio de las Convenciones, Havana. http://www.radiorebelde.cu/noticia/la-batalla-economica-constituye-hoy-mas-nunca-tarea-principal—video-20101109/.

In an effort to reduce dependence on the state . . . : Marc Frank, *Cuban Revelations Behind the Scenes in Havana* (Gainesville: University Press of Florida, 2013).

Tourism is now one of the top sources . . . : Feinberg, *Open for Business.*

The Revolution Is Not Over

Fernando Martínez Heredia eloquently said . . . : Gloria Muñoz Ramírez, "Incorrecto, hablar de un antes y un después de Fidel," *La Jornada,* December 10, 2016.

Daniel Duncan is a photographer and filmmaker who has produced more than 150 documentaries about Latin America for PBS in the United States. He has received twenty-seven Emmy awards for his work and is a Silver Circle Award recipient from the National Academy of Television Arts and Sciences. He has a master's degree in Latin American studies and entrepreneurship and is a producer/filmmaker at the University of Arizona's Southwest Center.

Marcela Vásquez-León is associate professor in anthropology and director of the Center for Latin America Studies at the University of Arizona. She is also director of the Women's Leadership Institute for Latin American Indigenous and Afro-descendent Students. She works in rural Latin America on issues related to collective organization, environmental justice and rural development. She started and codirected for several years the UA study-abroad program in Cuba.

Dereka Rushbrook is associate professor and director of undergraduate studies in the School of Geography and Development at the University of Arizona, and affiliate faculty with the Center for Latin American Studies. She has spent more than two years in the island and has traveled throughout the country on annual trips since her first visit in 2008. She has codirected the UA study-abroad program in Cuba since it began in 2012. Her research in Latin America focuses on social and environmental justice and globalization.